SIMPLIFIED ANATOMY
FOR THE COMIC BOOK ARTIST

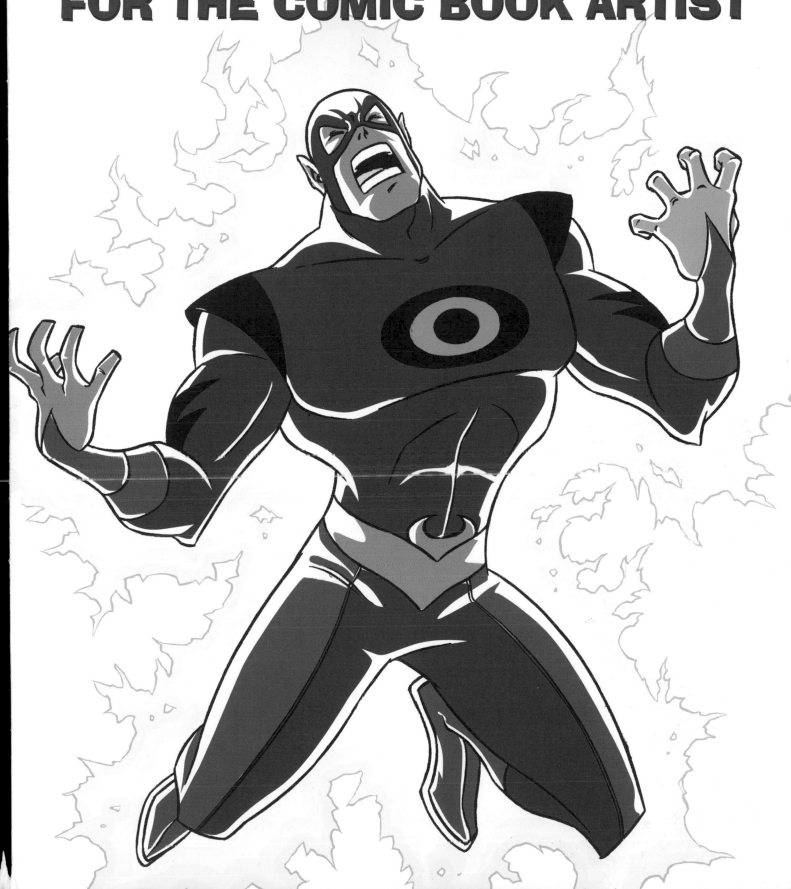

SIMPLIFIED ANATOMY
FOR THE COMIC
BOOK ARTIST

HOW TO DRAW THE NEW STREAMLINED LOOK OF ACTION-ADVENTURE COMICS!

WATSON-GUPTILL PUBLICATIONS
NEW YORK

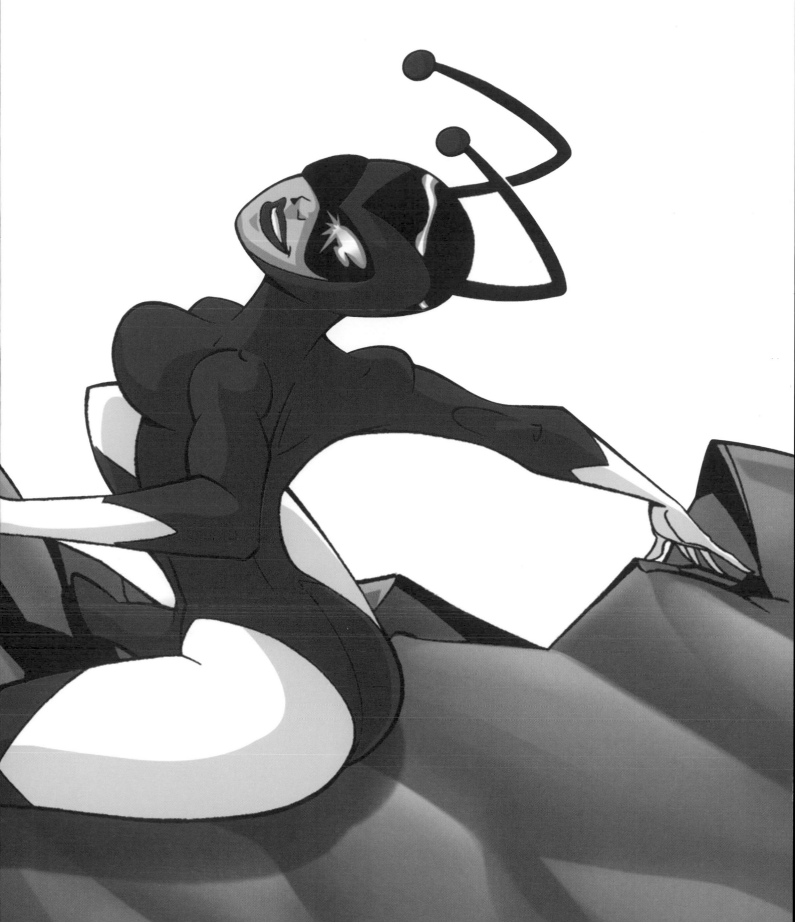

First published in 2007 by Watson-Guptill Publications,
a division of VNU Business Media, Inc.,
770 Broadway, New York, NY 10003
www.watsonguptill.com

Library of Congress Cataloging-in-Publication Data
Hart, Christopher.
 Simplified anatomy for the comic book artist : how to
draw the new streamlined look of action-adventure
comics / Christopher Hart.
 p. cm.
 Includes index.
 ISBN-13: 978-0-8230-4773-4 (alk. paper)
 ISBN-10: 0-8230-4773-3 (alk. paper)
 1. Human beings-Caricatures and cartoons. 2. Figure
 drawing-Technique. 3. Cartooning-Technique. I. Title.
 NC1764.8.H84H387 2007
 741.5'1-dc22
 2006029079

Executive Editor: Candace Raney
Editor: Michelle Bredeson
Design and color: MADA Design, Inc.
Senior Production Manager: Alyn Evans

Printed in China
1 2 3 4 5 6 7 8 9 / 15 14 13 12 11 10 09 08 07

Contributing Artists:
Cristina Francisco: 22, 92-111, 138-145, 148-159
Tom Hodges: 54-55, 76-89
Christopher Jones: 24-27
Fabio Laguna: 12-19, 38-49, 114-135, 136
Sean Murphy: 20-21, 65-70
Dave Santana: 28-35, 52-53, 56-64, 71-73

VISIT US AT
www.artstudiollc.com

DEDICATION

To all the aspiring artists, pros, serious hobbyists, comic book fans, and Comicon devotees.

CONTENTS

INTRODUCTION

As comic styles evolve, visual artists (that's you) will want and need to evolve with them. Nobody wants to be typecast by editors as "that guy who draws only one style." If you want to draw in one of most popular, exciting comic styles today, you've come to the right place. *Simplified Anatomy for the Comic Book Artist* shows you everything you need to know to draw the new, streamlined style of comics with a retro cartoon influence. This style requires a different approach from the comics of recent years that feature super-defined, hardcore bodybuilder costumed heroes. It doesn't replace it but is a vital addition to the genre. Rather than focus on greater and greater muscular definition, this streamlined style uses simplicity of design to give it its edge.

Because this style lends itself to a simpler interpretation of the muscle groups, it makes it much easier for the aspiring artist—as well as the more experienced one—to conceptualize the complexities of anatomy. Does anatomy have to be hard? The way most books teach it, you'd think so. The human body has just shy of seven hundred muscles in it. You would drive yourself crazy if you tried to memorize each one of them, and even if you did, it wouldn't make you a better artist. By simplifying anatomy, we omit very small, deep muscle groups that are featured in most anatomy books but never show up on the surface of the skin.

You'll learn exactly how to draw the head and skull at different angles, how to simplify the features of the face, and which muscles of the face to use to create specific expressions. You'll also learn how to draw a simplified skeleton that

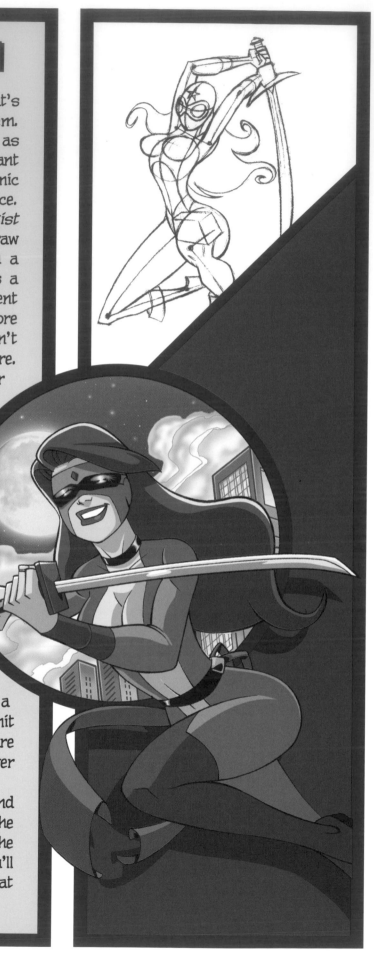

makes sketching difficult poses easier and see how the physiques of comic book characters can be used to create personality types. You'll dissect powerful perspective poses and get two huge, in-depth chapters that label all of the major muscles of the body, all in comic book action poses, for male and female costumed figures. You'll also learn how to stylize your line so that your characters exude a charisma built on personality and magnetism, not just bulk.

In short, if you can think of a comic book pose, you can find the anatomy answers to it in this book. This book is designed to make anatomy logical on a gut level. And isn't that what you've been waiting for?

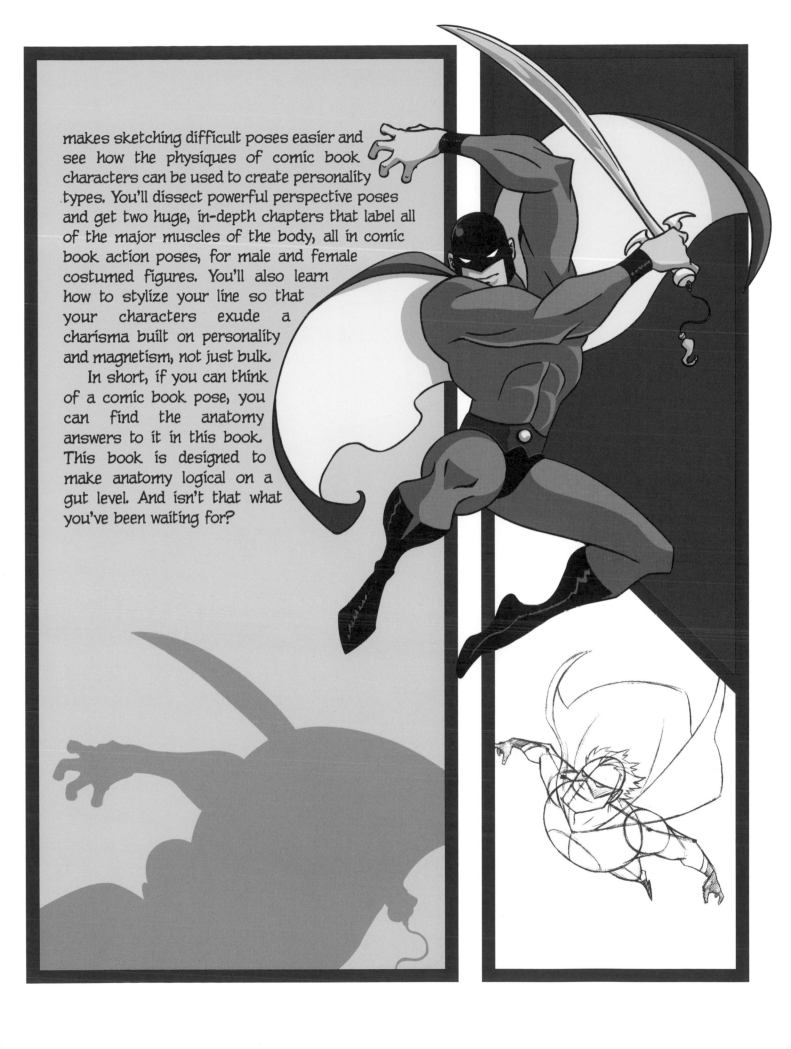

THE SIMPLIFIED HEAD & NECK

Whether you're drawing a manly superhero, an evil villain, or the girl next door, there are certain commonalities they all share. The head, for example, starts with a basic skull that we can then adapt to suit a particular character. On some characters, we might exaggerate the chin or maybe shrink the brow, but the underlying principles remain the same. Let's take a look.

TRADITIONAL COMIC BOOK STYLE VS. STREAMLINED

Let's start by comparing the traditional comic head to the new simplified, streamlined head. At first glance, the difference between the two appears to be a matter of more detail on the traditional drawings and less on the simplified ones. Though that's technically true, it misses a key point. The traditional drawings are full of small, choppy lines, whereas the simplified drawings are created with clean, fluid lines: Everything extraneous to the form is omitted.

Just as important is the quality of the line itself; the simplified line tends to curve rather than break into sharp angles. The line bends without any abrupt changes of direction (sharp right angles, for example). And streamlined characters are highly stylized.

Traditional **Simplified**

Traditional **Simplified**

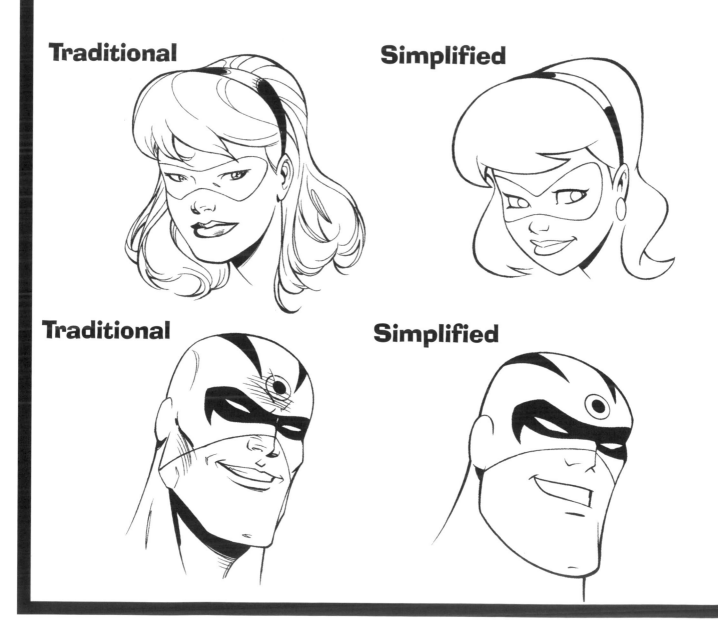

SIMPLIFYING THE SKULL

Here is an example of a detailed version of the skull that, for the purposes of drawing, does not need to be recreated with exacting accuracy. We're interested in using the form of the skull only as the foundation of the head. We need to take note of its major contours, holes, and bony protrusions, but only the ones that will eventually show up on the surface anatomy.

For example, is it really necessary to draw all of the contour lines that appear on the maxilla (the area above the upper lip and below the nose)? To do so is accurate, but so what? Details like these are lost from sight once the muscles and skin cover the bone, so we can comfortably leave them out when we simplify the skull.

We can also simplify our drawing style to suit the streamlined look by replacing shorter lines with longer lines and hard angles with soft angles.

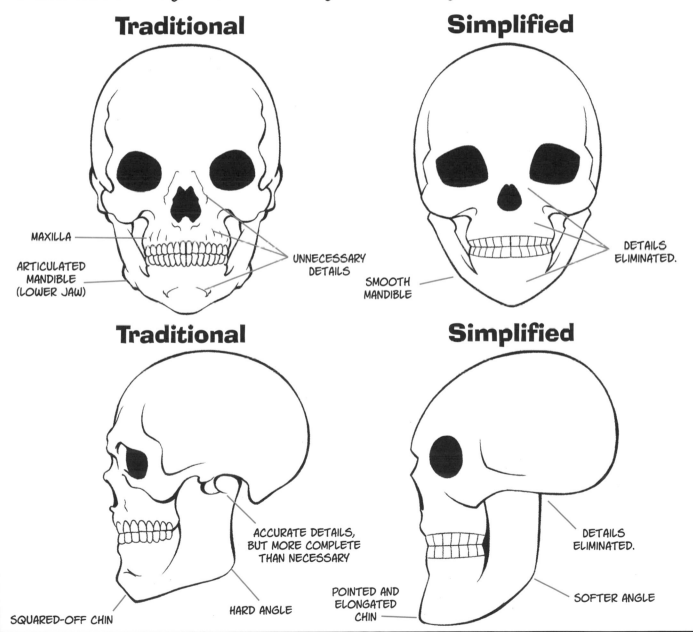

Traditional

MAXILLA

ARTICULATED MANDIBLE (LOWER JAW)

UNNECESSARY DETAILS

Simplified

DETAILS ELIMINATED.

SMOOTH MANDIBLE

Traditional

SQUARED-OFF CHIN

ACCURATE DETAILS, BUT MORE COMPLETE THAN NECESSARY

HARD ANGLE

Simplified

POINTED AND ELONGATED CHIN

DETAILS ELIMINATED.

SOFTER ANGLE

PUTTING THE SKULL INSIDE THE HEAD

Most anatomy books give you a section on skulls. Then they give you a section on heads. What they don't do is put the skull inside the head, where it would do you some good. Take a look at this hero. You're seeing him as a finished character. He's got several specific traits in this finished drawing that are carried over from the skull: a small forehead, wide cheekbones, a chin that can do push-ups, and widely spaced eyes. Now, let's walk the process backward and see how he looks when we place his skull inside of him.

Front View

Side View

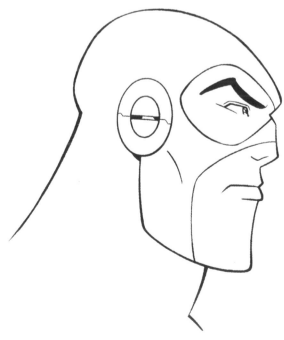

Now you can see that the skull really serves as the foundation for the shape of the head, the contours of the face, and the placement of the features. You may be asking yourself, "Why not just draw the head from an egg shape, as I've seen in some books?" The answer is that you can and you will. But you would never leave it like that. You need to mold it into something by adding mass for the brow, jaw, cheekbones, and ball of the chin, while indenting just above the bridge of the nose. So we're back to the skull again! Hey, why quibble? Let's go right to the source and see what it is we're borrowing from.

Front View

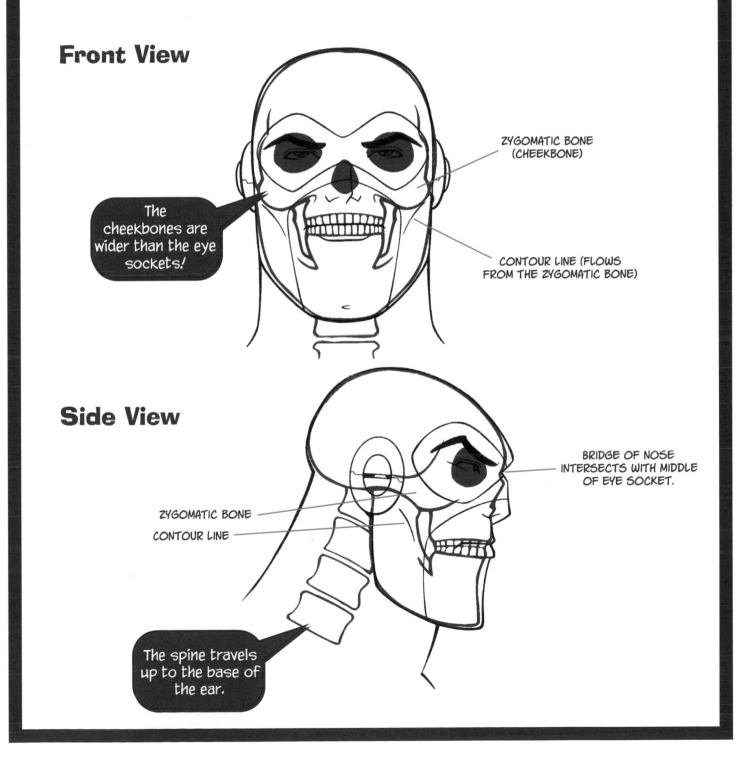

The cheekbones are wider than the eye sockets!

ZYGOMATIC BONE (CHEEKBONE)

CONTOUR LINE (FLOWS FROM THE ZYGOMATIC BONE)

Side View

ZYGOMATIC BONE

CONTOUR LINE

BRIDGE OF NOSE INTERSECTS WITH MIDDLE OF EYE SOCKET.

The spine travels up to the base of the ear.

MOLDING SKULL SHAPES TO CHARACTER TYPES

The skull on the previous page seems to have a very specific look. That begs the question: Are all skulls the same shape? If so, that would mean drawing a thug, a wispy genius, and a beautiful vampire with the same skull and just changing the facial features. Clearly that won't work. If the foundation—the starting point—of the head is the skull, then it has to be caricatured, as well as simplified. Each character requires a slightly different skull shape based on his or her personality and role. Now let's look at a cast of stock comic book characters and see how we can use the skull as a starting point for drawing their heads.

Hero: 3/4 View, Looking Down

The classic hero is strong, sometimes funny, and even a little sarcastic. The industrial-strength chin, wide cheekbones, and square jaw are typical of this character.

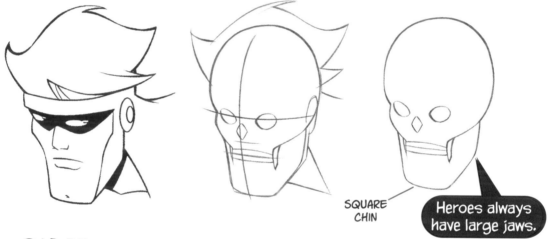

SQUARE CHIN

Heroes always have large jaws.

Villain: 3/4 View

Devious villains are an orthodontist's dream. They're recognized by their crooked teeth, small foreheads, and pointy faces. Note the insincere smile.

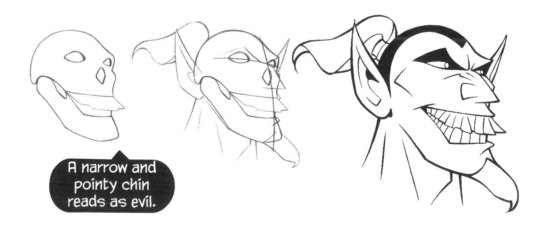

A narrow and pointy chin reads as evil.

Female Fighter: Profile, Looking Down

The female hero is attractive due to the classic combination of a large forehead and a small jaw. She is all soft curves: soft underside of jaw, soft curves of skull, small brow, and petite mouth.

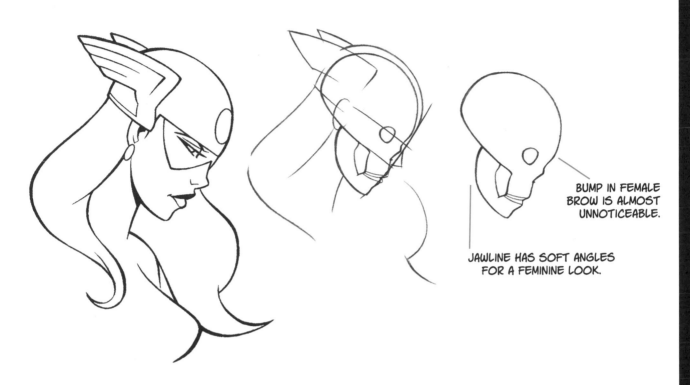

BUMP IN FEMALE BROW IS ALMOST UNNOTICEABLE.

JAWLINE HAS SOFT ANGLES FOR A FEMININE LOOK.

Brute: 3/4 View, Looking Up

Brutes and thugs sport thick brows, giant jaw areas, oversized chins, tiny foreheads (not a lot of gray matter to store), wide cheekbones, and eyes that are spaced widely apart.

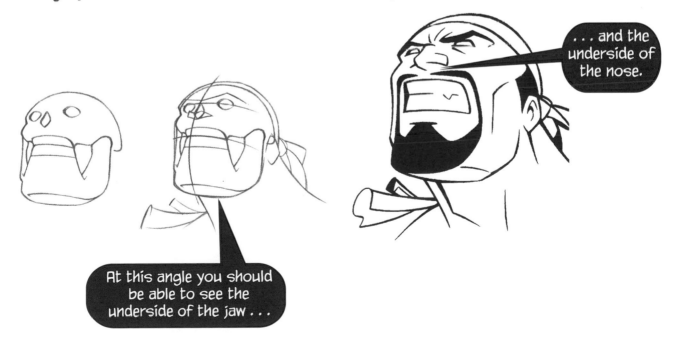

. . . and the underside of the nose.

At this angle you should be able to see the underside of the jaw . . .

Team Action Guy: Front View

He gets to go on the mission but doesn't get to rescue the girl. Since he's not the team leader, you gotta reduce the size of the cheekbones and the chin slightly.

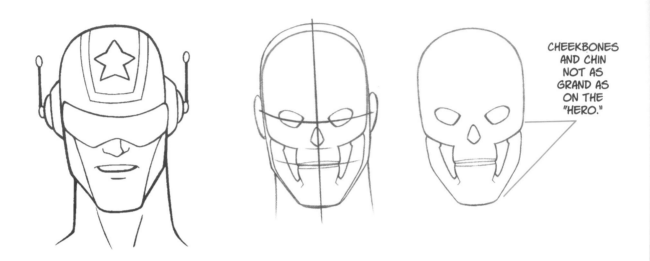

CHEEKBONES AND CHIN NOT AS GRAND AS ON THE "HERO."

Ticked-off Mutant: 3/4 View, Looking Down

And this is after twelve sessions of anger management. Note how thick the brow and jawbone are. We're talking about a pituitary on overdrive.

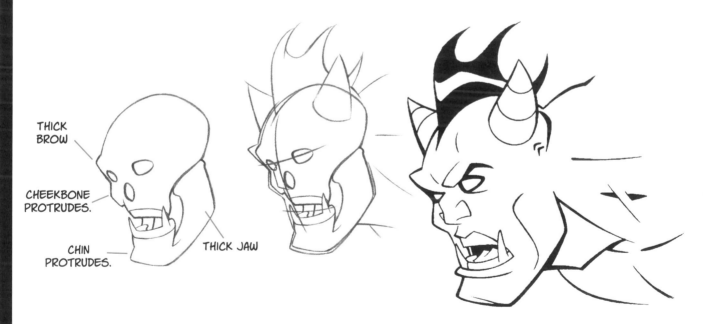

THICK BROW

CHEEKBONE PROTRUDES.

CHIN PROTRUDES.

THICK JAW

Team Action Babe: 3/4 View, Looking Down

Again, for a simplified and attractive look, start with a rounded outline, without any sharp angles, for the skull.

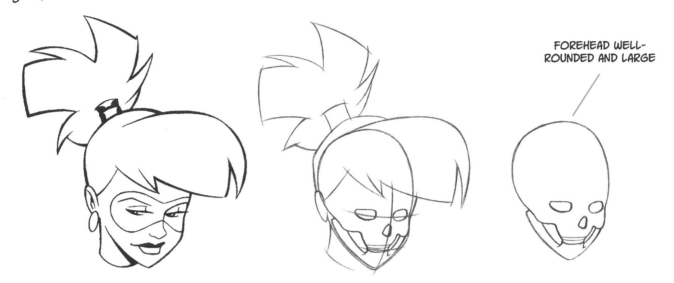

FOREHEAD WELL-ROUNDED AND LARGE

Really, Really (Really) Ticked-off Mutant: Profile

Who woke up a little cranky? You'll notice that the features of the upper skull (eyebrows, eyes) work independently of the lower half of the head (the mouth). In other words, the eyebrows can crush into a scowl, while the mouth can stretch into a roar.

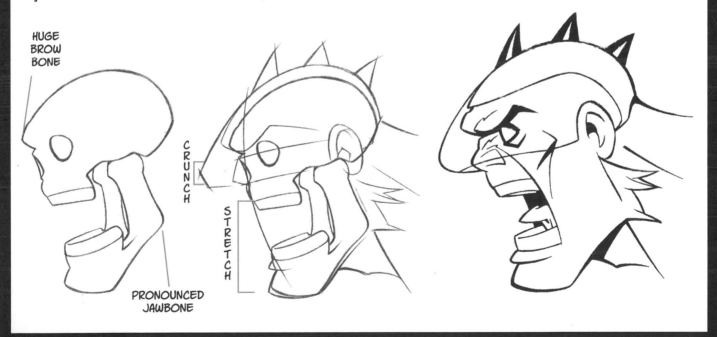

HUGE BROW BONE

CRUNCH

STRETCH

PRONOUNCED JAWBONE

A Note About Mutants

What are mutants, and why are we including them as a character "type"? Typically, though not always, a mutant is part human and part "other." That "other" can be feral beast, a fantasy creature, or something alien in nature. A mutant typically has the build of a hyper-inflated pro wrestler. It can be a supportive team member in a cast of characters or an immensely dangerous adversary.

THE MUSCLES OF THE FACE & NECK

The face is one of the most muscular areas of the body. It has to be in order to create the multitude of expressions that people are capable of.

Some facial muscles are used more than others in creating expressions. You've probably already guessed which ones they are, since crease lines form around those muscles. They include the cheekbone muscles, eyebrow muscles, under-eye muscles, and mouth muscles. You don't need to remember their Latin names, but since I have to call them something, I'm going to use the correct terminology. But it is far more important that you visualize the muscles in your mind than remember the terms. If you're doing a drawing and want to refresh your memory, pick up this book and flip to this page. It's not cheating. It's what artists do.

1. Frontalis: This muscle creates the wrinkles of the forehead.

2. Orbicularis oculi: The muscle that allows the hero to squint his famous "I'm going to get justice if it's the last thing I do" look.

3. Zygomaticus: The cheekbone muscle that pulls tautly on the edges of the mouth, giving a character a sleek, hungry look.

4. Masseter: The jaw muscle. The more definition you give this muscle, the sharper and more masculine the character looks.

5. Orbicularis oris: This muscle acts like an elastic band around the mouth, expanding and contracting to suit the expression. It can really stretch.

6. Triangularis: This muscle wraps around the chin and is sort of a continuation of the zygomaticus. It's an effective muscle to show when the mouth widens, pulling the orbicularis oris muscle out wide.

7. Mentalis: This is the muscle in the middle of the chin. Yep, it's a muscle. Crafty vixens use it to push their lower lip into a pout, which forces helpless men to bend to their will.

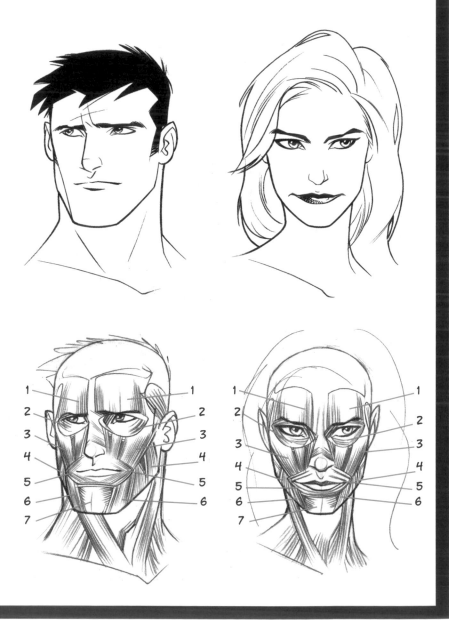

USING THE FACIAL MUSCLES TO CREATE EXPRESSIONS

Different muscles are called upon and emphasized to create different expressions. To demonstrate this concept, the following diagrams show only the muscles that are working to make each expression. Just remember, if a person makes an expression and creates a facial crease, there's a muscle group causing it.

It's your decision as an artist whether or not to draw the crease marks (or expression lines) on the finished drawing. In other words, just because an expression may call for a crease doesn't mean you have to put it in. You might choose to leave it out because you prefer the sleek look of an uncluttered face. Or perhaps the character is a leading man or woman who looks better with smooth skin. On the other hand, the character might be a craggy villain, in which case you may want to show every line that the muscle can possibly define. These are artistic choices and are completely up to you. Just remember that in the simplified style, less is more.

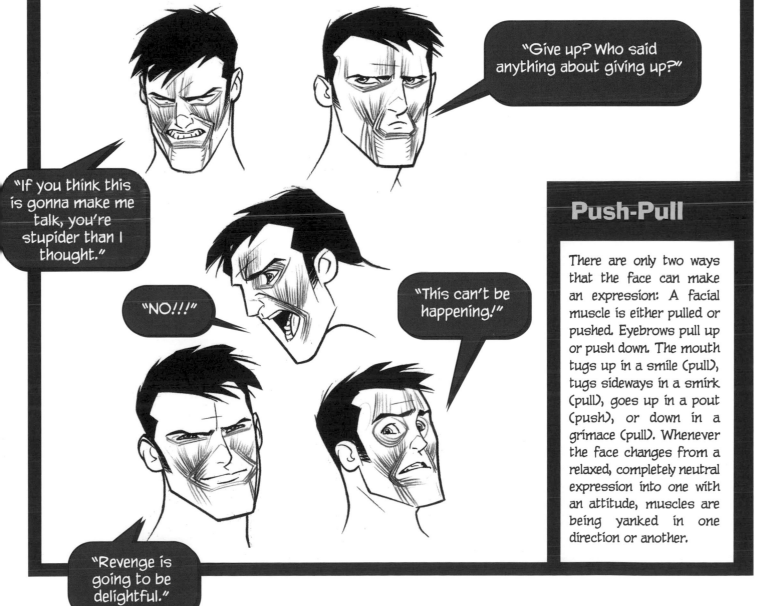

"Give up? Who said anything about giving up?"

"If you think this is gonna make me talk, you're stupider than I thought."

"NO!!!"

"This can't be happening!"

"Revenge is going to be delightful."

Push-Pull

There are only two ways that the face can make an expression: A facial muscle is either pulled or pushed. Eyebrows pull up or push down. The mouth tugs up in a smile (pull), tugs sideways in a smirk (pull), goes up in a pout (push), or down in a grimace (pull). Whenever the face changes from a relaxed, completely neutral expression into one with an attitude, muscles are being yanked in one direction or another.

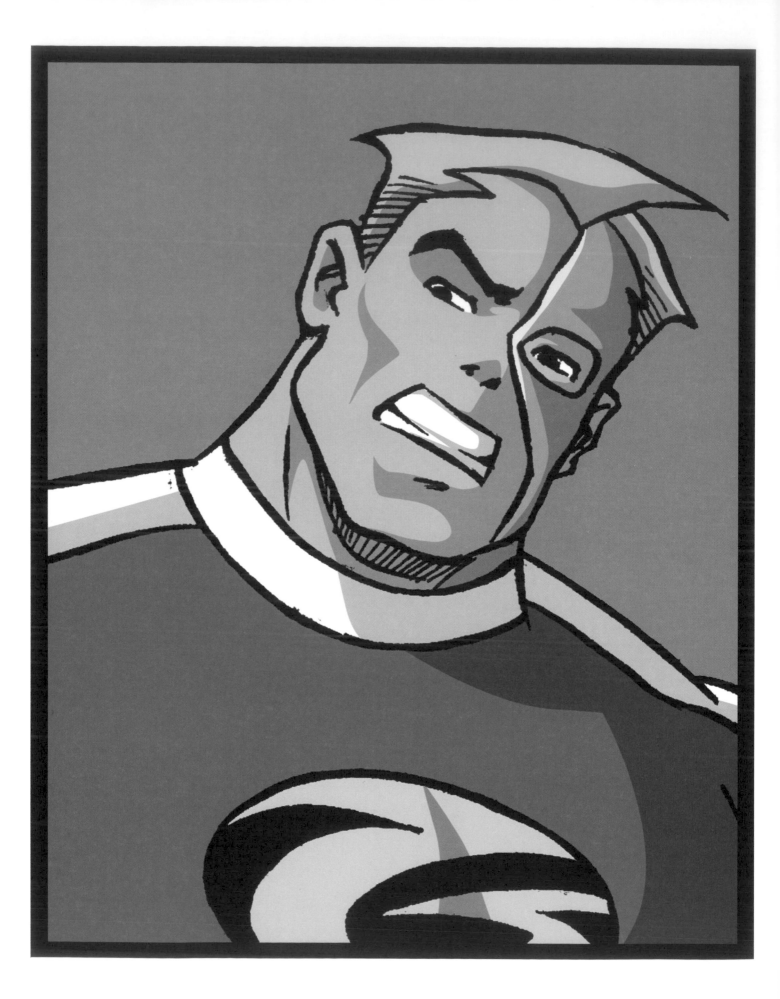

SIMPLIFYING THE FEATURES OF THE FACE

Aspiring comic book artists tend to focus too much detail on the features of the face and draw them with a heavy touch. If anything, it's best to underdraw the eyes, nose, and mouth. The individual features are only parts of the whole. Let the overall image convey the character. This chapter will show you how to simplify the features to make your work easier and stylize them to give your drawings an edge.

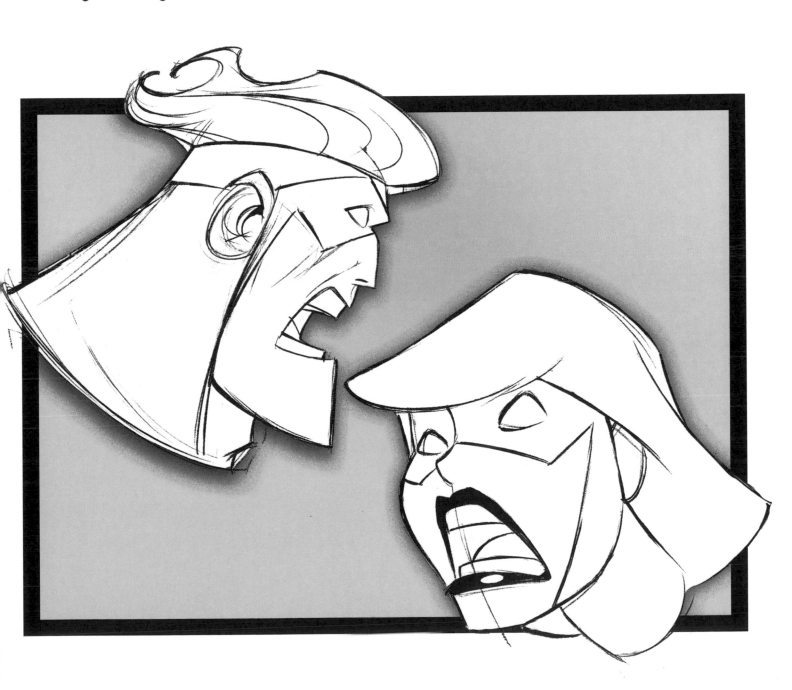

DRAWING MALE EYES: TRADITIONAL STYLE

We'll start off with the eyes, because they're the most expressive feature of the face. In order to understand the components of the eyes, we'll first take a look at a realistically drawn eye before we simplify and stylize it. Note that the male eyebrow is choppy, random looking, and placed close to the eyelid.

Eyelid Types

Eyelids come in different shapes and angles.

GENTLE CURVE

SLOPING DIAGONAL

The Iris

The shape of the iris changes to accommodate perspective. In this case, it becomes elliptical.

Side View

The eyeball protrudes beyond the outline of the face, and the surface of the eyeball is round, not flat. The eyelashes feather out and away from the eye.

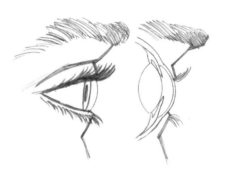

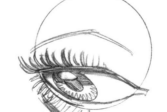

Male Eye: Step by Step

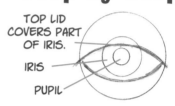

TOP LID COVERS PART OF IRIS.

IRIS

PUPIL

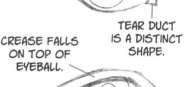

CREASE FALLS ON TOP OF EYEBALL.

TEAR DUCT IS A DISTINCT SHAPE.

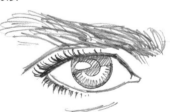

SHADOW FALLS ON UPPER IRIS.

SHOW THICKNESS OF LOWER EYELID.

Realistic Version

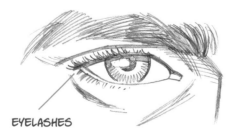

EYELASHES

Simplified Version

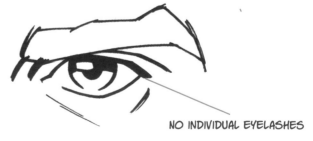

NO INDIVIDUAL EYELASHES

24

STYLIZED EYES: MALE

We don't have to use all of the elements of the eyes in every character. Eyes are often stereotyped in order to help identify characters in their roles. An evil genius may have no eyelashes at all. A mutant may have no pupils. You may want to exaggerate grossly in some areas, such as dark rings under the eyes or freaky eyebrows that look like two well-used hairbrushes. Heroic eyes, by contrast, can be drawn subtly, yet they usually have strong eyebrows.

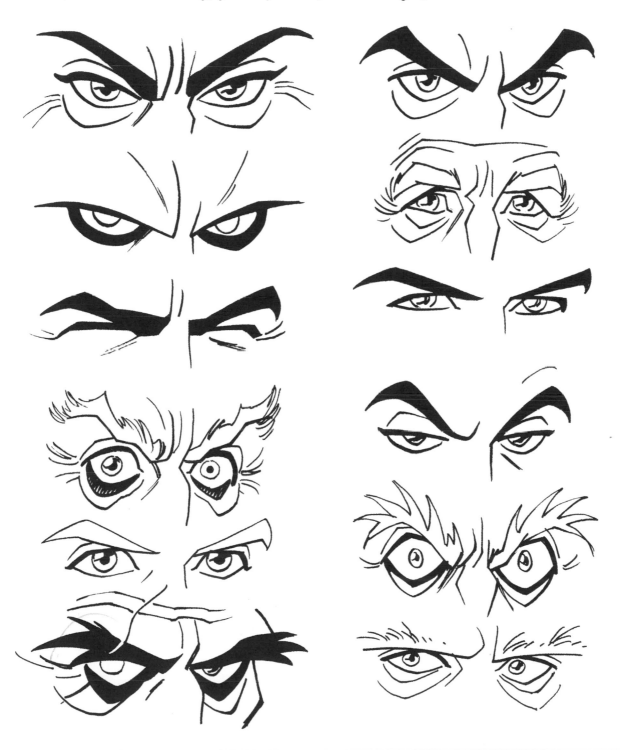

DRAWING FEMALE EYES: TRADITIONAL STYLE

The female eye is more almond-shaped than the male's, with a greater abundance of eyelashes (male characters are rarely shown with bottom lashes). The eyebrow is tapered at the end, with a high arch in the middle.

If you draw the upper eyelid resting on the pupil, it gives the female character a sultry look, known to drive the male of the species crazy with desire.

Varying the Eye Shape

Eyelids come in different shapes and angles.

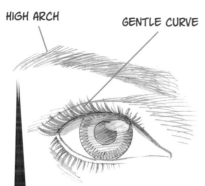

HIGH ARCH

GENTLE CURVE

Eyebrows are tapered and end in a neat point.

SLOPING DIAGONAL

HIGH ARCH

EYELID RESTS ON TOP OF PUPIL.

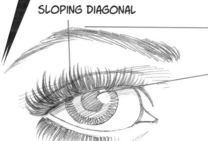

Side View

In a side view, draw the lashes all the way from the corner of the eye to beyond the outline of the face.

EYEBROW FEATHERS OUT PAST FOREHEAD.

MEMBRANE IN FRONT OF EYE

Female Eye: Step by Step

FEMALE CHARACTERS HAVE THICK UPPER EYELIDS.

THE HEAVIER THE SHADOW, THE MORE ALLURING THE FEMALE CHARACTER.

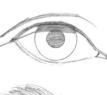

Realistic Version

Eyelashes are drawn individually for a realistic eye.

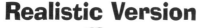

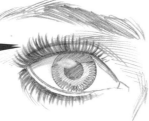

Simplified Version

Bunch the eyelashes together when drawing the simplified eye.

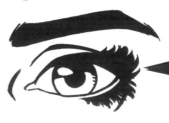

STYLIZED EYES: FEMALE

When we simplify and stylize the eyes, the differences between the genders become even more pronounced. The eyelashes become thick, serpentine lines that ooze sex appeal. And here's a subtle hint that will really send your drawings to the head of the pack: To draw attractive female characters, blend the pupil with the shadows that occur under the upper eyelid. To see what I mean, take a look at the examples of the eyes on this page. See how the pupils all blend directly into the thick lines of the upper eyelids? That's the key to a seductive look. The one set of eyes that doesn't have it—the second from the top, on the left side—doesn't look as sexy. And now you know why. Keep this technique in your arsenal of drawing weapons.

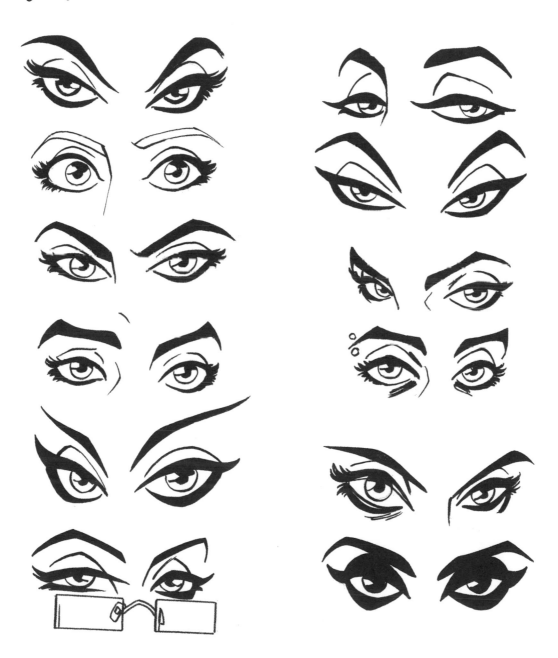

THE SIMPLIFIED MALE NOSE

Unless the character you're drawing is an arch-villain or a funny- or strange-looking male character, less is usually better when drawing the nose. The bridge of the nose is prominent on the male face because the light hits it and runs its length, vertically, until the bottom, where it widens out—but a simple line traveling down the center of the face (the "center line") is often enough to represent it. The shape of the bottom of the nose changes depending on the angle of the head tilt. The nostrils are just small holes, which are often indicated as slits.

Side View
In the side view, you can see the small indentation between the bridge of the nose and the forehead. The nostril is indicated, but the hole itself is not drawn.

Front View
In the front view, the bottom of the nose is flat, and the nostrils barely show.

3/4 Rear View
At this angle, the nose peeks out slightly, just enough to anchor its location on the face.

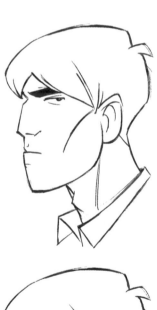 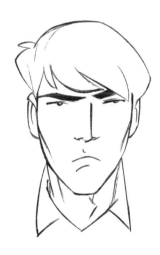 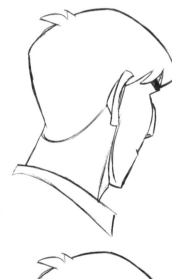

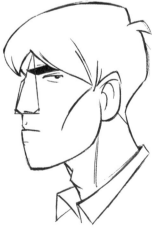 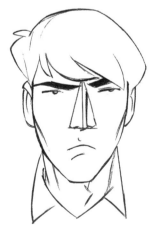 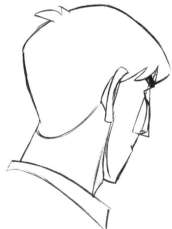

Front View, Looking Down

At this angle, the bottom of the nose turns into a "V" shape, and the nostrils are not visible.

Front View, Looking Up

At this angle, the nostrils are most obvious, as we are looking up at them.

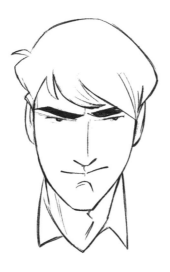

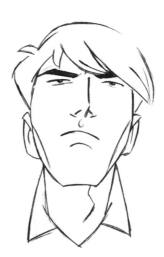

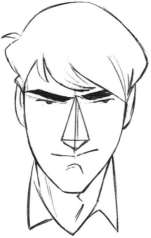

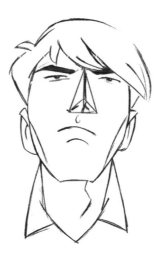

The Nose in Perspective

A simple, three-dimensional triangle serves as a good template or guideline for the simplified nose. It works especially well when the character looks up and down, because the "floor" of the triangle tilts up and down, according to perspective, which keeps it in agreement with the tilt of the head.

THE SIMPLIFIED FEMALE NOSE

Whereas the bridge of the nose on the male character can be drawn directly down the middle of the face in the front view, the female nose is best drawn slightly off to one side. This will soften her look. In addition, the bridge of the nose looks better if it's drawn as a line that extends to the eyebrow, creating almost a single flowing line. This long, sweeping line is decidedly feminine. But keep in mind that an eyebrow can't attach itself to the middle of the bridge of the nose but only to one side or the other—so you have to choose which side to draw the bridge of the nose on.

In addition, the simplified nose on the female comic book character generally omits nostrils altogether. Her nose is petite. In those cases where the nostrils *are* indicated, the bridge of the nose is usually mostly omitted.

We're drawing her nose using just two lines: a long, vertical line for the bridge of the nose and a short, upturned line for the end of the nose. The three-dimensional triangle can still help us to visualize the basic construction, though, even if we may not actually need to use it in our sketches.

As a general rule, attractive female characters have upturned noses. That's not to say that you must adhere slavishly to this suggestion, but it's a pleasing style that has found wide acceptance. And for simplified, stylized characters, it's hard to beat it.

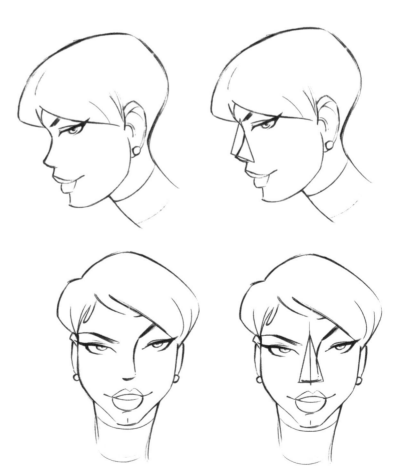

Side View
In a side view, there is a gentle curve from the bridge of the nose to the brow of the forehead.

Front View
Notice that the line of the bridge of the nose is not the centerline but falls off to the side. Attach the bridge of the nose to the eyebrow—or let the line *almost* attach.

3/4 View, Looking Up

At this angle, we see the bottom of her nose. Also note that in this pose, the bridge of her nose cuts off part of her far eye. This is very important. Do not try to "correct" your drawing by showing all of the far eye.

3/4 View, Looking Down

At this angle, perspective causes the eyebrows to appear closer to the eyes than in the other views. Again, see how the far eyebrow almost attaches to the bridge of the nose. Even though her head is tilted downward, her nose is still upturned at the end because of its natural shape.

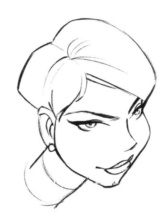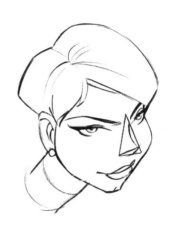

3/4 Rear View

Be sure that the nose on your female character remains upturned at this angle. Anything else will not look attractive.

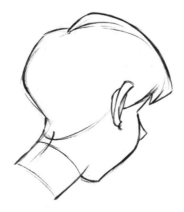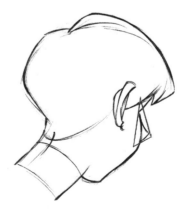

NOSE TYPES BY CHARACTER

Every feature has its own personality, depending on the owner. You can caricature a nose just as you would a face. Let's take a look at the noses of a few comic character types.

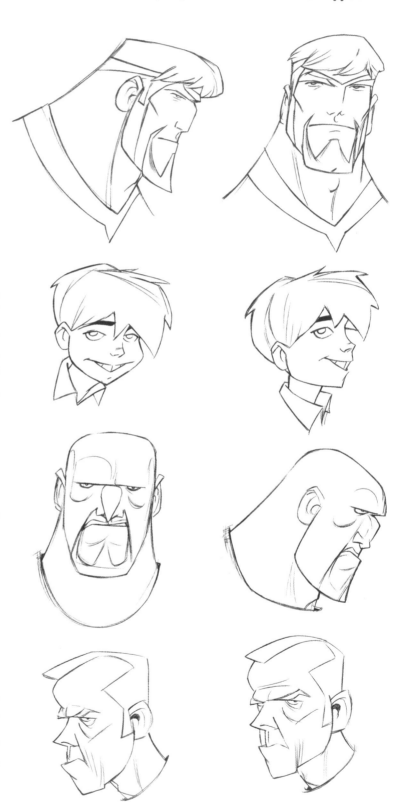

Gothic Hero

The hero's nose is straight and true.

Boy

The boy's nose is small and upturned. The bridge is classically adolescent: It curves like a ski slope. When he's older, it will look straight and strong—if he eats lots of vegetables, exercises, and drinks plenty of soda.

Gladiator

The gladiator's nose swells on top, creating a ridge on which his heavy brow rests. The nose looks like it's been flattened a few times at the Colosseum.

Nasty Neighbor

This shifty character has a pointy nose to go along with his bony face and sharp demeanor. And this is how he looked *before* you hit a baseball through his window.

NOSES OF ASSORTED MISCREANTS

Now let's take a specific genre and arrange a cast of characters with all different types of noses, so you can see just how much variety you can get from just one facial feature. We'll use one of my favorites categories of comics: the crime genre. It's rich with toughs, thugs, and other colorful characters. Notice how the bridge of the nose can be bent, and how the bottom of the nose can be pulled and widened into different shapes.

Bookie **Union Boss** **Thug**

Gun Moll **"Ma"** **Small-time Crook**

Dirty Cop **"Muscles"**

DRAWING THE MOUTH & LIPS

When you draw the mouth, it should wrap around the face in the same way that the "eye line" or any other horizontal facial guideline does. So don't think of the mouth as a straight line, but instead visualize it as a curved line wrapping around a cylinder.

The Male Mouth

In the simplified comic book style, male characters usually don't have prominent lips.

The longer the distance the mouth is from the nose, the weaker the character looks, generally speaking. The hero's mouth is drawn just under his nose.

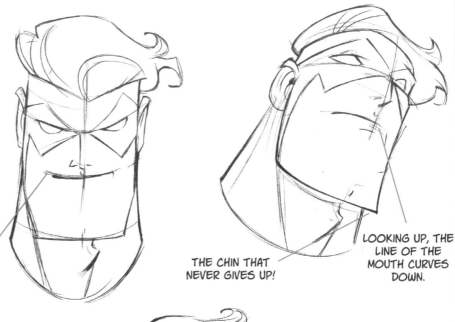

LOOKING DOWN, THE LINE OF THE MOUTH CURVES UP.

THE CHIN THAT NEVER GIVES UP!

LOOKING UP, THE LINE OF THE MOUTH CURVES DOWN.

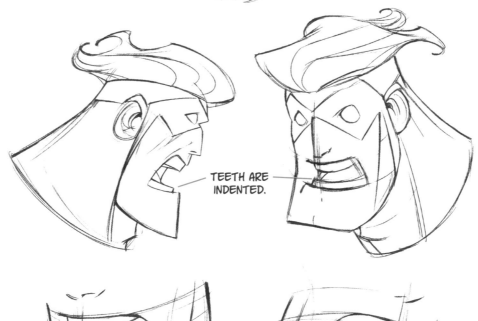

TEETH ARE INDENTED.

The guidelines of the mouth wrap around the face.

The Female Mouth

Some female characters have the "cupid's bow" (that dip in the middle of the upper lip), and others do not. It can be drawn subtly or exaggerated; it all depends upon the character's design and your personal taste.

The teeth are never drawn individually on the female character, as it would look too busy. A simple slash delineates the upper set from the bottom set, and it doesn't even have to extend all the way across the mouth. It's a cool look to leave it incomplete. If you leave the interior of the mouth blank (white), it will read as a mouthful of teeth.

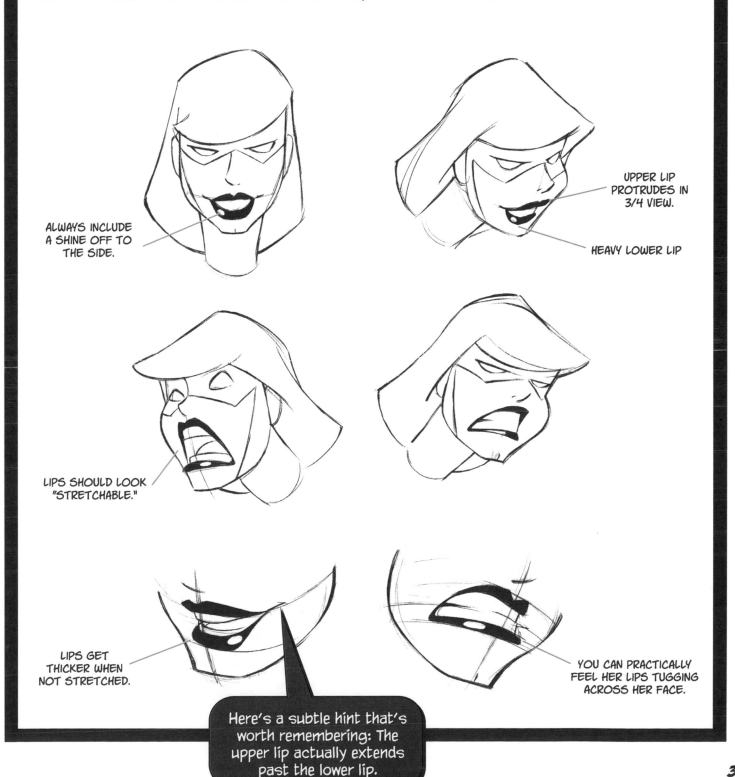

ALWAYS INCLUDE A SHINE OFF TO THE SIDE.

UPPER LIP PROTRUDES IN 3/4 VIEW.

HEAVY LOWER LIP

LIPS SHOULD LOOK "STRETCHABLE."

LIPS GET THICKER WHEN NOT STRETCHED.

YOU CAN PRACTICALLY FEEL HER LIPS TUGGING ACROSS HER FACE.

Here's a subtle hint that's worth remembering: The upper lip actually extends past the lower lip.

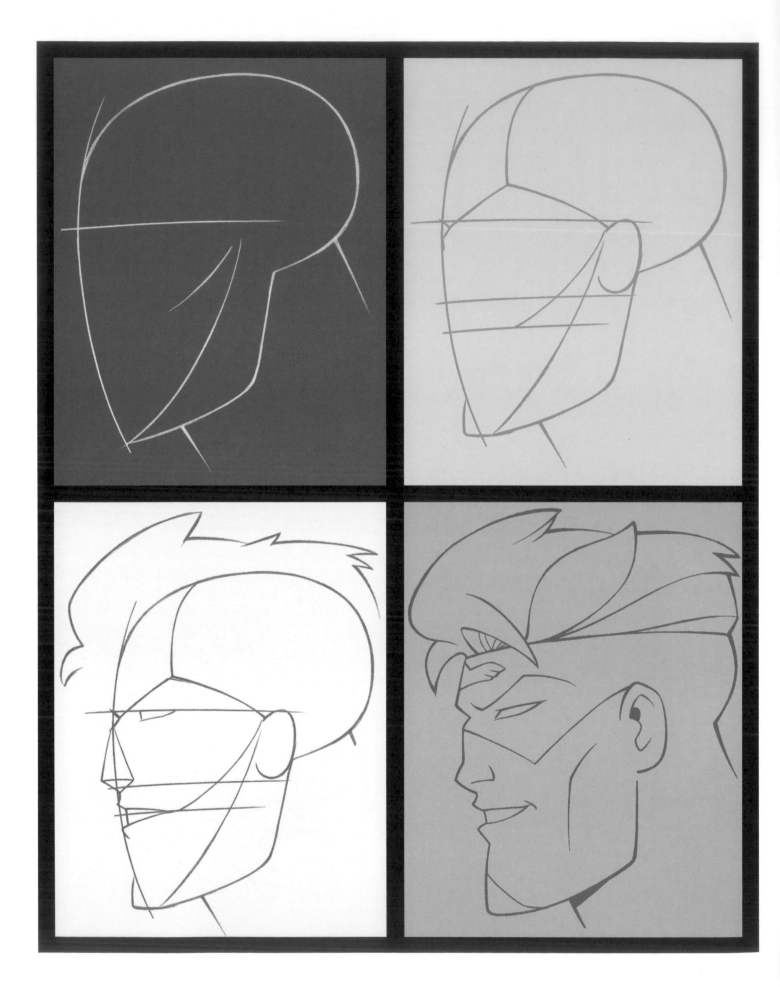

DRAWING THE SIMPLIFIED HEAD: STEP BY STEP

Now we'll move on to drawing the head in a step-by-step manner, while keeping in mind some anatomical "landmarks" that we've already covered along the way. We'll look at the heads of a male hero, a female hero, and a mutant in front view and side view and then show them with a variety of head tilts to make sure we cover all the angles. Relax, this is gonna be easy. You'll ace this.

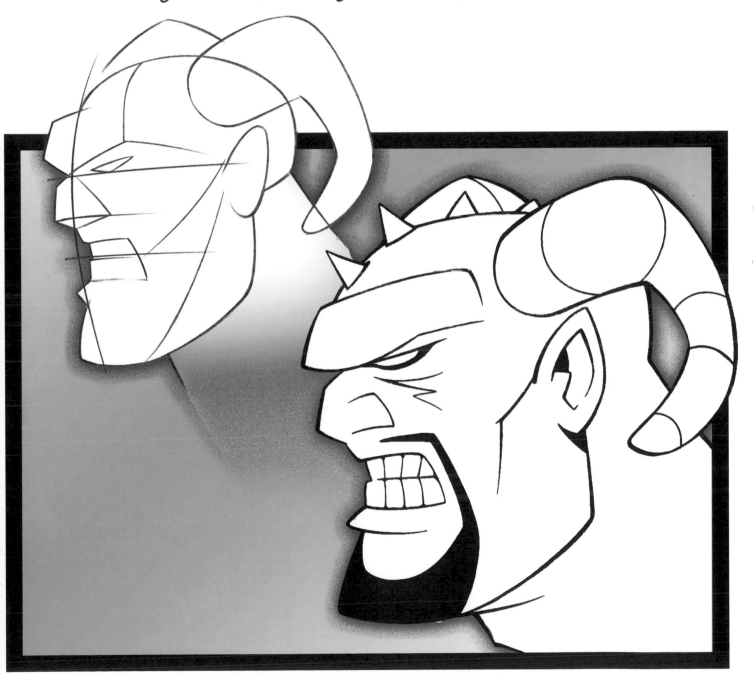

THE MALE HERO: STEP BY STEP

I ran out of figure models to pose for this chapter, so I had to sit in for it instead. Yep, that's a picture of me. It's pretty accurate, too, except it's missing the bald spot. But I'm told that it makes me look distinguished, in a paunchy sort of way.

In true human proportions, the eyes are placed exactly in the middle of the head, measuring from the bottom of the chin to the top of the head. (Most people think the eyes are placed toward the top of the head, but that's because they are eyeballing the distance as being from the bottom of the chin to the hairline of the forehead, which excludes a few inches.) On a heroic male comic book figure, however, we usually place the eyes closer to the top of the head, because the oversized chin adds length to the bottom.

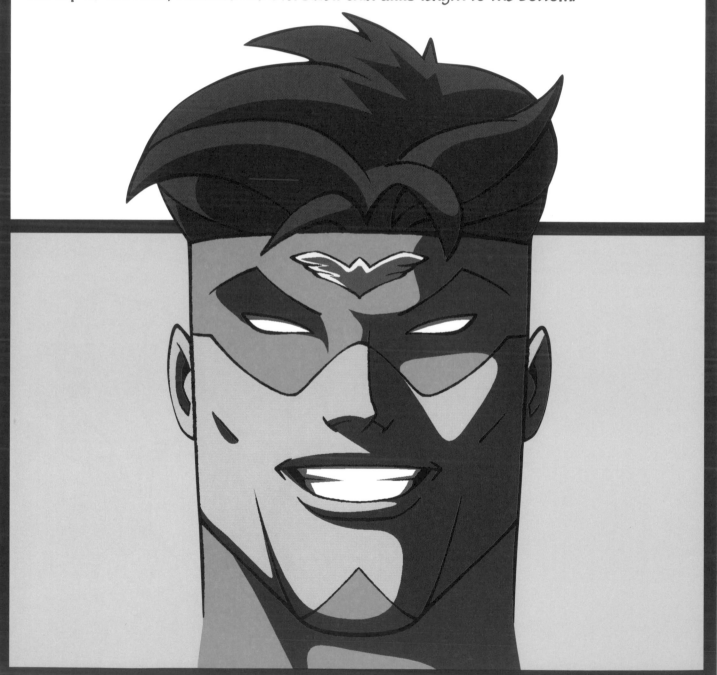

Front View

Here's another trap we can fall into. We usually think of the face as flat. Well, it's not. If it were, we'd all look like pancakes. Actually, the sides of the face come at us at a 45-degree angle. Then the front of the face flattens out, and that is where the eyes, nose, and mouth are placed. The point where the face shifts from a 45-degree angle to a flat, front-facing angle has a defining line, which is indicated in the first step below. You can also see remnants of that defining line in the final step. Now you can understand what those contour lines represent. And this understanding should, in turn, help your drawings.

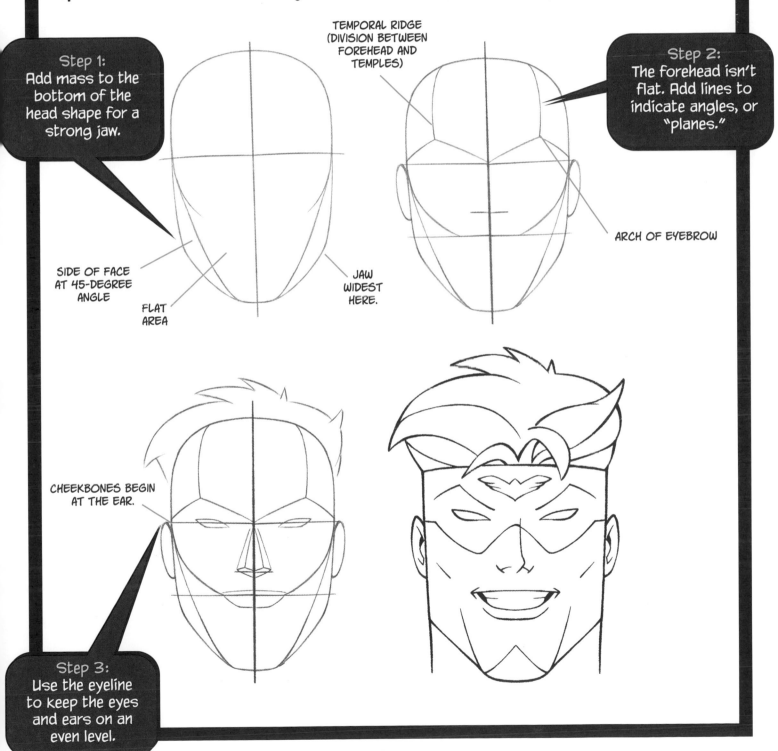

Step 1:
Add mass to the bottom of the head shape for a strong jaw.

TEMPORAL RIDGE (DIVISION BETWEEN FOREHEAD AND TEMPLES)

Step 2:
The forehead isn't flat. Add lines to indicate angles, or "planes."

ARCH OF EYEBROW

SIDE OF FACE AT 45-DEGREE ANGLE

FLAT AREA

JAW WIDEST HERE.

CHEEKBONES BEGIN AT THE EAR.

Step 3:
Use the eyeline to keep the eyes and ears on an even level.

39

Side View

When drawing the side view, you can begin any way you like. But here's a good way to get started.

Step 2: Add guidelines before you actually draw the features. This way you can keep the proportions in place. These little sketch lines should be drawn lightly. They're just for you—your own visual notes to yourself.

Step 1: Start by drawing the front of the face as one continuous line. The neck should be attached to the head at a 45-degree angle, not straight up and down, which would make the character look stiff.

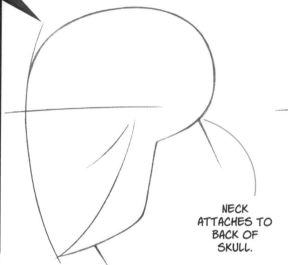

NECK ATTACHES TO BACK OF SKULL.

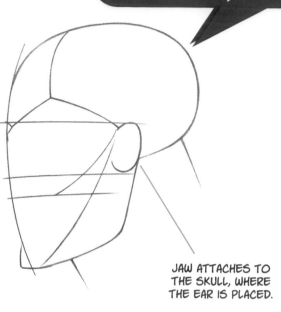

JAW ATTACHES TO THE SKULL, WHERE THE EAR IS PLACED.

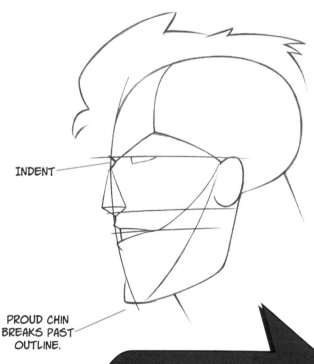

INDENT

PROUD CHIN BREAKS PAST OUTLINE.

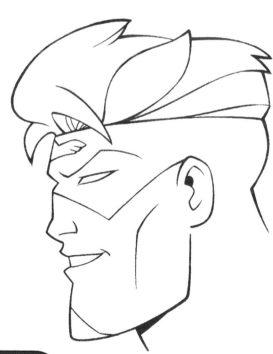

Step 3: Begin to carve out the details of the outline—bumping out the brow, pasting on the bridge of the nose, bumping out the lips, and so on. But continue to follow the basic perimeter of the face that you've laid down.

MALE HERO: HEAD TILTS & PERSPECTIVES

One thing that separates a pro from an amateur is the ability to draw a character at any angle and still make him look the same. To the pro, there's nothing amazing about it. What you have to do is break down your character into its most basic construction before drawing the features, expressions, and costumes.

The amateur artist really has no idea how he came up with his character in the first place, so he can't replicate it. If this same amateur were to take a piece of tracing paper, place it over his original drawing, and then deconstruct it—in other words, go backward, creating a mannequin out of his original, with a simplified skull and simplified features—he could see it as a three-dimensional form. Then he could begin to draw it at other angles.

You have to be willing to draw a rough, simplified construction at the new angle before adding the finishing touches. Here's where the amateur gets impatient. He's so anxious to make it look like his cherished character, with feeling and emotion, that he doesn't wait to complete a well thought out construction. Instead he begins to complete the details of his drawing too early, and the underlying construction is left undone. If you recognize some of these habits in yourself, you can now avoid them. If you recognize them in other people, you can tease them mercilessly about it.

3/4 View

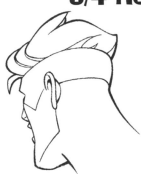 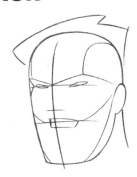

3/4 Rear View

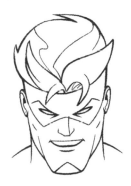 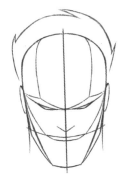

Front View, Looking Down

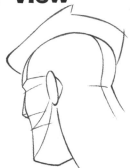

3/4 View, Looking Up

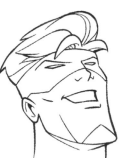 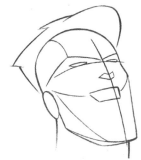

THE FEMALE HERO: STEP BY STEP

Unlike the male hero, the female has no turbo-charged, V-12 chin. Without an unnaturally long face, her proportions are more realistic. As a result, her eyes are placed closer to the middle of her head (measured top to bottom), like a normal flesh-and-blood person.

The female's head doesn't usually show the 45-degree-angle definition lines on the sides of the face that the male's head does (see page 39) for the simple reason that it would make her appear too angular and take away from her attractiveness. Crease lines on women do that. So do big pirate scars.

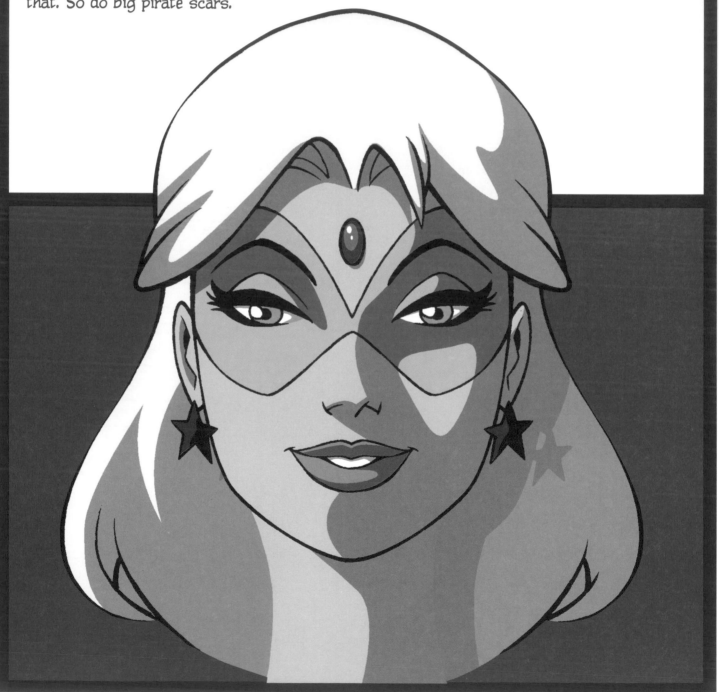

Front View

You'll notice a stylistic choice in this view of the female hero: The bridge of the nose has been omitted entirely. Whether you decide to include it in the construction step anyway is your choice. It's more difficult to omit the bridge of the nose in a 3/4 view and, of course, impossible to do it in a profile, unless you're a plastic surgeon who specializes in rock stars.

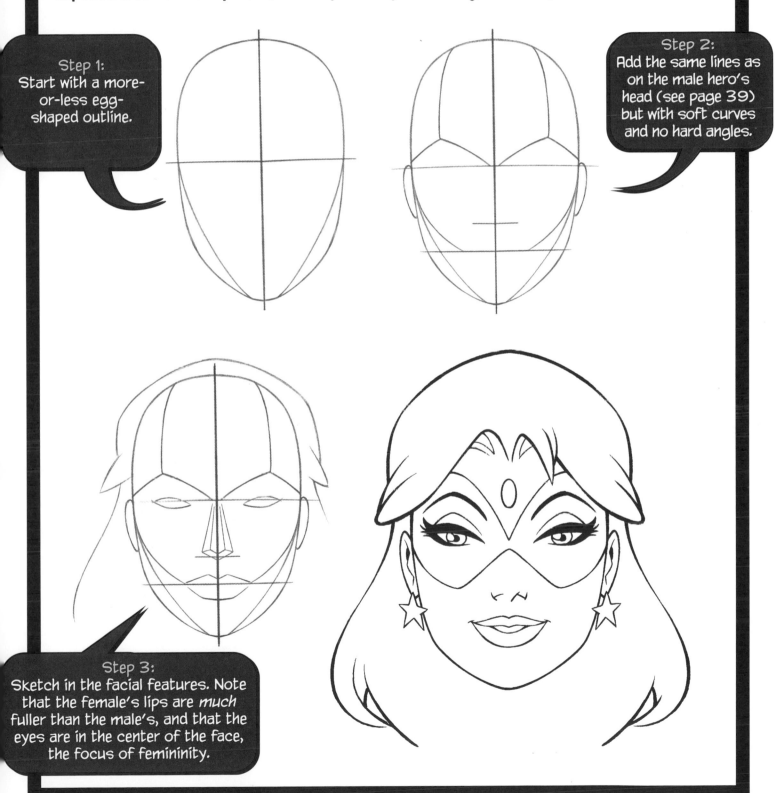

Step 1:
Start with a more-or-less egg-shaped outline.

Step 2:
Add the same lines as on the male hero's head (see page 39) but with soft curves and no hard angles.

Step 3:
Sketch in the facial features. Note that the female's lips are *much* fuller than the male's, and that the eyes are in the center of the face, the focus of femininity.

43

Side View

If you look at the final drawing, you'll see that her neck curves gently outward, rather than inward as you might expect. This is a female look, which is rarely used when drawing male characters. Female necks show no Adam's apple.

To feminize the character further, don't close the line that connects the jaw to the base of the skull (right below the ear) in the final drawing. For the same reason, don't articulate the temporal ridge (the vertical line running down the side of the forehead).

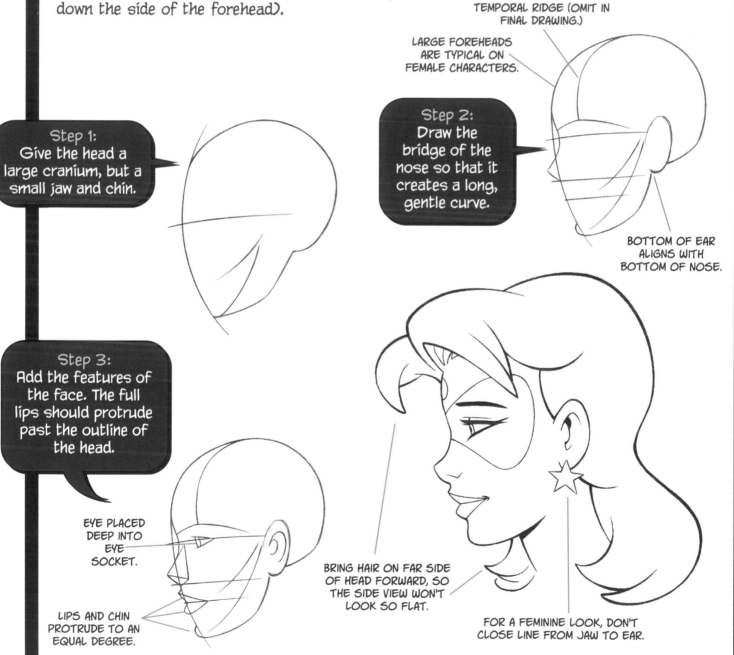

Step 1:
Give the head a large cranium, but a small jaw and chin.

TEMPORAL RIDGE (OMIT IN FINAL DRAWING.)

LARGE FOREHEADS ARE TYPICAL ON FEMALE CHARACTERS.

Step 2:
Draw the bridge of the nose so that it creates a long, gentle curve.

BOTTOM OF EAR ALIGNS WITH BOTTOM OF NOSE.

Step 3:
Add the features of the face. The full lips should protrude past the outline of the head.

EYE PLACED DEEP INTO EYE SOCKET.

LIPS AND CHIN PROTRUDE TO AN EQUAL DEGREE.

BRING HAIR ON FAR SIDE OF HEAD FORWARD, SO THE SIDE VIEW WON'T LOOK SO FLAT.

FOR A FEMININE LOOK, DON'T CLOSE LINE FROM JAW TO EAR.

FEMALE HERO: HEAD TILTS & PERSPECTIVES

When a character looks *down*, draw the guidelines across the face so that they're all curving *up*. In this position, the eyebrows should be very close to the eyes, almost resting on them. The bridge of the nose is full-length. The end of the nose looks slightly wider than usual. And the mouth usually curves up, following the path of the guidelines as well. The mouth is small and petite at this angle.

If a character is looking *up*, draw all of the guidelines across the face so that they're curving *down*. There should be a comfortable amount of space between the eyebrows and the eyes. The bridge of the nose, due to perspective, becomes slightly shortened, and you can see the underside of the nose because you're looking at it from below.

3/4 View

IN 3/4 VIEW, THE FRONT OF THE LIPS STOPS ABRUPTLY, WHILE THE BACK OF THE LIPS TRAILS OFF.

3/4 Rear View

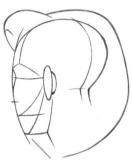

IN THE 3/4 REAR VIEW YOU CAN SEE THE SOFT UNDERSIDE OF THE CHARACTER'S JAW (MALE OR FEMALE).

3/4 View, Looking Down

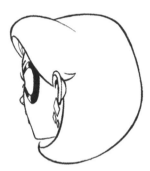

GUIDELINES CURVE UP.

3/4 View, Looking Up

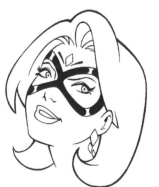

GUIDELINES CURVE DOWN.

THE MUTANT: STEP BY STEP

You don't want to start off your career as a cage fighter facing this guy. With this type of awesome character—and there are plenty of 'em in comics—the design has to get locked in at the early outline stages. That means you've either got him by step one or you never will. That's how important the overall outline of the head is. This typical brute character has half a bowling ball for his rock-solid skull, and the rest of him is pure jaw and teeth. Super-huge characters have necks that begin at the ears and widen out from there.

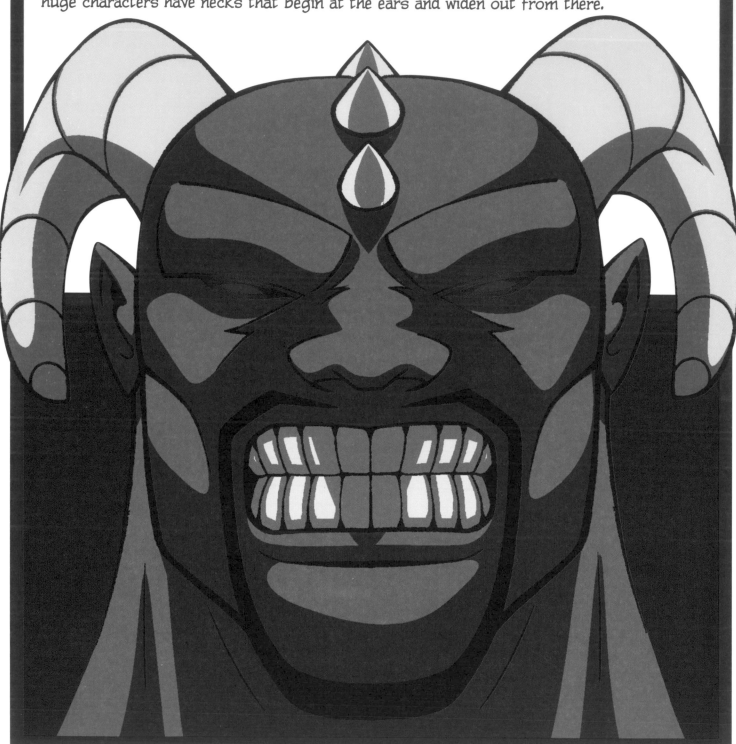

Front View

Don't talk to him in the morning before he's had his coffee. You've got to know that about mutants. And another thing—don't touch the horns. They really hate that. You can feel the power of the character as early as the first and second steps. Everything that follows must stay consistent with the brute power of the first two steps.

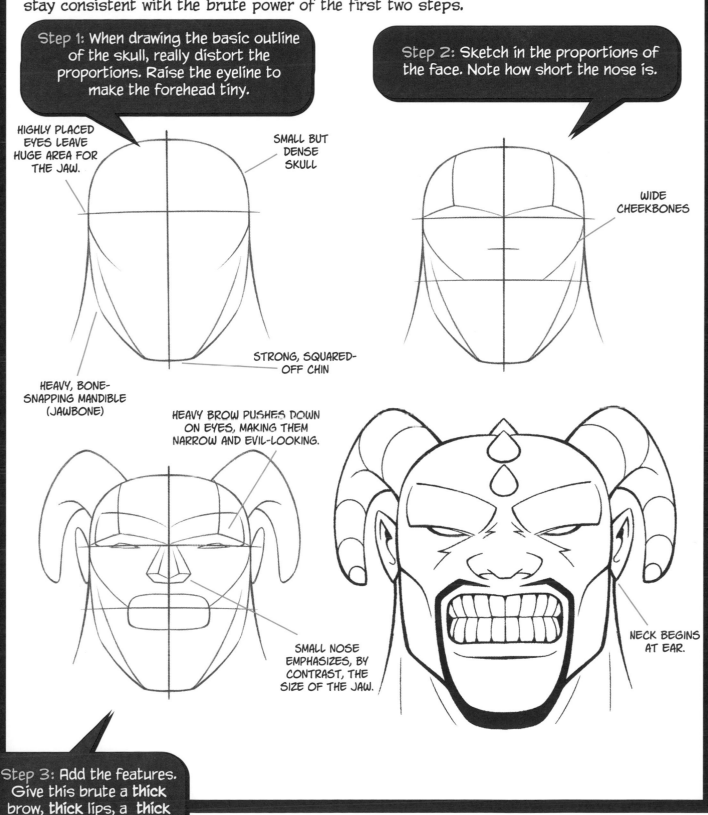

Step 1: When drawing the basic outline of the skull, really distort the proportions. Raise the eyeline to make the forehead tiny.

Step 2: Sketch in the proportions of the face. Note how short the nose is.

HIGHLY PLACED EYES LEAVE HUGE AREA FOR THE JAW.

SMALL BUT DENSE SKULL

WIDE CHEEKBONES

STRONG, SQUARED-OFF CHIN

HEAVY, BONE-SNAPPING MANDIBLE (JAWBONE)

HEAVY BROW PUSHES DOWN ON EYES, MAKING THEM NARROW AND EVIL-LOOKING.

SMALL NOSE EMPHASIZES, BY CONTRAST, THE SIZE OF THE JAW.

NECK BEGINS AT EAR.

Step 3: Add the features. Give this brute a **thick** brow, **thick** lips, a **thick** neck. Everything **thick**.

Side View

Drawing comics is about making choices. Sometimes, you go out on a limb to see how far you can push the envelope. For example, the forehead on this character is extremely small. Sure, it could've been larger and he still would've looked like a brute. But comics work best when they go to extremes, especially when you're looking to stylize them. So his forehead has been taken down just as far as it can comfortably go, without giving him a total lobotomy.

Look at the finished drawing: There's hardly any forehead rising up above the brow. It's a definite look. It means you've gone for it—you've committed the character design in a specific direction. Remember, if it doesn't work, you can always get more conservative. No one has found his style by playing it safe. On the other hand, it's also worth remembering that this is an art form that requires readers. If your characters are so extreme that your mom is the only one who appreciates them, then maybe you'd better tone it down a notch.

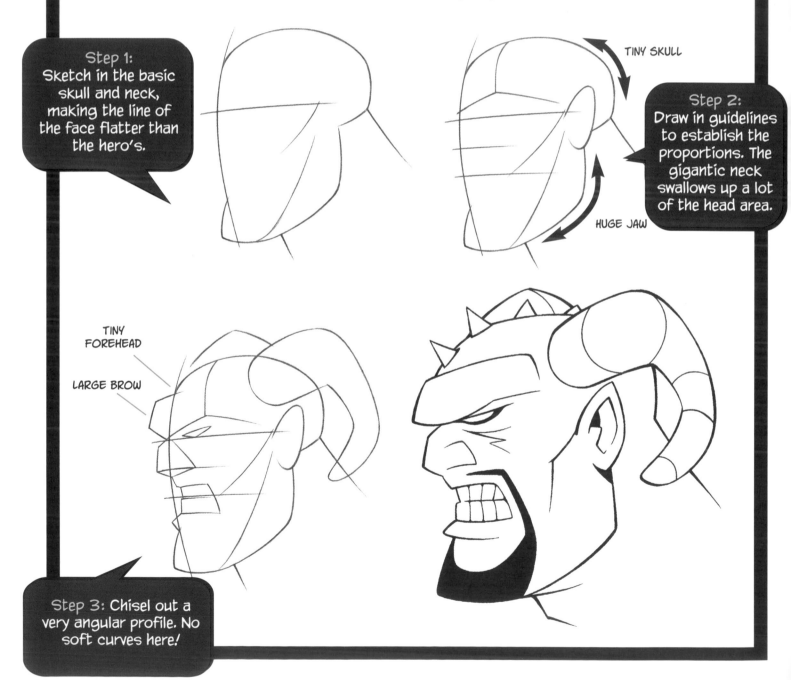

Step 1: Sketch in the basic skull and neck, making the line of the face flatter than the hero's.

TINY SKULL

Step 2: Draw in guidelines to establish the proportions. The gigantic neck swallows up a lot of the head area.

HUGE JAW

TINY FOREHEAD

LARGE BROW

Step 3: Chisel out a very angular profile. No soft curves here!

MUTANT HEAD TILTS & PERSPECTIVES

It may sound counterintuitive, but sometimes it's easier to draw more complex characters in various angles than it is to draw simpler characters. That's because the more complex characters tend to have bony skulls, with cheekbones, brows, and chins that act as "landmarks," which the artist looks for. With less defined, more generic faces, it's easier to wander, because the features and contours seem to be less fixed into place. I'll note these facial "landmarks" on the construction drawings.

3/4 View

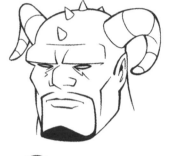

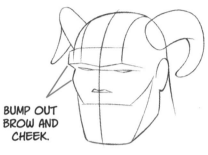

BUMP OUT BROW AND CHEEK.

3/4 Rear View

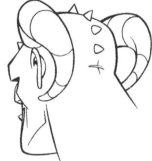

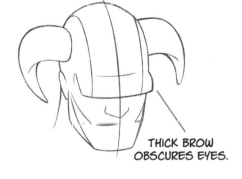

BROW PROTRUDES.
CHEEKBONE PROTRUDES.
NOSE PROTRUDES.

3/4 View, Looking Down

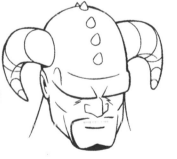

THICK BROW OBSCURES EYES.

EXTREME ANGLE HIDES BRIDGE OF NOSE.

Front View, Looking Up

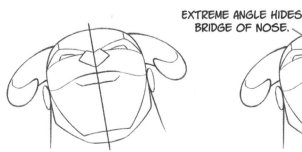

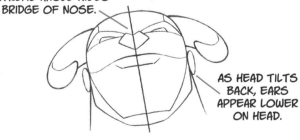

AS HEAD TILTS BACK, EARS APPEAR LOWER ON HEAD.

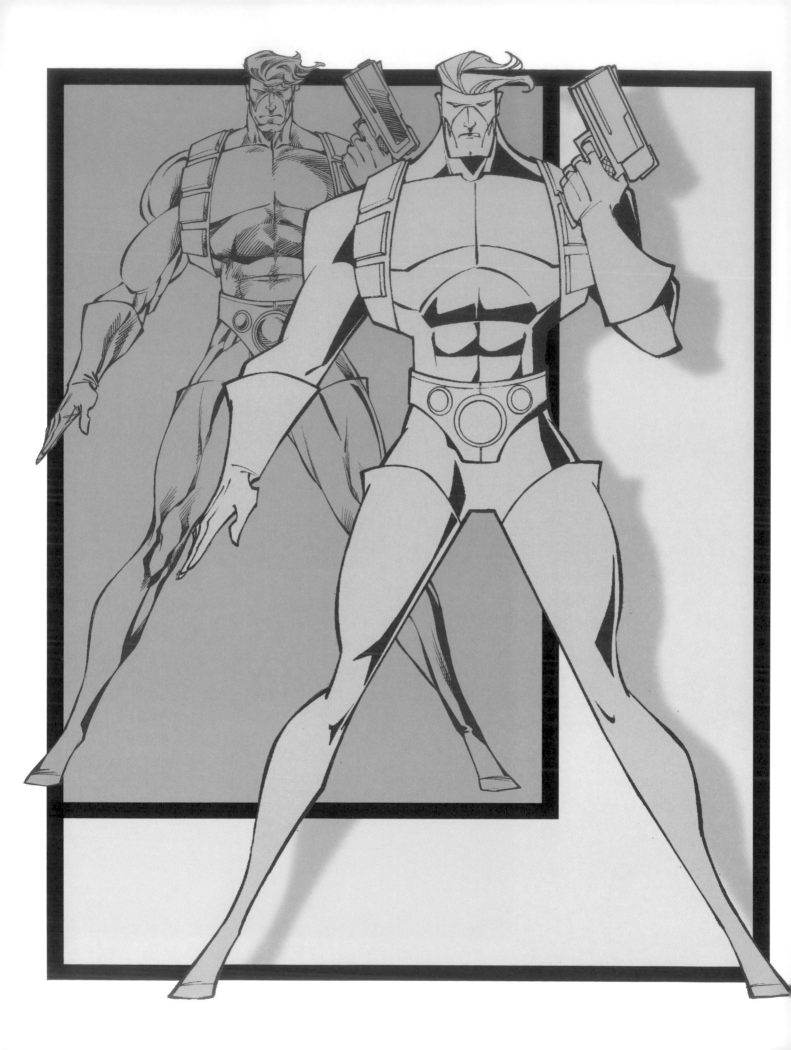

DRAWING THE SIMPLIFIED BODY: THE BASICS

If the simplified approach to anatomy made learning to draw the head less complex for you—and even fun—then you'll be blown away by how effective it is for taking on the human body. The new streamlined style of comics requires a correct understanding of anatomy, but one that allows the artist to avoid super-defining every supporting sinew in the body. In its place, we're left with athletic physiques that exude attitude rather than merely size.

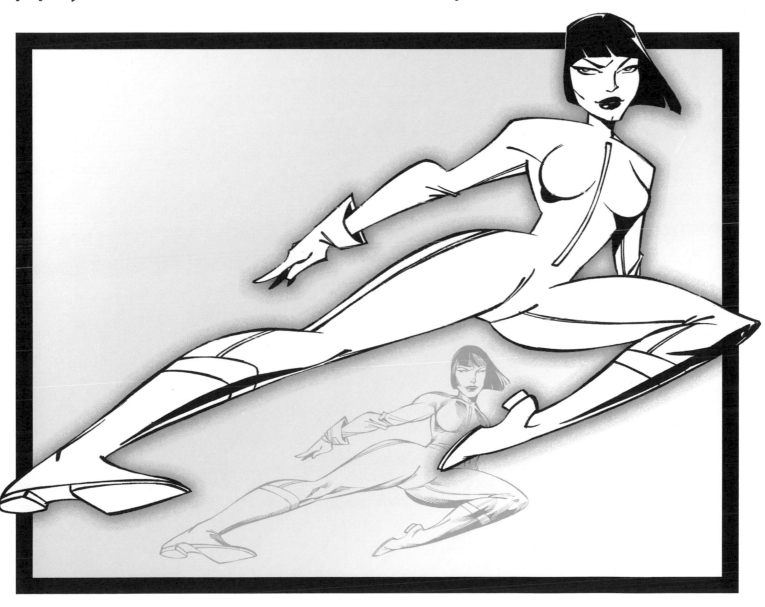

TRADITIONAL COMIC BOOK STYLE VS. STREAMLINED

Compare the two looks shown here to appreciate how pleasing, clean, and refreshing the streamlined look is. There are a number of traits that distinguish the new simplified style from the traditional comic book style.

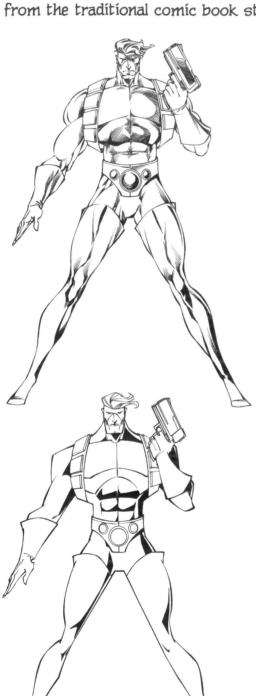

Traditional Look

- Shading and cross-hatching
- Emphasis on defining the muscle inside of the body outline
- Small, choppy lines
- Heavy use of shadows
- A delicate line
- Can look cluttered in small areas
- Outline is rounded

Streamlined Look

- Thicker ink line
- No cross-hatching
- Exterior body outline is super important—almost like a silhouette
- Minimal use of shadows
- Slightly retro, cartoon-style influence
- Always a clean, open look
- Outline is more angular

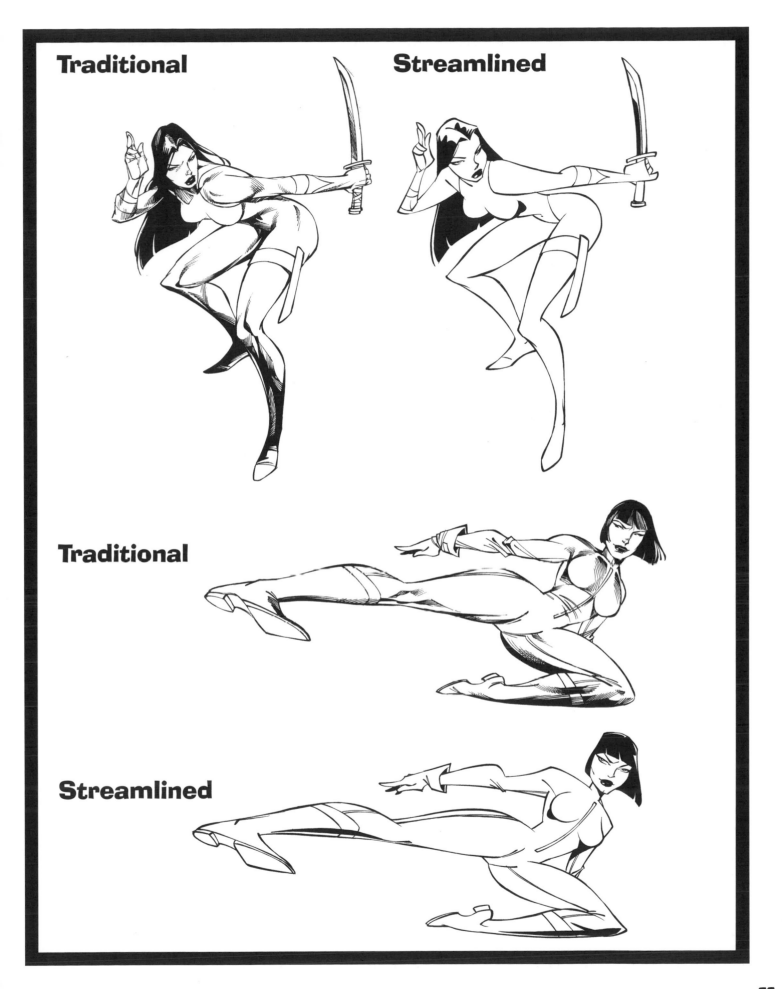

Traditional

Streamlined

Traditional

Streamlined

SIMPLIFYING THE SKELETON

From the time you're a little kid, you're taught to draw from stick figures. Teachers especially are keen for you to use stick figures as the building blocks for drawings. Of course, no one has ever made a decent figure from a stick figure. A classic stick figure has zero to do with the human figure, because it lacks any indication of a pelvis or collarbone—and therefore the figure has no width.

But that doesn't mean that you have to be able to draw a realistic skeleton in order to draw the human body. The skeleton, when used for artistic purposes, is simply a great foundation. In fact, once you get familiar with it, you can even create a customized, simplified skeleton to suit your own needs.

Realistic Skeleton

Although it's valuable to be aware of the major bones and the proportions of the realistic skeleton, generally it's unnecessary to begin a drawing with as much detail as this for the foundation of your figure. Here are some important landmarks that you should be aware of:

- The width of the shoulders

- The line of the collarbone (clavicle)

- The bump (acromion) at the ends of the collarbone

- The shape of each shoulder blade (scapula)

- Where the rib cage stops and the waist begins

- The width of the hips

- Protrusion of the elbow bone (ulna)

- Bony protrusions (iliac crest) on the pelvic bone, which bookends the bottom of the abdominal muscles

- Where the thigh joint (the outermost point of which is called the greater trochanter) wedges into the pelvic bone

- Angle (slope) of the leg bones (femur and tibia)

- Location of the kneecap (patella)

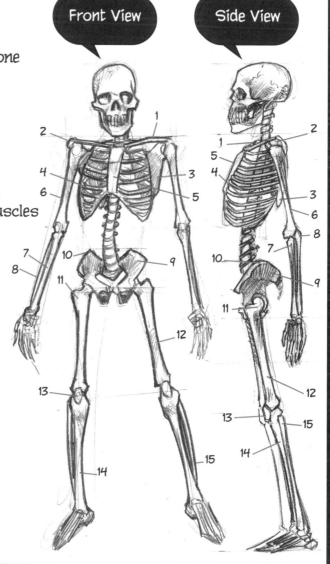

Front View

Side View

1. Clavicle (collarbone)
2. Acromion
3. Scapula (shoulder blade)
4. Rib cage
5. Sternum (breastbone)
6. Humerus
7. Radius
8. Ulna (elbow bone)
9. Pelvis
10. Iliac crest
11. Greater trochanter
12. Femur
13. Patella (kneecap)
14. Tibia (shinbone)
15. Fibula (calf bone)

Simplified Skeleton

In simplifying the skeleton, you eliminate certain redundancies while still maintaining a solid foundation for the drawing. For example, the "double bones" on the lower limbs of the arms and legs become single bones in the simplified skeleton. In the next chapter, we'll further simplify the skeleton when we use it as the first step in the process of drawing actual comic book characters. Yes, you heard me right—it gets easier still, not harder. I know what you're thinking: "This Chris Hart guy's making it too easy! Why, he's got to be mad—mad, I say!!" Oh, come on now. Just because a person dreams of taking over the world and turning everybody else into mindless robots to do his bidding doesn't mean he's crazy.

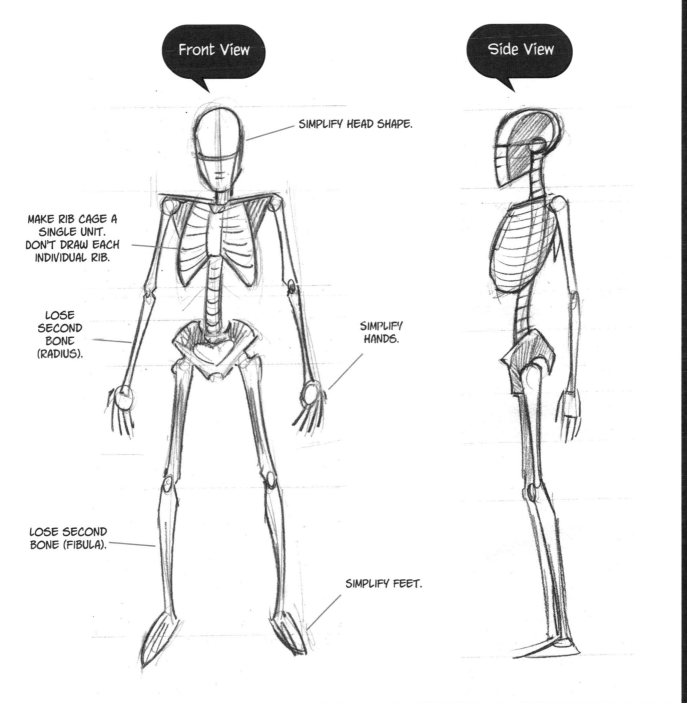

Front View

Side View

SIMPLIFY HEAD SHAPE.

MAKE RIB CAGE A SINGLE UNIT. DON'T DRAW EACH INDIVIDUAL RIB.

SIMPLIFY HANDS.

LOSE SECOND BONE (RADIUS).

LOSE SECOND BONE (FIBULA).

SIMPLIFY FEET.

MUSCLES: A SIMPLIFIED APPROACH

Later in this book we'll break down each individual muscle group in detail, but first let's examine a way to draw the human—and not so human—body with simplified muscle "charts." I'm going to use informal terms to identify these areas before using the proper Latin names of the muscles in the more specific chapters ahead.

In the new, streamlined look of comics, not every sinew is defined. There is no extreme detail in the muscular definition. And yet, does it look like something's missing? Do these figures look flabby to you? Underdeveloped? Somehow less powerful?

They are incredibly muscular. The simplified, streamlined approach gives you the same powerful effect without the mental aggravation of memorizing and drawing dozens of strands of minor muscles that add little to the overall impression. Therefore, even when we do study individual muscles, we'll look only at the major ones.

Hero: Front View

You'd think, just once, an action hero might have some modesty and buy a costume that's a little loose on him. But no, it's always gotta be skintight and put all of us regular guys to shame.

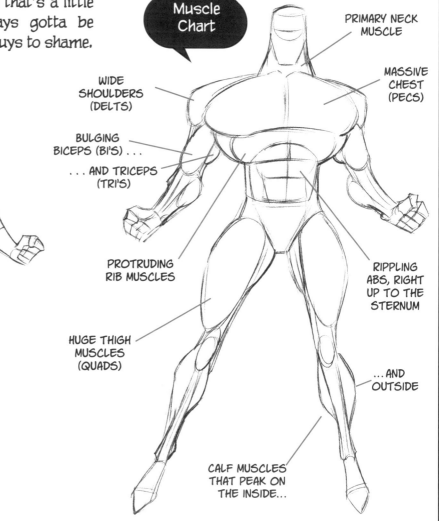

Surface

Muscle Chart

PRIMARY NECK MUSCLE

WIDE SHOULDERS (DELTS)

MASSIVE CHEST (PECS)

BULGING BICEPS (BI'S) . . .

. . . AND TRICEPS (TRI'S)

PROTRUDING RIB MUSCLES

RIPPLING ABS, RIGHT UP TO THE STERNUM

HUGE THIGH MUSCLES (QUADS)

. . . AND OUTSIDE

CALF MUSCLES THAT PEAK ON THE INSIDE . . .

Hero: Side View

It's not uncommon to see artists draw the side view of a figure and begin the back at the shoulder. But that's not the way the body works—unless your action hero is a vegan. Even when a character sports tree-trunk arms, you should still be able to see the mass of his back peeking out from behind his shoulders. Directly behind his shoulders are his shoulder blades, which are covered in a layer of muscles. And beneath those, there's a long sheet of thick back muscles called the latissimus dorsi, or "lats" in bodybuilder lingo.

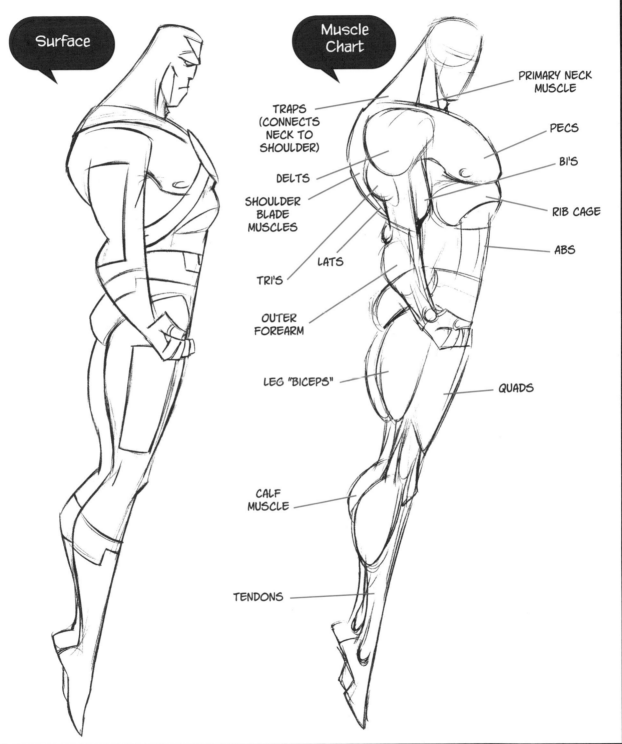

Surface

Muscle Chart

PRIMARY NECK MUSCLE

TRAPS (CONNECTS NECK TO SHOULDER)

PECS

DELTS

BI'S

SHOULDER BLADE MUSCLES

RIB CAGE

ABS

LATS

TRI'S

OUTER FOREARM

LEG "BICEPS"

QUADS

CALF MUSCLE

TENDONS

Hero: Rear View

The natural curve of the upper back of the male hero is rounded forward, which can be seen clearly from the rear view.

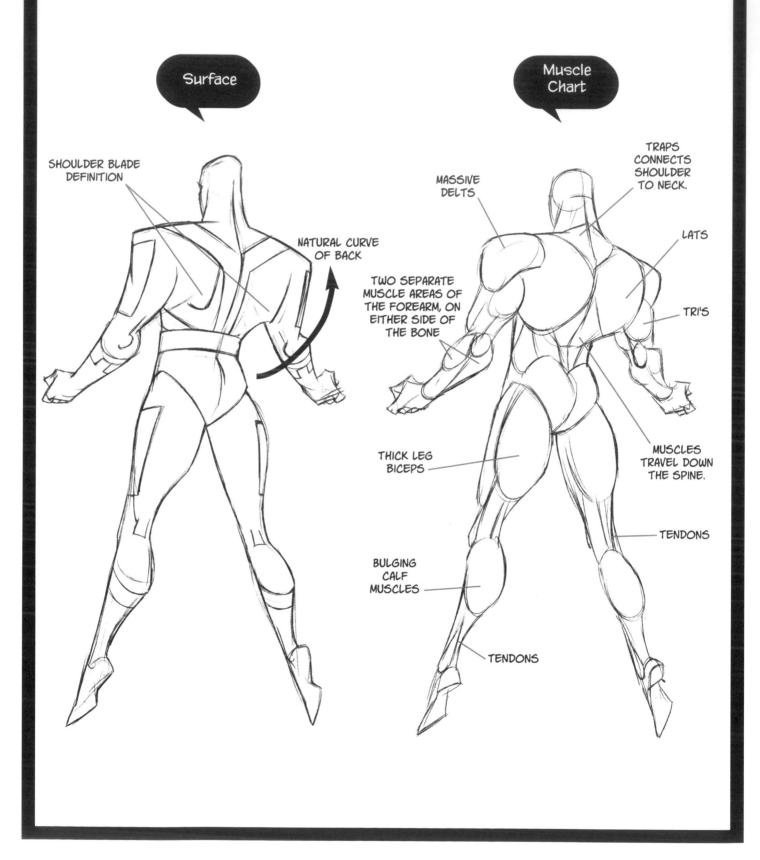

Surface

Muscle Chart

SHOULDER BLADE DEFINITION

NATURAL CURVE OF BACK

THICK LEG BICEPS

BULGING CALF MUSCLES

TENDONS

MASSIVE DELTS

TWO SEPARATE MUSCLE AREAS OF THE FOREARM, ON EITHER SIDE OF THE BONE

TRAPS CONNECTS SHOULDER TO NECK.

LATS

TRI'S

MUSCLES TRAVEL DOWN THE SPINE.

TENDONS

Female Fantasy Figure: Front View

A few artists have ventured off into the area of Amazon-looking women: female bodybuilder types with beautiful looks and well-endowed figures. But no matter what you do to feminize them, women with giant biceps and super-bulging thigh muscles still look a little strange. You kind of expect their voices to be three octaves too low.

For attractive comic book females, draw long, uninterrupted curves, small joints (for a petite look), and a very narrow waistline.

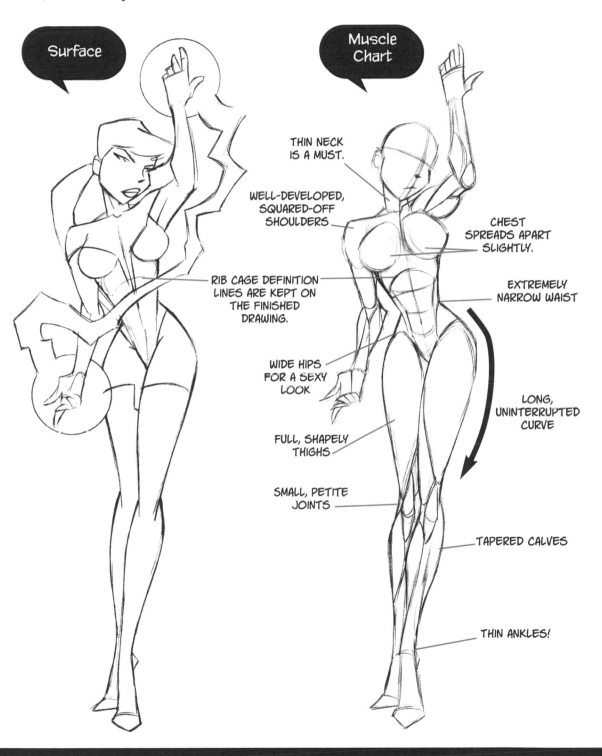

Surface

Muscle Chart

THIN NECK IS A MUST.

WELL-DEVELOPED, SQUARED-OFF SHOULDERS

CHEST SPREADS APART SLIGHTLY.

RIB CAGE DEFINITION LINES ARE KEPT ON THE FINISHED DRAWING.

EXTREMELY NARROW WAIST

WIDE HIPS FOR A SEXY LOOK

LONG, UNINTERRUPTED CURVE

FULL, SHAPELY THIGHS

SMALL, PETITE JOINTS

TAPERED CALVES

THIN ANKLES!

Female Fantasy Figure: Side View

You almost never see a technically accurate side view in comics. Why? Is it because comic book artists like to break rules, get lots of traffic tickets, and have a history of cutting class more times than they'd like to admit? Hey, what's with all the personal questions? And it wasn't that many classes anyway.

The real reason why the side views are almost always "cheats" is that a strict side view is totally flat. It destroys the illusion that your character is three-dimensional, which you've worked so hard to establish with your character designs and previous panels.

But you can't avoid side views—nor should you. Instead, add a body twist, as this character demonstrates. Also, pull the far leg out, so that it isn't totally hidden by the front leg. This, too, will add some depth.

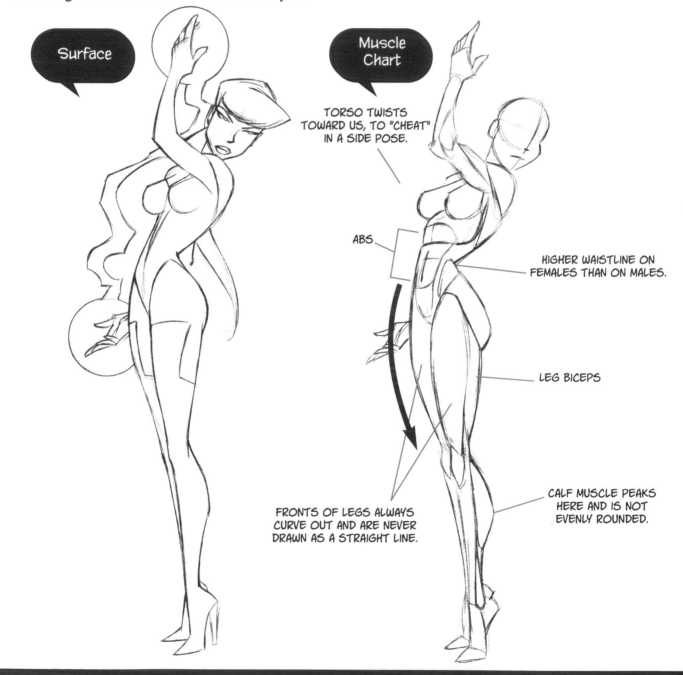

Surface

Muscle Chart

TORSO TWISTS TOWARD US, TO "CHEAT" IN A SIDE POSE.

ABS

HIGHER WAISTLINE ON FEMALES THAN ON MALES.

LEG BICEPS

FRONTS OF LEGS ALWAYS CURVE OUT AND ARE NEVER DRAWN AS A STRAIGHT LINE.

CALF MUSCLE PEAKS HERE AND IS NOT EVENLY ROUNDED.

Female Fantasy Figure: Rear View

There is very little interior definition to the body of the female figure. But one area that does get it is the back, primarily the spine and the shoulder blades. You don't always want to draw the spine as a single, unbroken line beginning at the top of the neck and traveling down to the base of the pelvis. Sometimes, for style, you may want to let the line get lighter and disappear, and then pick it up a moment later and continue with it.

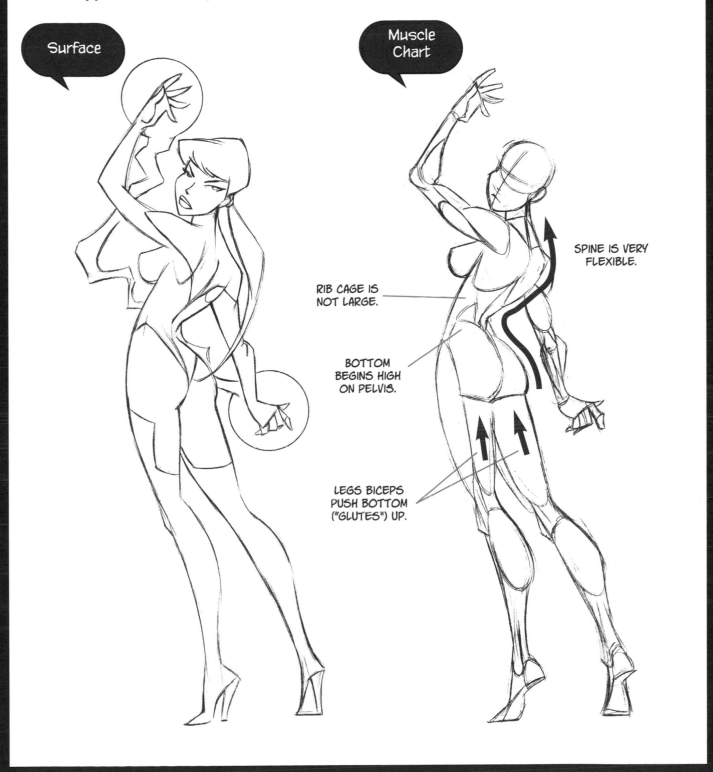

Surface

Muscle Chart

SPINE IS VERY FLEXIBLE.

RIB CAGE IS NOT LARGE.

BOTTOM BEGINS HIGH ON PELVIS.

LEGS BICEPS PUSH BOTTOM ("GLUTES") UP.

Mutant: Front View

This beast of a character, like many of his type, has a small head that fits snugly and deeply into the shoulder/neck area. Gargantuan shoulders and pecs make him a brute. The huge thighs give him the power to punch or swing his weapon. But all that muscle also makes him slow to move—which is his weakness. His waist tapers, but it's not skinny. In fact, there's very little waistline at all. Brutes are built without much connective tissue between the rib cage and the pelvis, in order to keep them stocky.

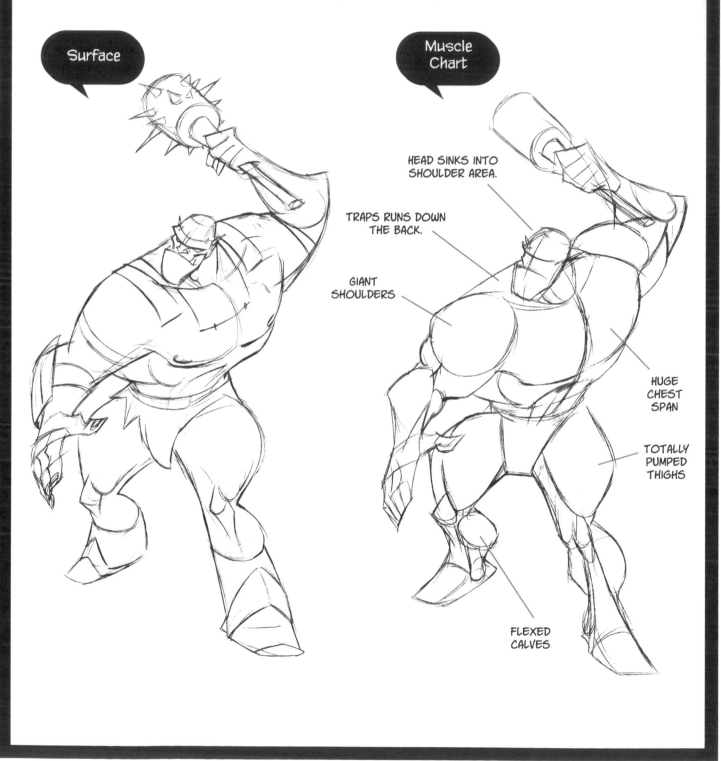

Surface

Muscle Chart

HEAD SINKS INTO SHOULDER AREA.

TRAPS RUNS DOWN THE BACK.

GIANT SHOULDERS

HUGE CHEST SPAN

TOTALLY PUMPED THIGHS

FLEXED CALVES

Mutant: Side View

Heaviness creates instability, so the stance must be widened to maintain balance. The heavier the character, the wider the placement of the feet. Big characters also have a lower center of gravity, which means they generally look better with shorter legs. Bend their knees to get them even closer to the ground. If you were to pose a top-heavy character standing upright, he would look vulnerable, as if he could be toppled.

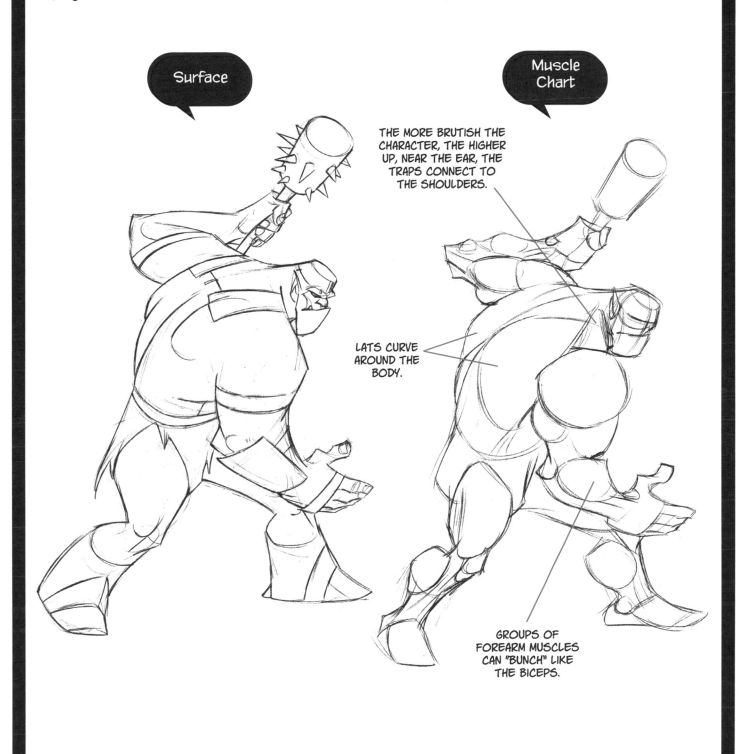

Surface

Muscle Chart

THE MORE BRUTISH THE CHARACTER, THE HIGHER UP, NEAR THE EAR, THE TRAPS CONNECT TO THE SHOULDERS.

LATS CURVE AROUND THE BODY.

GROUPS OF FOREARM MUSCLES CAN "BUNCH" LIKE THE BICEPS.

Mutant: Rear View

From the back view, you can see how immense you can go when drawing a character like this. Now you know why the waist is so short: There's no room for it—it's all back muscle! The shoulders are so broad and wide that the head looks like a tiny hill peeking over the horizon of the shoulder line.

Pump up the upper and lower leg muscles so outrageously huge that they look like they're about to burst.

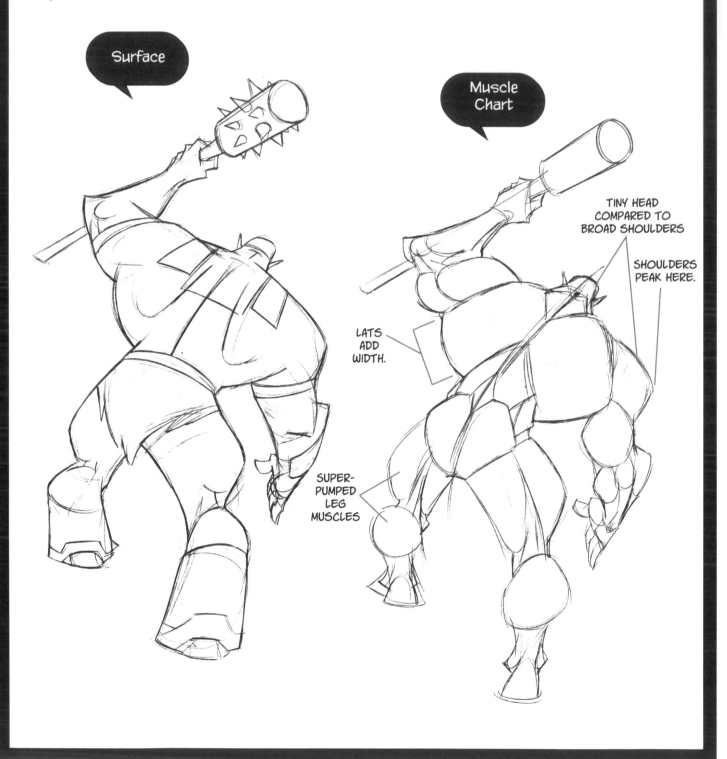

Surface

Muscle Chart

TINY HEAD COMPARED TO BROAD SHOULDERS

SHOULDERS PEAK HERE.

LATS ADD WIDTH.

SUPER-PUMPED LEG MUSCLES

BODY TYPES BY CHARACTER ROLES: MEN

Everyone, no matter what their build, has the same muscles. But the posture, body outline, and size and shape of the muscles change from person to person. If your character is a lean and lanky villain, do you really need to bother with overly developed chest and thigh muscles? Probably not. Is your Joe Average reporter going to have a set of flexed abs? Not necessarily. How about the 25-year-old guy with the sunglasses and the sports car? That would be a "yes." Which muscles you emphasize, and how you emphasize them, will largely depend on the type of character you're drawing.

So let's take a look at some characters you would likely run across in comics and check out what their different roles say about their builds.

Street Fighter (left)

This character has an athletic build with wide shoulders, but in the normal range of proportions.

Hero (right)

Our hero has massive shoulders and lats. You've got to get out the tape measure if you want to see how big those biceps are.

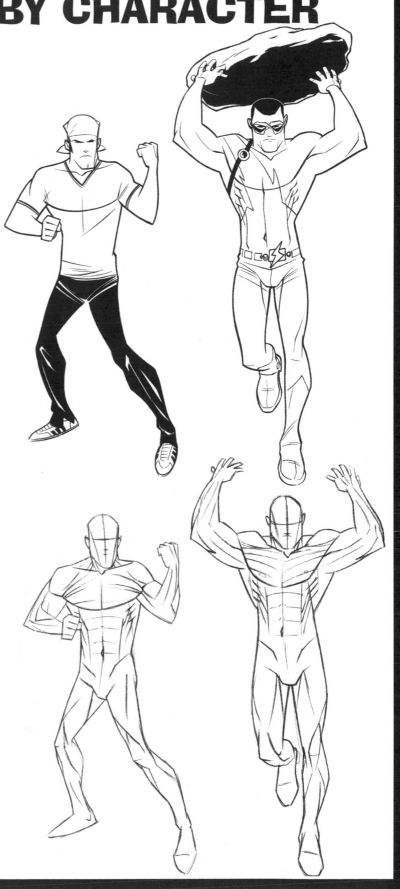

Average Working Guy

This regular Joe still has a somewhat V-shaped torso, like our hero, but looks like he should have eaten a few more veggies growing up.

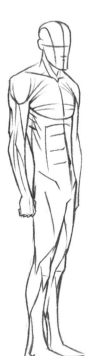

Outlaw Guy

He's big, strong, and fat. But don't tell him I said that.

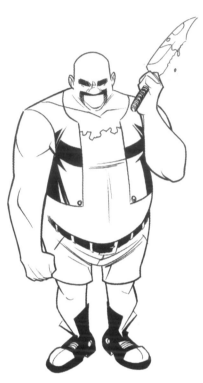

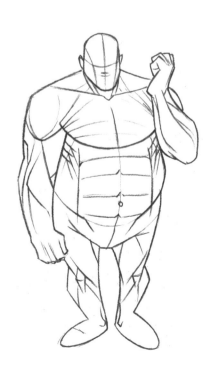

Head of Security

When he's not busting heads, he's bench-pressing. Trim and hard, he cuts a clean silhouette. The first time he ever smiled, his mother told him to cut it out.

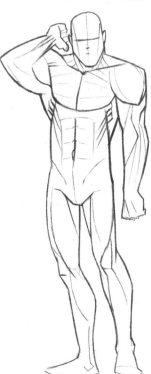

Occult Figure

This creepy character is all skin and bones. He's slippery, with long fingers and pointy nails.

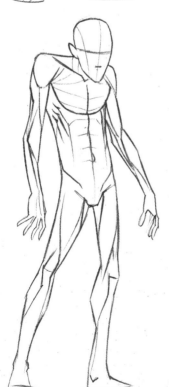

Weird Scientist-for-Hire

He's pocket-sized, short-limbed, and as powerful as a Dandie Dinmont Terrier after a bubble bath.

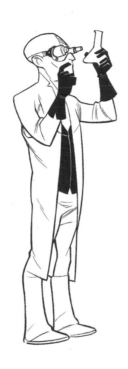

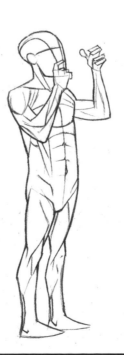

Goth Guy

This dark persona has wide shoulders and a gaunt face. He's tall and long-limbed, like a male fashion model who escaped from a psych ward.

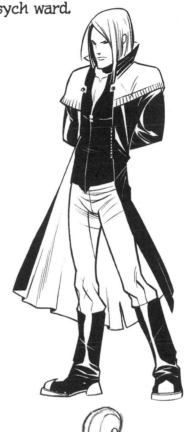

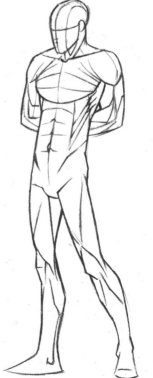

BODY TYPES BY CHARACTER ROLES: WOMEN

It's a fact that in comics, female physiques vary less than male physiques. You just don't tend to see a lot of short females, fat females, and burly females. Not gonna happen. Some of the body types will overlap, and their roles—their identities—will be shaped as much by costume and posture as by their physiques. That's especially true of the last two figures in this lineup: TV Reporter and Fantasy Girl (page 70).

Pampered Villainess (left)

Rich, pampered players are always thin and tall. They hold themselves rather stiffly, allowing their soft, fluffy clothes to surround them.

Fitness Babe (right)

She's got lots of curves and a muscular, yet attractive, look.

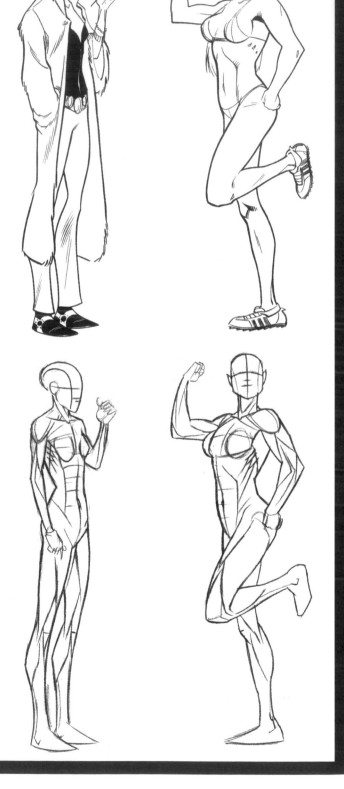

Witchy Mama

This scary lady is ultra bony and painfully thin with a hunched posture. But she doesn't look a day over 80.

Urban Chick

Urban Chick is your average 20-something-year-old, who needs a deluxe set of tetanus shots for all of her body piercings.

Tough Teen

She has a thin body but isn't skinny. Exaggerate the curved line of the legs to give her a youthful appearance.

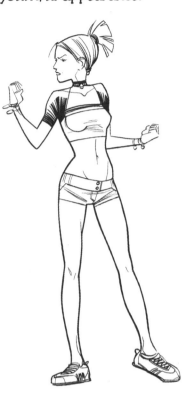

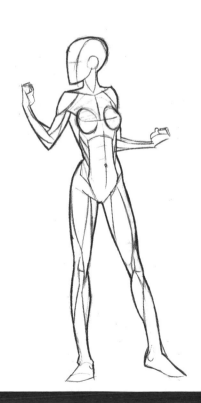

Crime Fighter

She's all there. The, idealized female figure. Strong and sexy with wide shoulders, a narrow waist, wide hips, and long legs. Hey, if someone's got to defeat you, there are worse ways to go.

TV Reporter

She's all business. Thin, medium height, with a slight torso and no significant body strength. If you want to date her, she'll try to pencil you in between meetings.

Fantasy Girl

More of an elegant poser than someone with a specific posture, Fantasy Girl has long limbs for a combination of grace and strength.

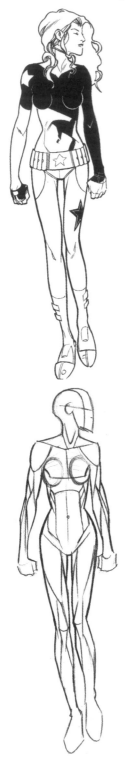
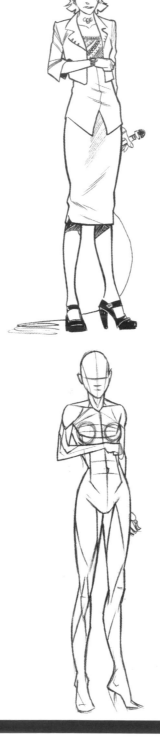
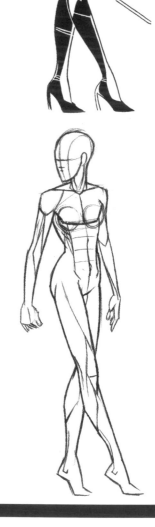

POLISHING & TWEAKING
Power Hero: Front View

Never heard these two terms in art school? You won't see them listed in the course catalogues either. But comic editors will use 'em and expect you to know what they mean.

"Your stuff needs a little more attitude. More style. Give it a polish. Just a tweak. I need it in two days." Are you going to give that editor what he wants, or are you going to ask him to explain what he means and make him late for his next meeting?

No, you're going to go home and make the changes. And since you're ambitious, you're not going to hold back. If he wants to see changes, you'll give him great big changes. And you'll never get work from that editor again. Why not? Because you don't understand what a polish or a tweak means! It doesn't mean change it completely! It means alter it enough-and only just enough—to give it the flavor it needs, like a dash of salt and a pinch of garlic, to give it spice. In the new, streamlined style, that means taking out the more traditional, bumpy muscles and replacing them with sleeker, straighter lines. It means making the body slightly more angular, to bring an edge to the retro-cartoony figure. It means exaggerating the anatomy, just a bit, to sharpen the style.

Let's see how a little polishing and tweaking can add the style we need to make these figures zing.

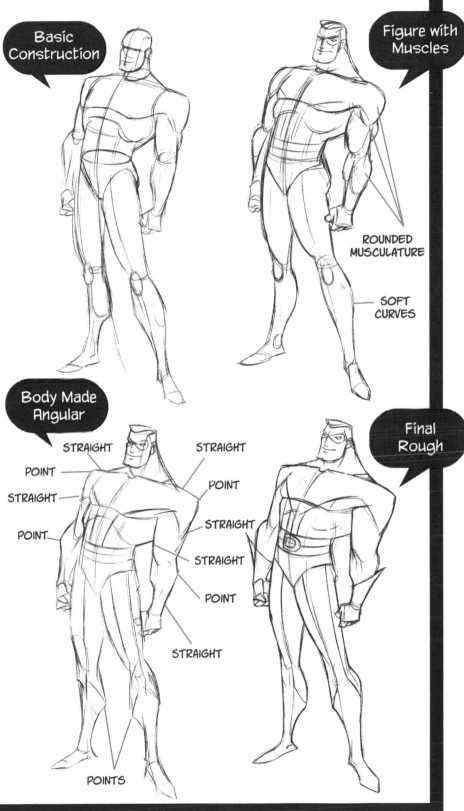

Basic Construction

Figure with Muscles

ROUNDED MUSCULATURE

SOFT CURVES

Body Made Angular

STRAIGHT

POINT

STRAIGHT

POINT

STRAIGHT

POINT

STRAIGHT

STRAIGHT

POINT

STRAIGHT

POINTS

Final Rough

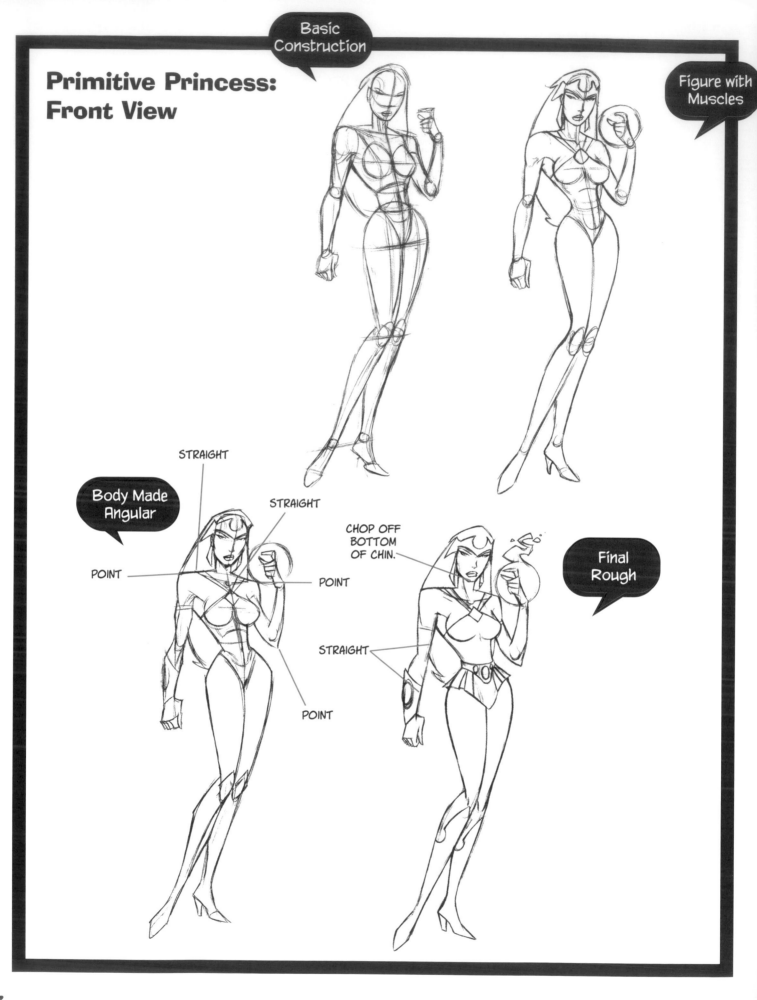

Primitive Princess: Front View

Basic Construction

Figure with Muscles

Body Made Angular

STRAIGHT

STRAIGHT

POINT

POINT

POINT

CHOP OFF BOTTOM OF CHIN.

STRAIGHT

POINT

Final Rough

Primitive Princess: Flying Pose

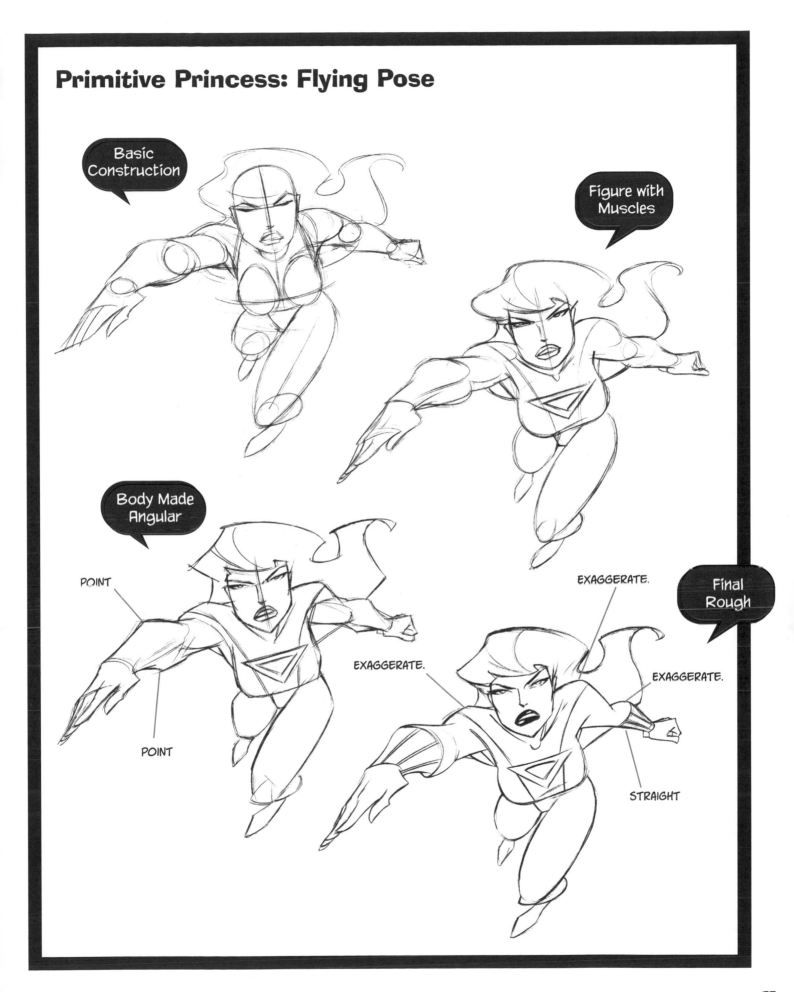

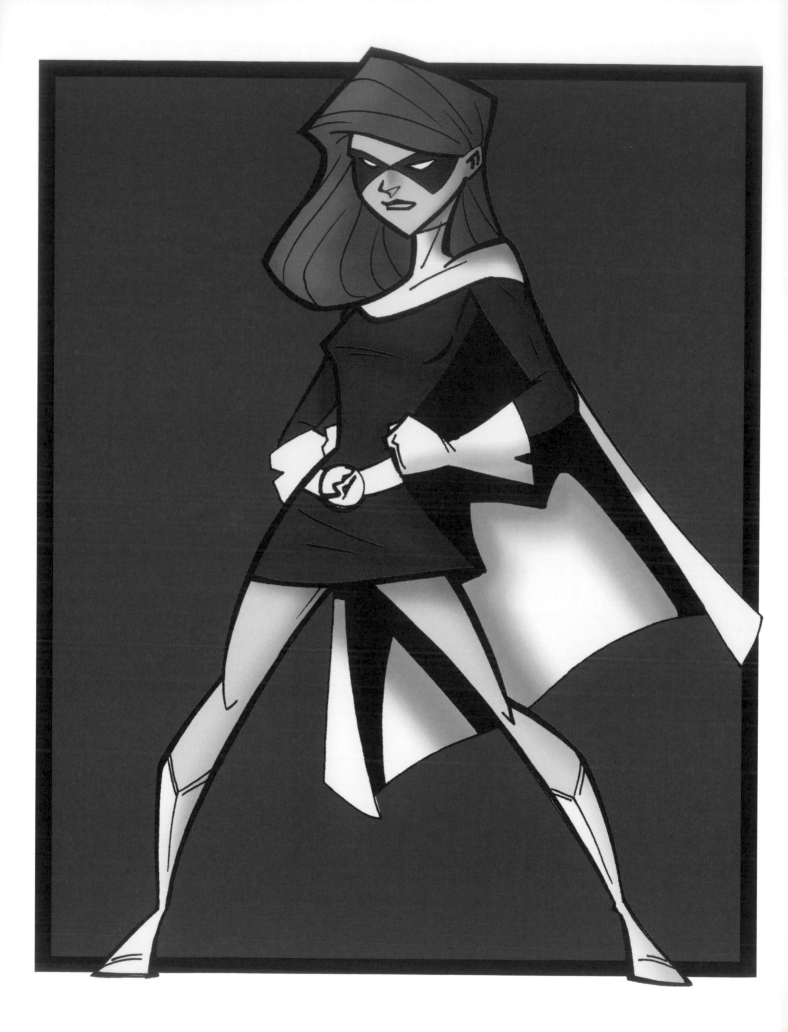

DRAWING CHARACTERS FROM THE SIMPLIFIED SKELETON

This is what I call the "It's so much fun, are you sure I'm really learning anything?" part of the book. The answer is unequivocally "yes!" In this chapter, you'll be using an even more basic version of the simplified skeleton on page 55. This vastly simplified skeleton is all you need to convey an impression of weight, presence, and attitude. The simplified skeleton is not a static thing. As you'll see, it can be molded to fit all the different character types you may come across.

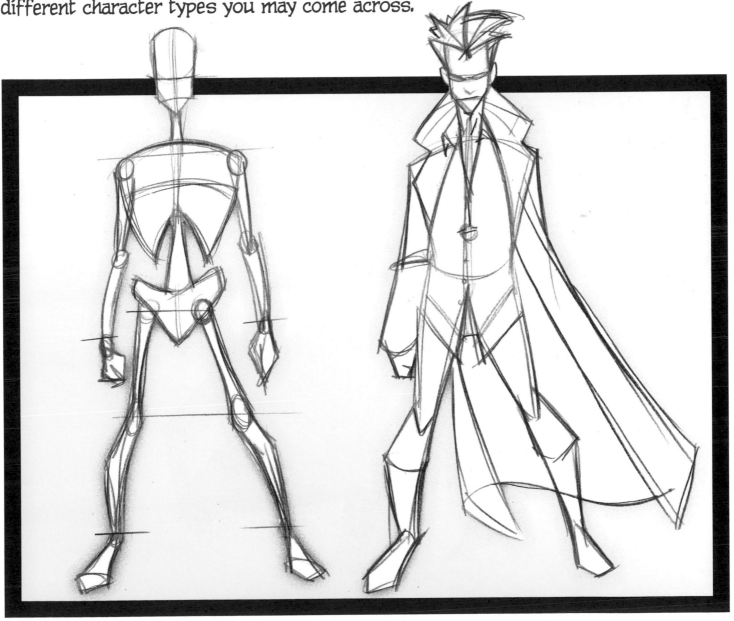

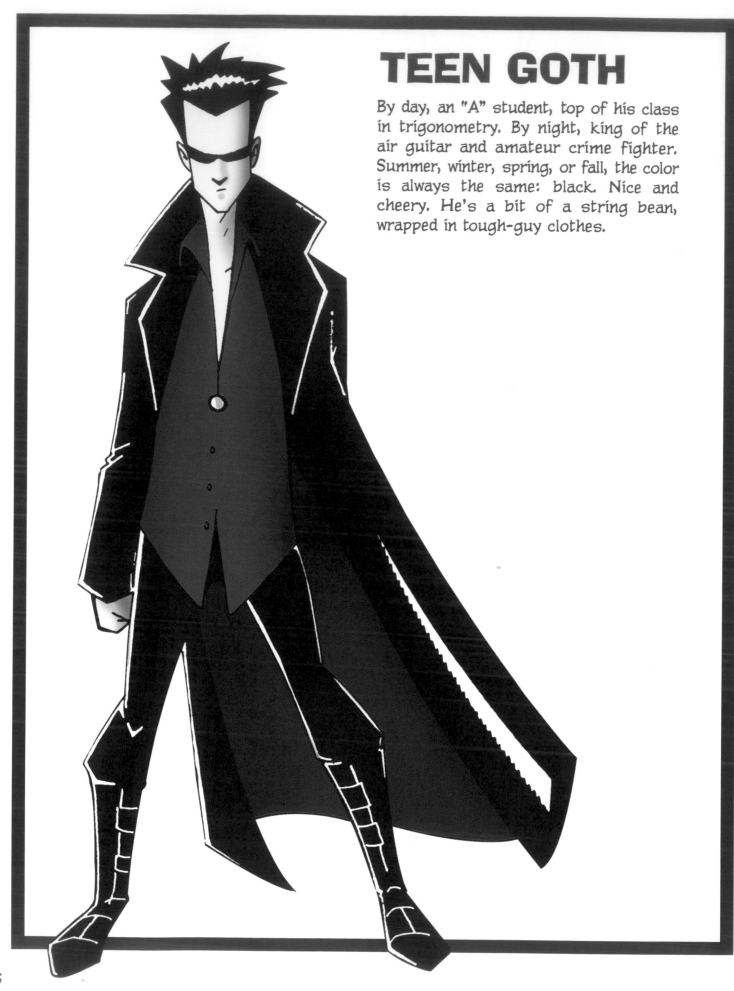

TEEN GOTH

By day, an "A" student, top of his class in trigonometry. By night, king of the air guitar and amateur crime fighter. Summer, winter, spring, or fall, the color is always the same: black. Nice and cheery. He's a bit of a string bean, wrapped in tough-guy clothes.

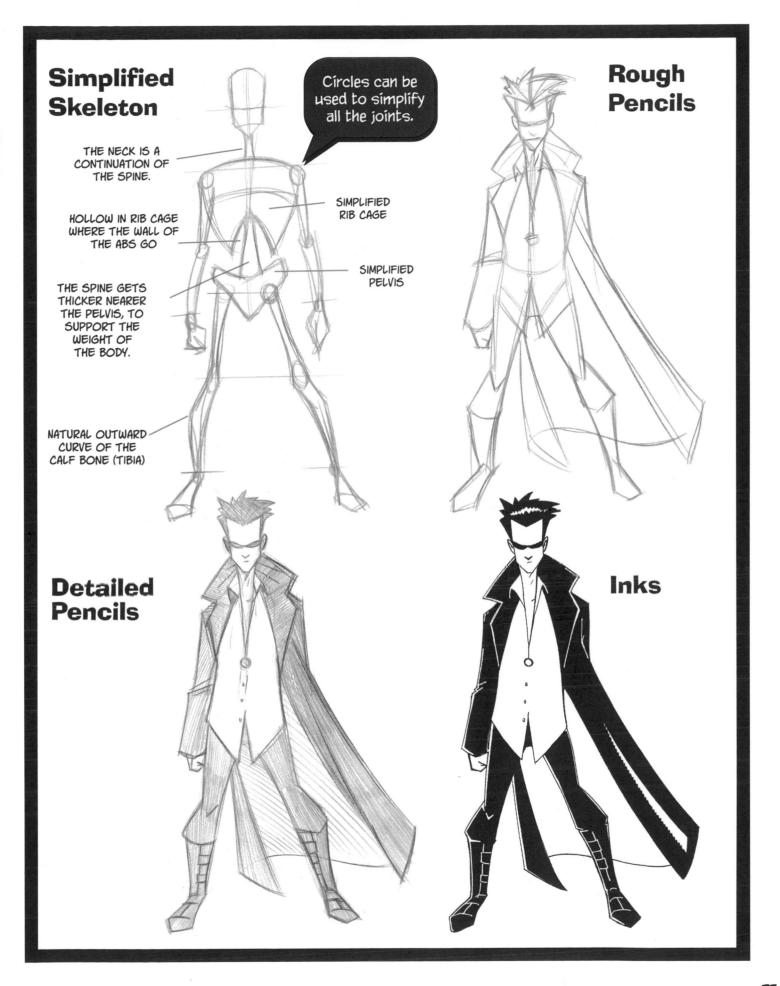

Simplified Skeleton

THE NECK IS A CONTINUATION OF THE SPINE.

HOLLOW IN RIB CAGE WHERE THE WALL OF THE ABS GO

THE SPINE GETS THICKER NEARER THE PELVIS, TO SUPPORT THE WEIGHT OF THE BODY.

NATURAL OUTWARD CURVE OF THE CALF BONE (TIBIA)

Circles can be used to simplify all the joints.

SIMPLIFIED RIB CAGE

SIMPLIFIED PELVIS

Rough Pencils

Detailed Pencils

Inks

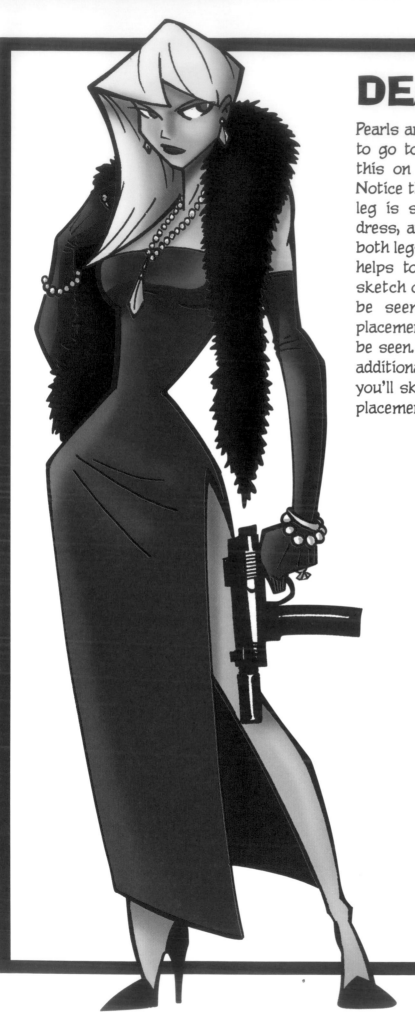

DEADLY BEAUTY

Pearls and guns: Sometimes, they just seem to go together. What do you get a gal like this on her birthday? Anything she wants. Notice that by the final drawing only a partial leg is showing. The rest is hidden by her dress, and yet, we still have bothered to draw both legs. Why? Because most of the time, it helps to draw at least a very light, rough sketch of the part of the limbs that will not be seen, in order to locate the correct placement of the part of the limbs that *will* be seen. But we're not talking about a lot of additional work. These "invisible parts" that you'll sketch can be quite rough—they're for placement purposes only.

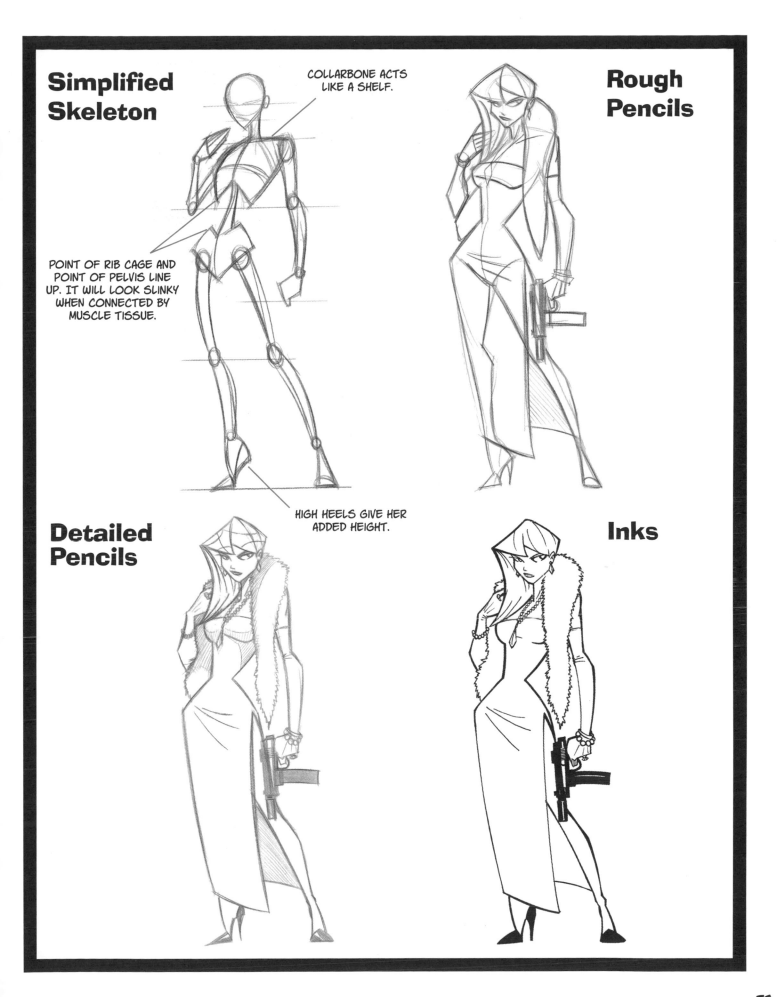

Simplified Skeleton

COLLARBONE ACTS LIKE A SHELF.

POINT OF RIB CAGE AND POINT OF PELVIS LINE UP. IT WILL LOOK SLINKY WHEN CONNECTED BY MUSCLE TISSUE.

Rough Pencils

HIGH HEELS GIVE HER ADDED HEIGHT.

Detailed Pencils

Inks

MR. MUSCLES

When you need a little backup, it's nice to have Mr. Muscles here on your speed dial. He's not particularly loquacious, yet it's amazing how clearly he can communicate his message. And the message is always, "Do what I say, or else."

Characters of gigantic girth almost always have short legs, which emphasize, by way of contrast, the size of the upper body. The collarbones are incredibly wide, making room for a tanklike chest. Typically, the space between the bottom of the rib cage and the pelvis is short, making the character appear stocky (strong) rather than lanky (athletic and nimble). Not a lot of "rippling abs" here. This classic tough-guy character also has a short neck, which may not even show once his frame is fleshed out.

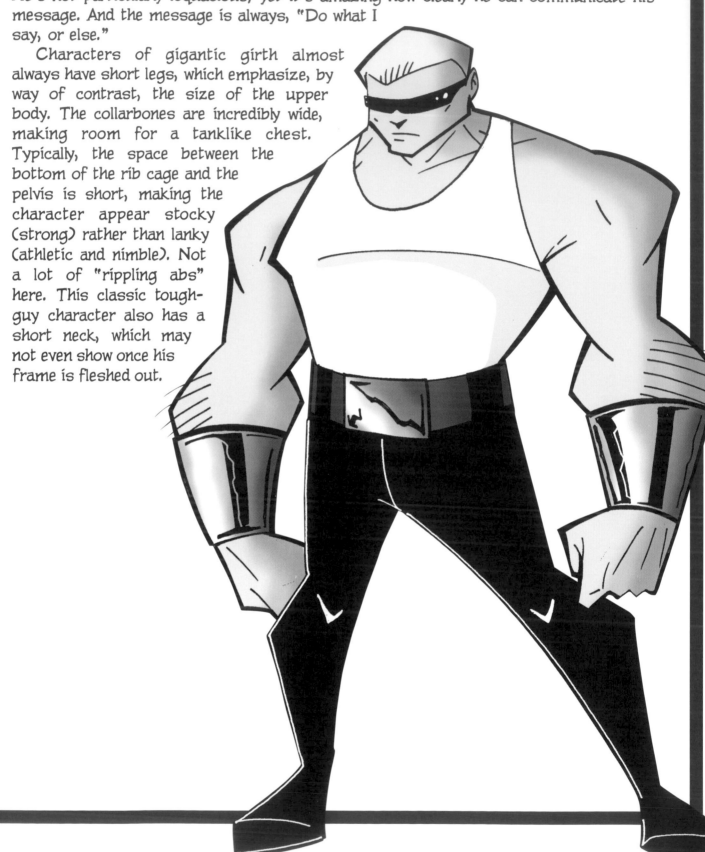

Simplified Skeleton

VERY WIDE COLLARBONES

SHORT NECK

MASSIVE RIB CAGE

SMALL SPACE BETWEEN RIB CAGE AND PELVIS

ANGLE IN.

THICK WAIST AND LOW CENTER OF GRAVITY

SHORT LEG BONES

Rough Pencils

Detailed Pencils

Inks

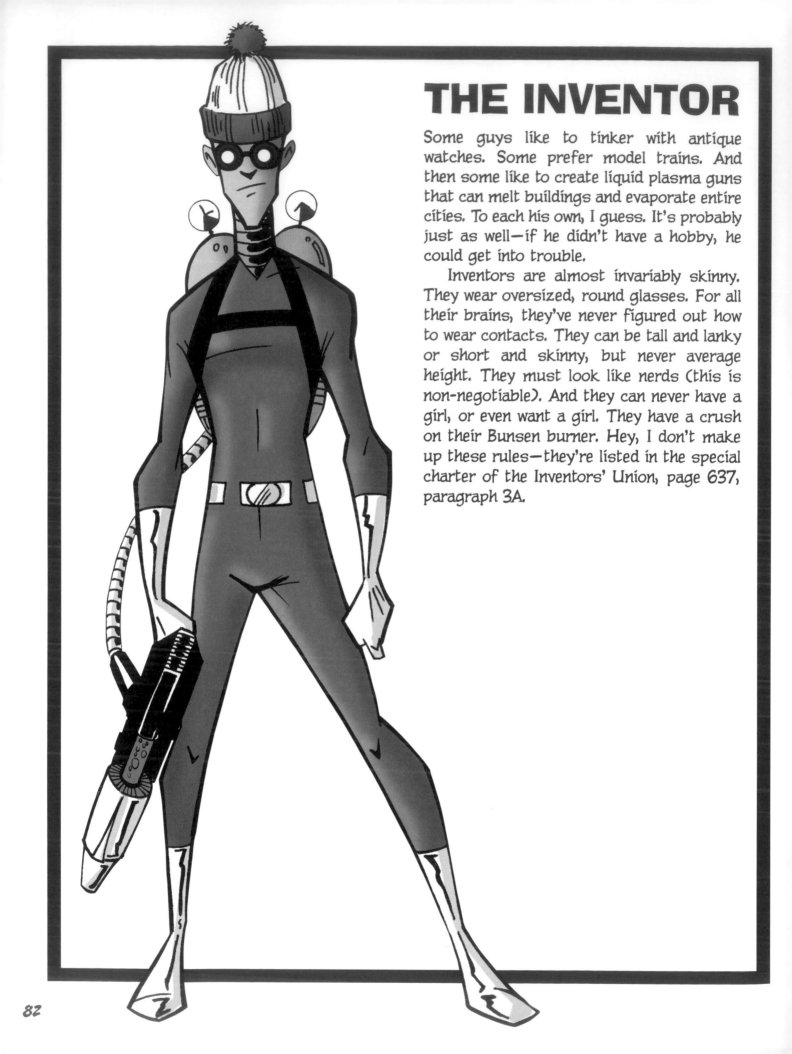

THE INVENTOR

Some guys like to tinker with antique watches. Some prefer model trains. And then some like to create liquid plasma guns that can melt buildings and evaporate entire cities. To each his own, I guess. It's probably just as well—if he didn't have a hobby, he could get into trouble.

Inventors are almost invariably skinny. They wear oversized, round glasses. For all their brains, they've never figured out how to wear contacts. They can be tall and lanky or short and skinny, but never average height. They must look like nerds (this is non-negotiable). And they can never have a girl, or even want a girl. They have a crush on their Bunsen burner. Hey, I don't make up these rules—they're listed in the special charter of the Inventors' Union, page 637, paragraph 3A.

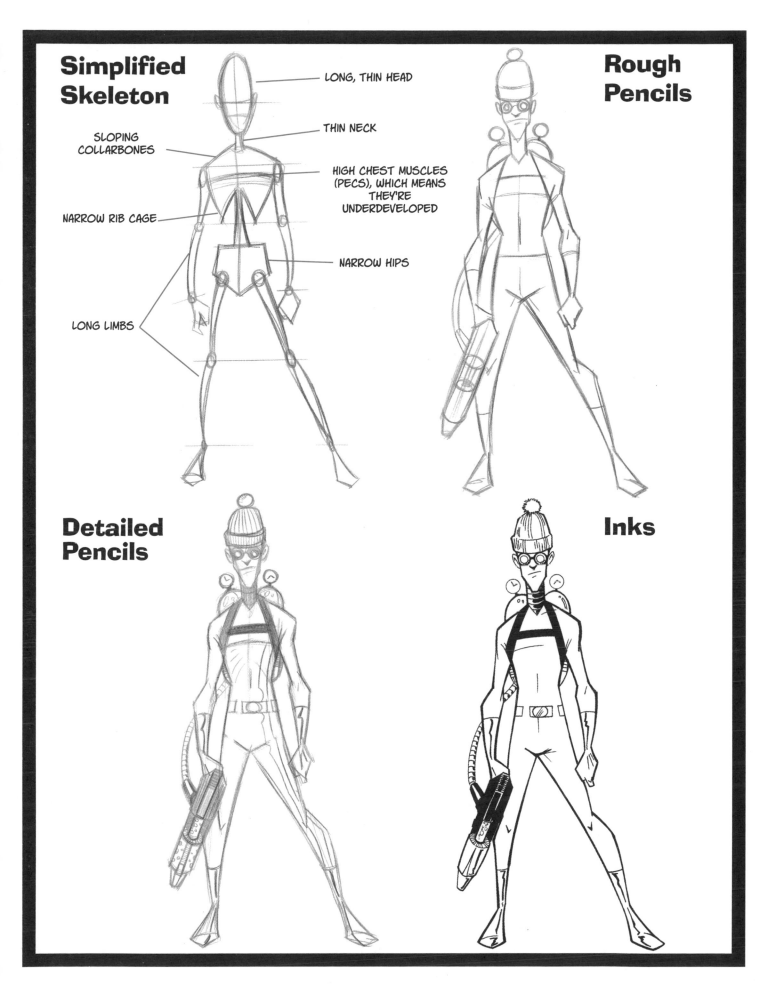

Simplified Skeleton

LONG, THIN HEAD

THIN NECK

SLOPING COLLARBONES

HIGH CHEST MUSCLES (PECS), WHICH MEANS THEY'RE UNDERDEVELOPED

NARROW RIB CAGE

NARROW HIPS

LONG LIMBS

Rough Pencils

Detailed Pencils

Inks

83

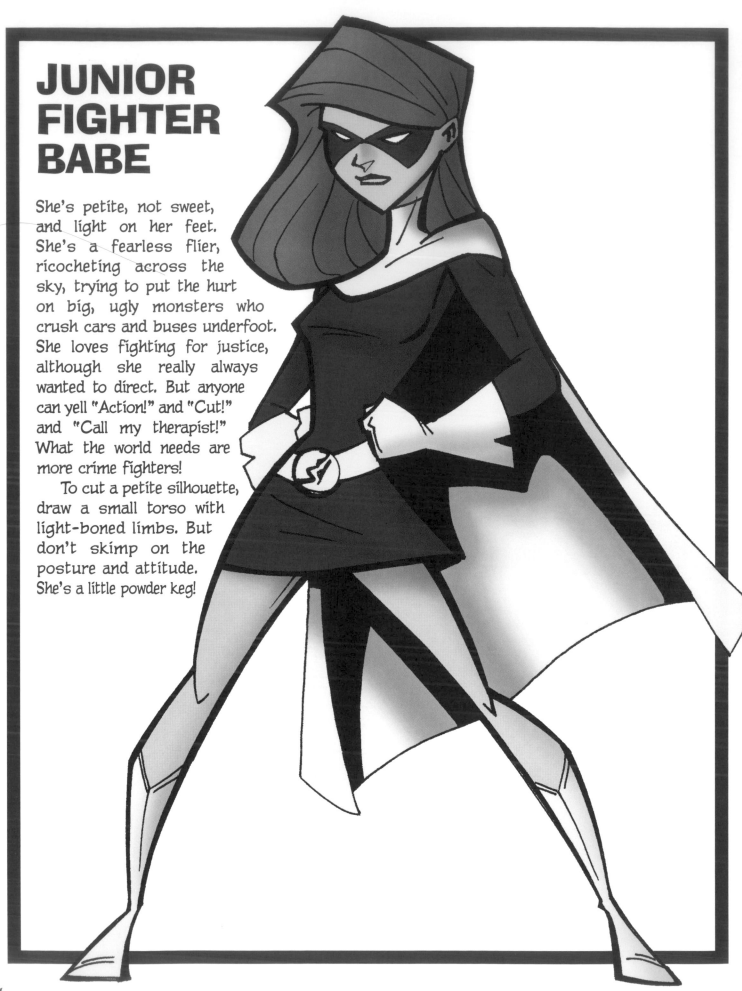

JUNIOR FIGHTER BABE

She's petite, not sweet, and light on her feet. She's a fearless flier, ricocheting across the sky, trying to put the hurt on big, ugly monsters who crush cars and buses underfoot. She loves fighting for justice, although she really always wanted to direct. But anyone can yell "Action!" and "Cut!" and "Call my therapist!" What the world needs are more crime fighters!

To cut a petite silhouette, draw a small torso with light-boned limbs. But don't skimp on the posture and attitude. She's a little powder keg!

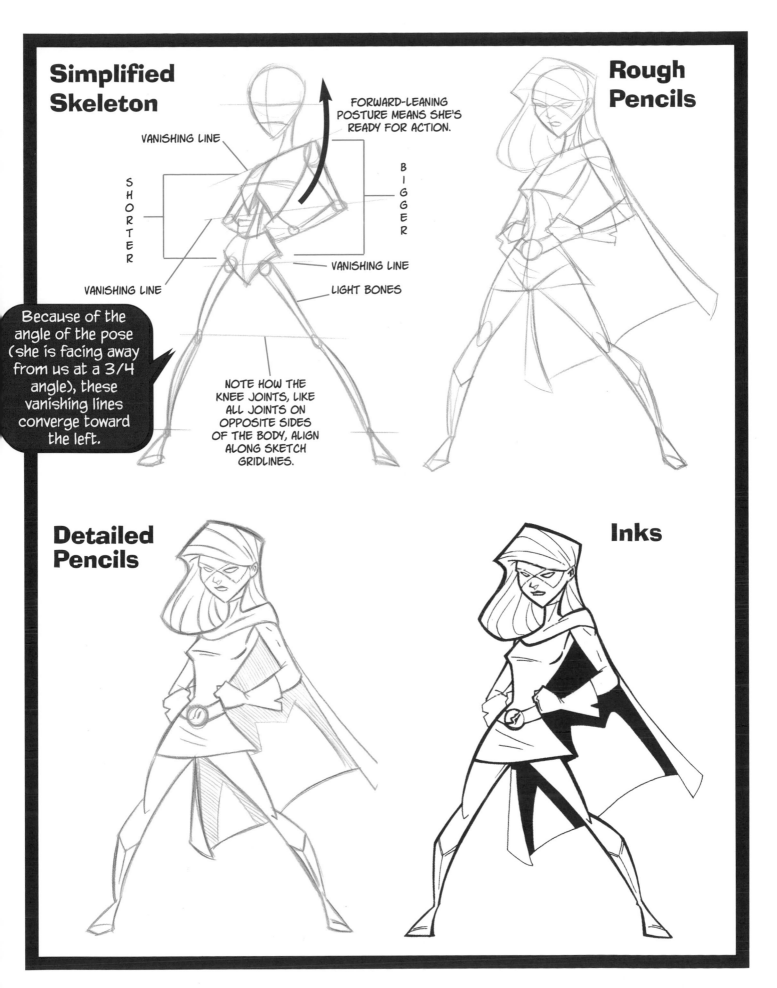

Simplified Skeleton

VANISHING LINE

SHORTER

VANISHING LINE

FORWARD-LEANING POSTURE MEANS SHE'S READY FOR ACTION.

BIGGER

VANISHING LINE

LIGHT BONES

Because of the angle of the pose (she is facing away from us at a 3/4 angle), these vanishing lines converge toward the left.

NOTE HOW THE KNEE JOINTS, LIKE ALL JOINTS ON OPPOSITE SIDES OF THE BODY, ALIGN ALONG SKETCH GRIDLINES.

Rough Pencils

Detailed Pencils

Inks

SUPER-SIZED VILLAIN

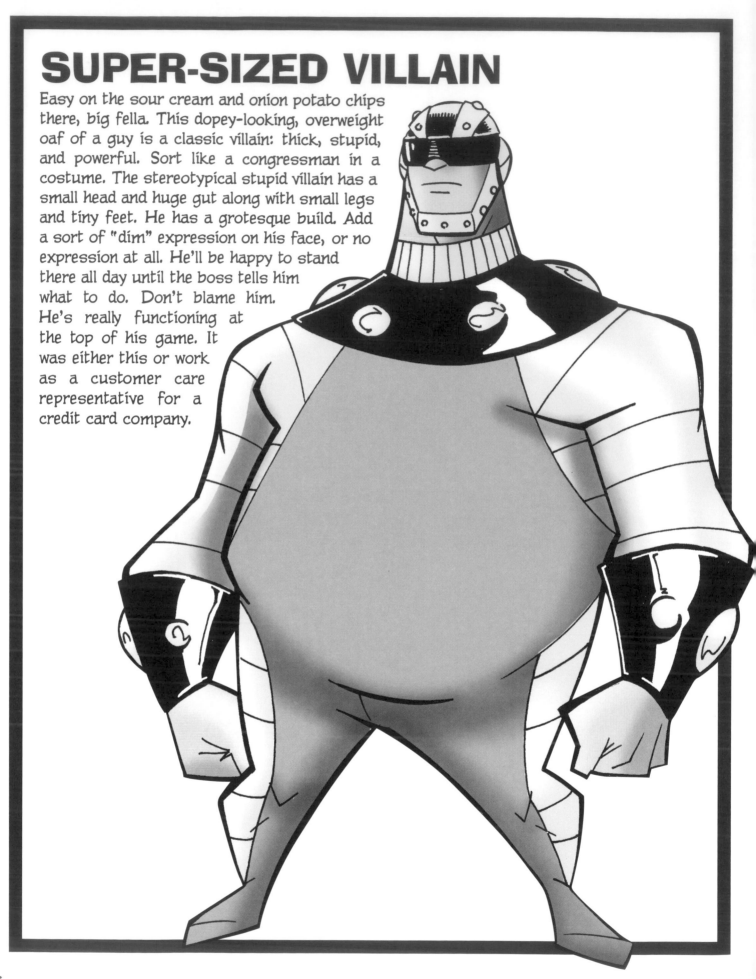

Easy on the sour cream and onion potato chips there, big fella. This dopey-looking, overweight oaf of a guy is a classic villain: thick, stupid, and powerful. Sort like a congressman in a costume. The stereotypical stupid villain has a small head and huge gut along with small legs and tiny feet. He has a grotesque build. Add a sort of "dim" expression on his face, or no expression at all. He'll be happy to stand there all day until the boss tells him what to do. Don't blame him. He's really functioning at the top of his game. It was either this or work as a customer care representative for a credit card company.

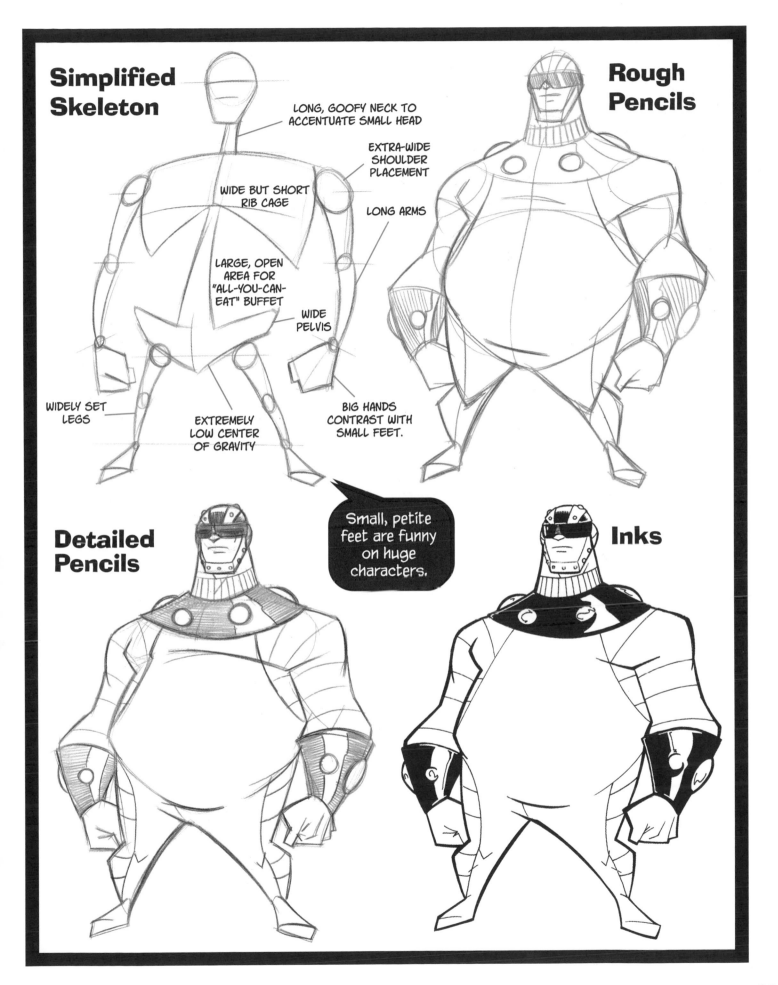

Simplified Skeleton

LONG, GOOFY NECK TO ACCENTUATE SMALL HEAD

EXTRA-WIDE SHOULDER PLACEMENT

WIDE BUT SHORT RIB CAGE

LONG ARMS

LARGE, OPEN AREA FOR "ALL-YOU-CAN-EAT" BUFFET

WIDE PELVIS

WIDELY SET LEGS

EXTREMELY LOW CENTER OF GRAVITY

BIG HANDS CONTRAST WITH SMALL FEET.

Rough Pencils

Detailed Pencils

Small, petite feet are funny on huge characters.

Inks

FEMALE FIGHTER

Not a "flier" type, she's more of a kick-and-punch-your-lights-out covert "ops" babe. Most often, she's part of a team. She's had a few boyfriends. Most of them are still in triage.

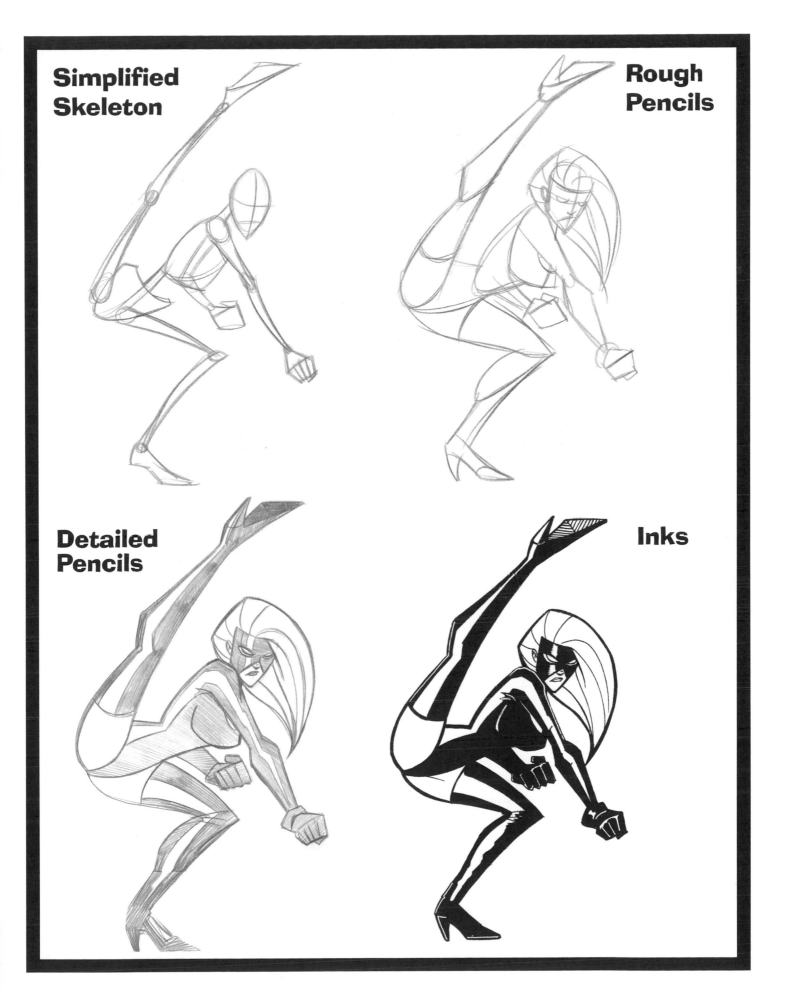

Simplified Skeleton

Rough Pencils

Detailed Pencils

Inks

MANLY MEN: ONE MUSCLE GROUP AT A TIME

Here's the part of anatomy that can be abstruse—the serpentine pathways muscles travel as they wrap around the bones and interlace with other muscles. We're going to examine each muscle group and isolate the muscles that, when stressed or flexed, show lines of definition—without dwelling on muscles that don't show up on your character. And in this chapter and in the chapter on women that follows, you'll learn to draw anatomy from comic book action poses—because who wants to see action heroes standing still?

DRAWING AN IMPRESSIVE CHEST

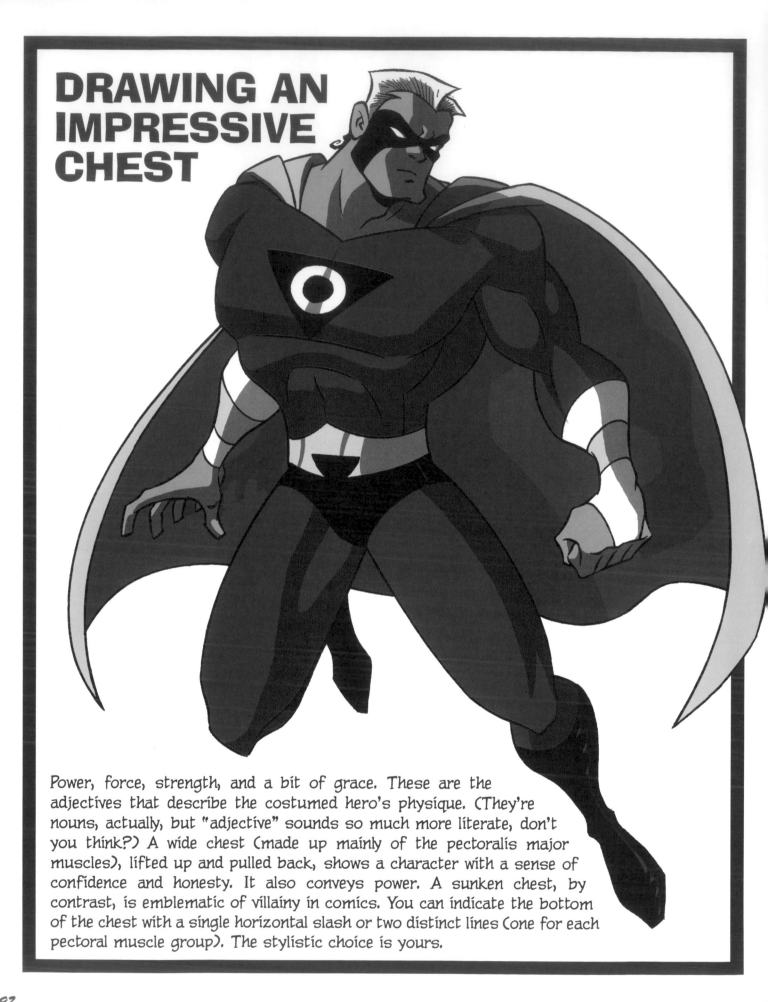

Power, force, strength, and a bit of grace. These are the adjectives that describe the costumed hero's physique. (They're nouns, actually, but "adjective" sounds so much more literate, don't you think?) A wide chest (made up mainly of the pectoralis major muscles), lifted up and pulled back, shows a character with a sense of confidence and honesty. It also conveys power. A sunken chest, by contrast, is emblematic of villainy in comics. You can indicate the bottom of the chest with a single horizontal slash or two distinct lines (one for each pectoral muscle group). The stylistic choice is yours.

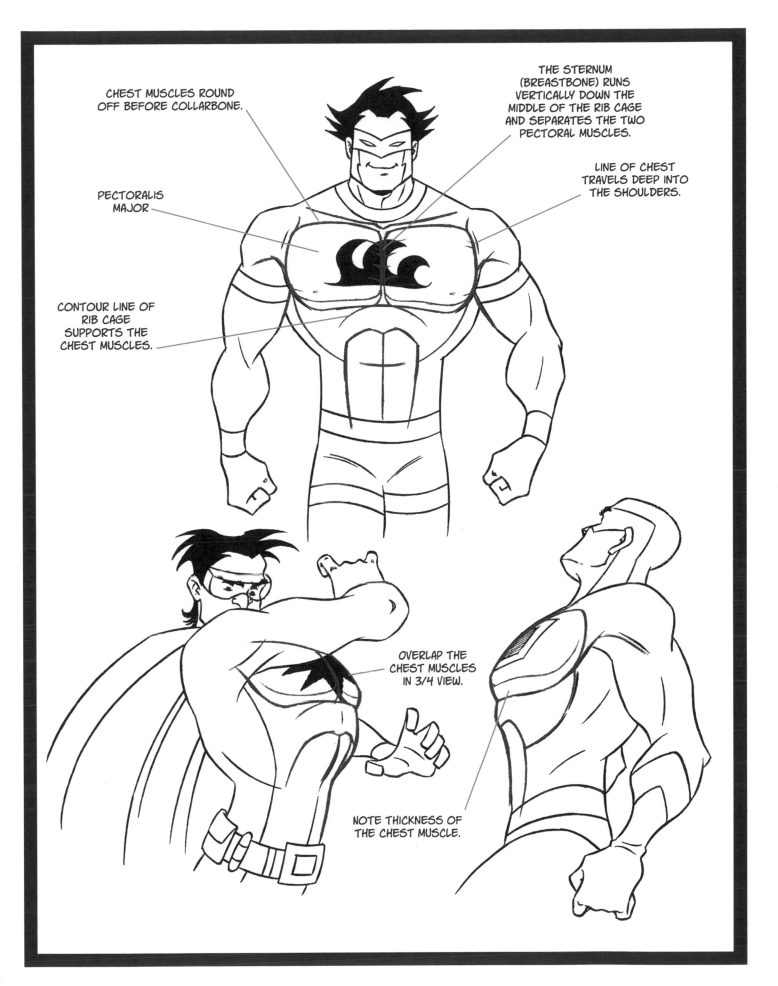

CHEST MUSCLES ROUND OFF BEFORE COLLARBONE.

THE STERNUM (BREASTBONE) RUNS VERTICALLY DOWN THE MIDDLE OF THE RIB CAGE AND SEPARATES THE TWO PECTORAL MUSCLES.

PECTORALIS MAJOR

LINE OF CHEST TRAVELS DEEP INTO THE SHOULDERS.

CONTOUR LINE OF RIB CAGE SUPPORTS THE CHEST MUSCLES.

OVERLAP THE CHEST MUSCLES IN 3/4 VIEW.

NOTE THICKNESS OF THE CHEST MUSCLE.

THE "CORE": ABDOMINAL & RIB CAGE MUSCLES

Ripped abs (rectus abdominis muscles) on a character means internal strength and fortitude. And developed muscles on the ribs (serratus anterior muscles) signify two things: 1) a body in a highly evolved state of physical fitness and 2) an artist who really knows his stuff, because even experienced amateurs have difficulty drawing this area of the body. Not every character will sport super-defined rib muscles. But most exhibit significant definition of the hollow of the rib cage itself, which is essential for drawing the abs, because it frames them.

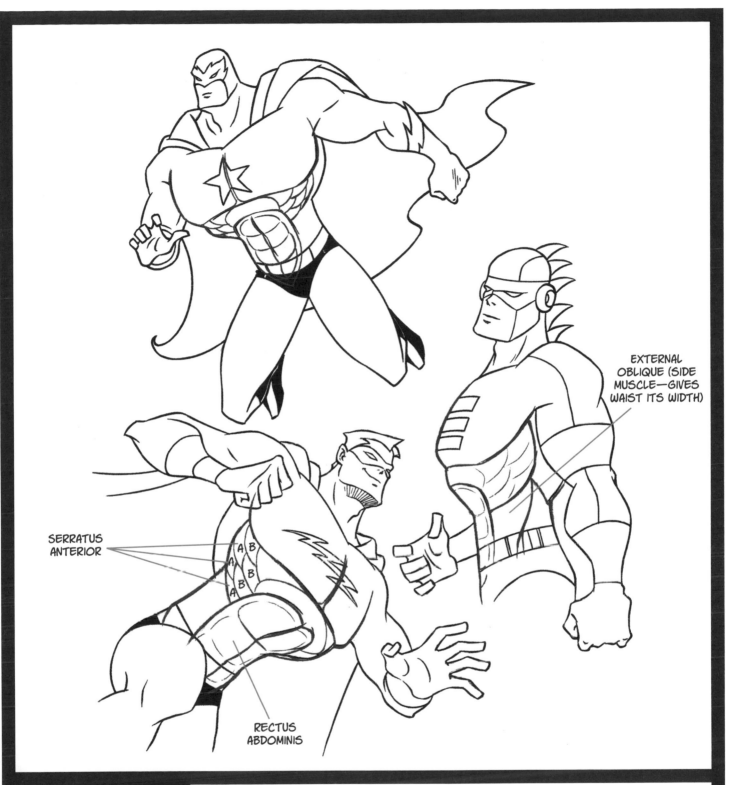

EXTERNAL OBLIQUE (SIDE MUSCLE—GIVES WAIST ITS WIDTH)

SERRATUS ANTERIOR

A B
A B
A B
A B
A

RECTUS ABDOMINIS

"The Mysterious" Serratus Anterior

The rib cage muscles can be simplified into two sets of curved lines. The first interlaces with the second. Keep it that basic.

If you want more information: The first set of rib cage muscles (labeled "A" on the drawing above) are attached from the bottom of the shoulder blade (scapula) to the ribs. The second set of rib cage muscles (B) are side torso muscles that travel from the ribs to the lower pelvic region. But you see how complicated it can become? And does that make you any better as an artist? Or just confuse the heck out of you? Right. Stick with the first explanation!

MUSCLES OF THE NECK

There's always the temptation, when drawing the neck, to add a few loose definition lines here and there without really paying attention to what the heck you're drawing. But you're not going to impress the editors during portfolio reviews at comic book conventions with work habits like that. So unless you've got an uncle in the business, this spread is for you.

The good news is that there are actually only a few muscles in the neck that create the definition lines. And no matter which way the head turns, it's always those same few muscles doing the work. In fact, the muscles of the neck are among the easiest to memorize.

The main neck muscles (sternocleidomastoideus—just give me two minutes alone with the guy who came up with that name!) may look like two separate muscles but actually are not. They start off as one muscle at the base of the ear but fork off, with one branch attaching to the collarbone at the pit of the neck, and the other branching off to the collarbone, a bit farther up, nearer to the shoulder.

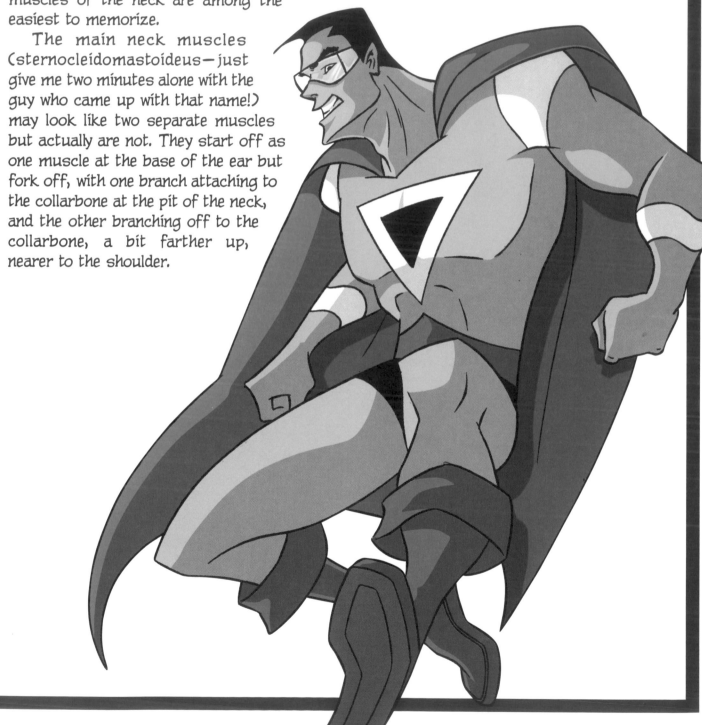

96

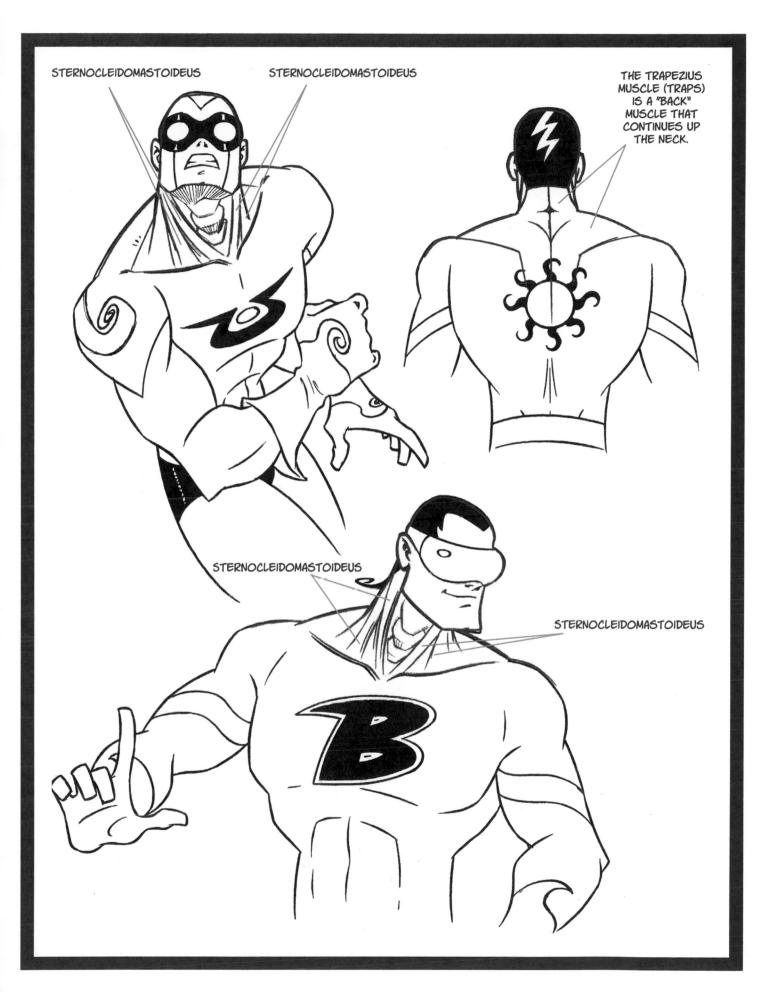

STERNOCLEIDOMASTOIDEUS

STERNOCLEIDOMASTOIDEUS

THE TRAPEZIUS MUSCLE (TRAPS) IS A "BACK" MUSCLE THAT CONTINUES UP THE NECK.

STERNOCLEIDOMASTOIDEUS

STERNOCLEIDOMASTOIDEUS

BOWLING BALL SHOULDERS

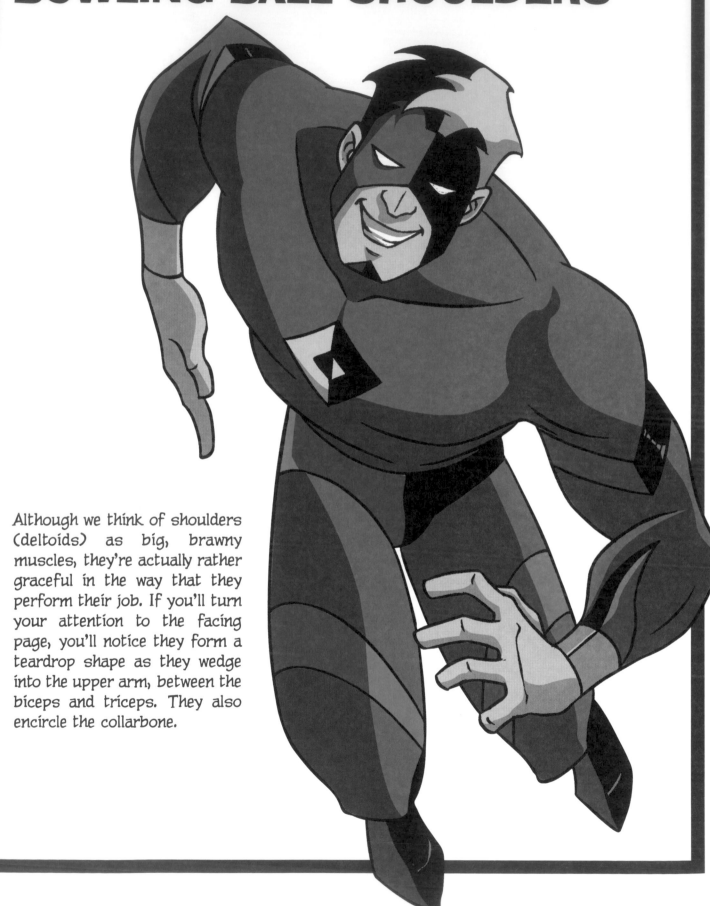

Although we think of shoulders (deltoids) as big, brawny muscles, they're actually rather graceful in the way that they perform their job. If you'll turn your attention to the facing page, you'll notice they form a teardrop shape as they wedge into the upper arm, between the biceps and triceps. They also encircle the collarbone.

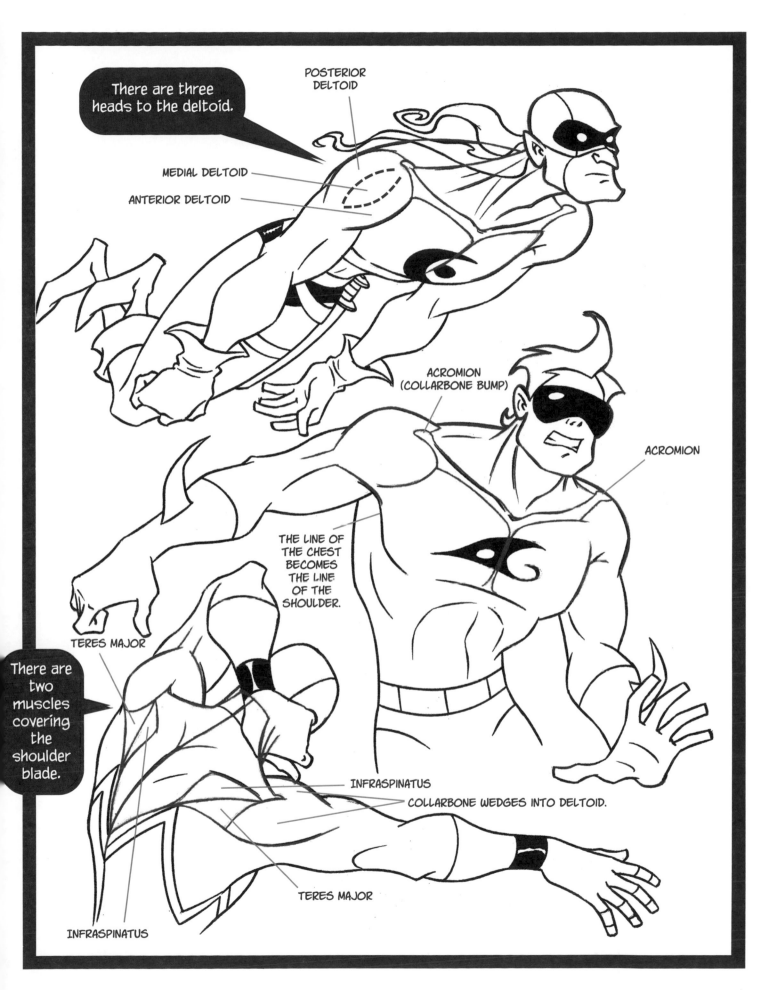

THE "BARN DOOR" BACK

Why do the muscles of the back give artists more difficulty than the muscles of the front of the body? It's all about familiarity. When we look at ourselves in the mirror with our shirts off, we see our chests, not our backs.

The back is a huge area of the body, especially on broad, muscular comic book characters. And there's a lot going on there. It's especially challenging because the "landmark" muscles aren't as familiar to us. In the front of the body, we're all well acquainted with the famous chest muscles and wall of abs that give it shape. In the back, we know there are shoulder blades, but we're generally less familiar with the muscles that surround them, as well as the middle and lower areas of the back. When we simplify them, though, they become clear and ultimately easy to remember. And the anatomy may surprise you, too. For example, you'll see that certain muscles that you may have assumed were small are actually very large, like the trapezius muscle, which is among the largest muscles of the back. So linger on the following page for an extra beat and take it all in.

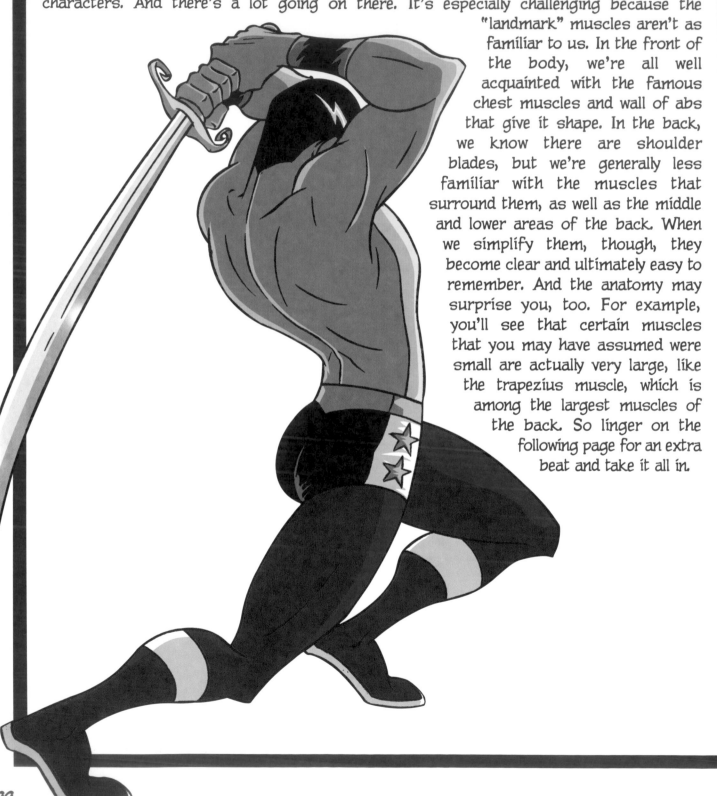

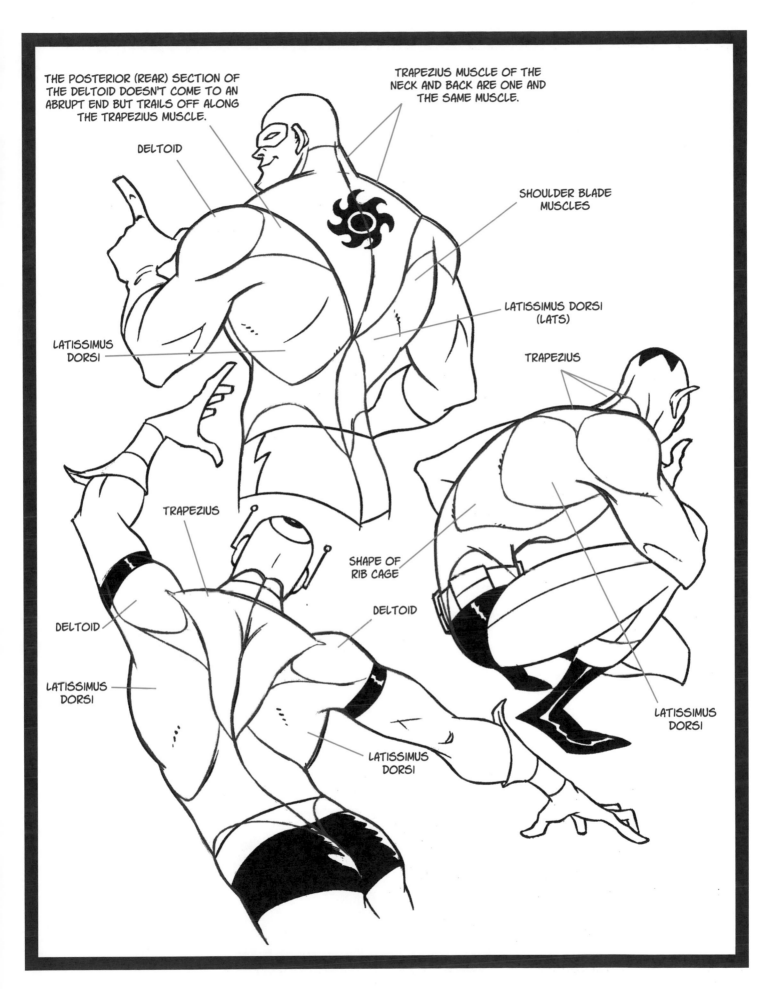

THE POSTERIOR (REAR) SECTION OF
THE DELTOID DOESN'T COME TO AN
ABRUPT END BUT TRAILS OFF ALONG
THE TRAPEZIUS MUSCLE.

TRAPEZIUS MUSCLE OF THE
NECK AND BACK ARE ONE AND
THE SAME MUSCLE.

DELTOID

SHOULDER BLADE
MUSCLES

LATISSIMUS DORSI
(LATS)

LATISSIMUS
DORSI

TRAPEZIUS

TRAPEZIUS

SHAPE OF
RIB CAGE

DELTOID

LATISSIMUS
DORSI

DELTOID

LATISSIMUS
DORSI

LATISSIMUS
DORSI

LATISSIMUS
DORSI

BICEPS: THE FAMOUS "SHOW" MUSCLE

A comic book character with big biceps is like a guy carrying a pair of grenades: explosive power, ready to go off. Yes, I know, you want to draw the biggest, meanest bi's this side of Arnold's. I hate to break it to you, but everything's got to be in proportion. Come on, what's with the long face? Your hero's still gonna be grotesquely huge. It's just that if you make his arms over-the-top huge, you'll lose that streamlined look. Remember, we're not concerned about just one muscle, but about the entire figure working as a slick unit.

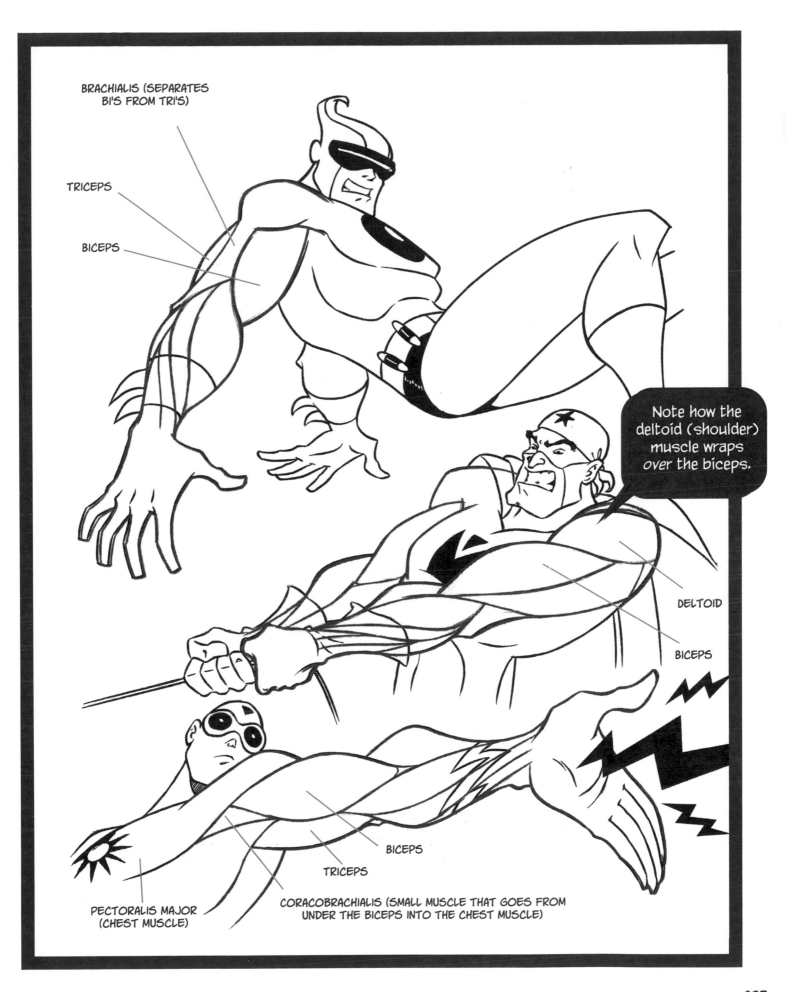

103

TREMENDOUS TRICEPS

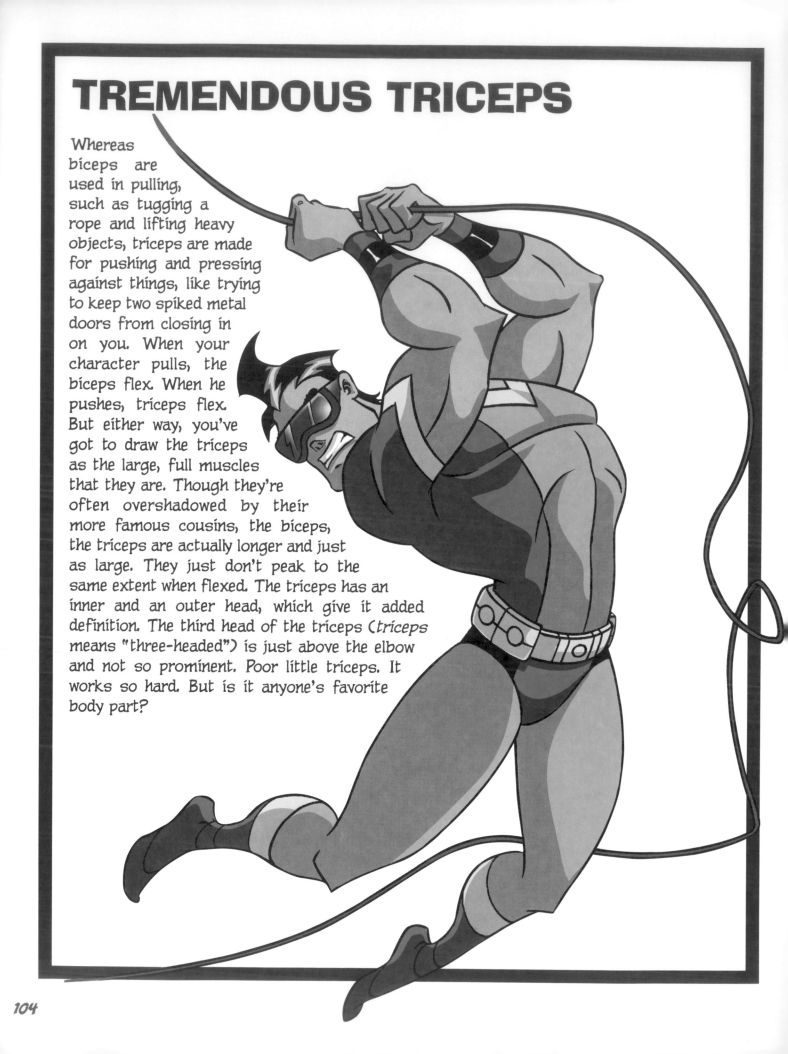

Whereas biceps are used in pulling, such as tugging a rope and lifting heavy objects, triceps are made for pushing and pressing against things, like trying to keep two spiked metal doors from closing in on you. When your character pulls, the biceps flex. When he pushes, triceps flex. But either way, you've got to draw the triceps as the large, full muscles that they are. Though they're often overshadowed by their more famous cousins, the biceps, the triceps are actually longer and just as large. They just don't peak to the same extent when flexed. The triceps has an inner and an outer head, which give it added definition. The third head of the triceps (*triceps* means "three-headed") is just above the elbow and not so prominent. Poor little triceps. It works so hard. But is it anyone's favorite body part?

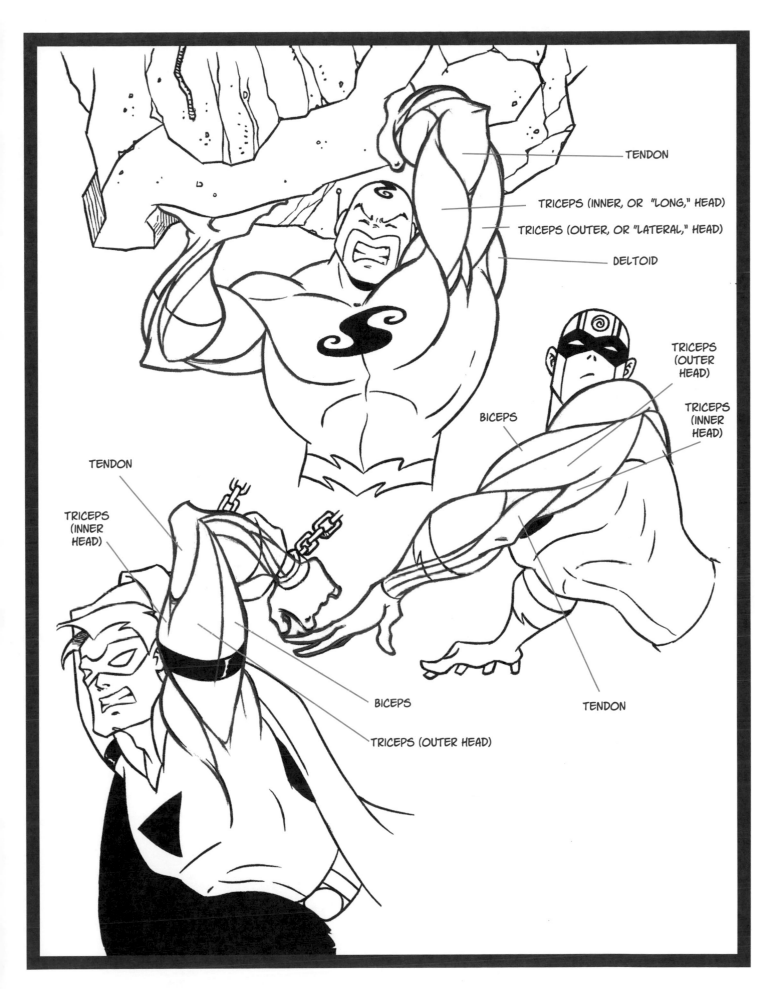

TENDON

TRICEPS (INNER, OR "LONG," HEAD)

TRICEPS (OUTER, OR "LATERAL," HEAD)

DELTOID

TRICEPS (OUTER HEAD)

TRICEPS (INNER HEAD)

BICEPS

TENDON

TRICEPS (INNER HEAD)

BICEPS

TENDON

TRICEPS (OUTER HEAD)

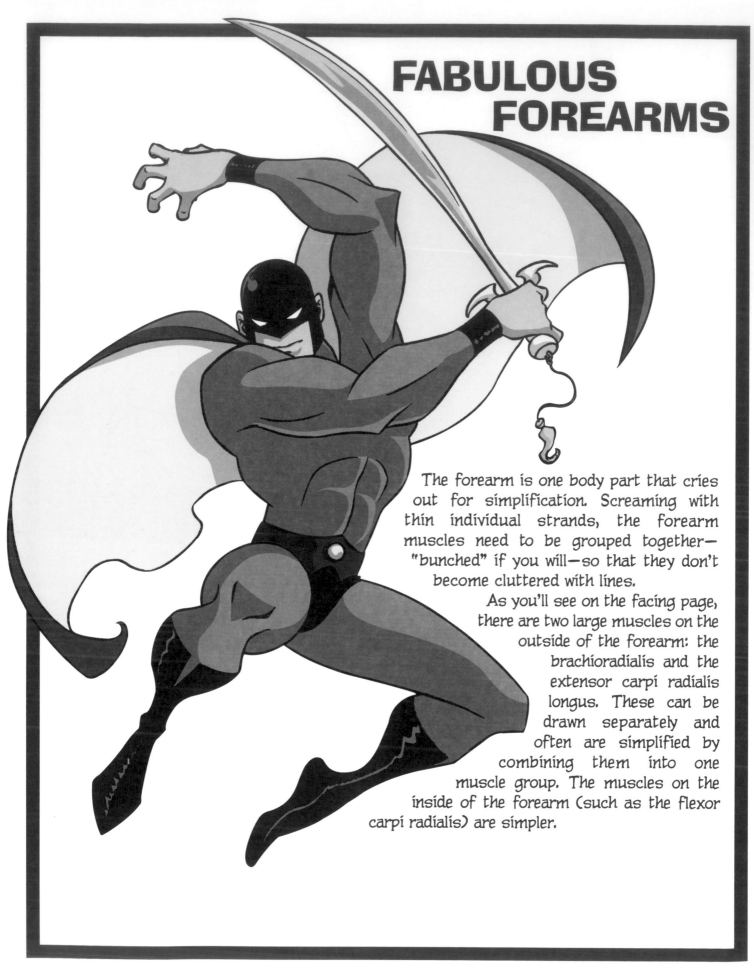

FABULOUS FOREARMS

The forearm is one body part that cries out for simplification. Screaming with thin individual strands, the forearm muscles need to be grouped together—"bunched" if you will—so that they don't become cluttered with lines.

As you'll see on the facing page, there are two large muscles on the outside of the forearm: the brachioradialis and the extensor carpi radialis longus. These can be drawn separately and often are simplified by combining them into one muscle group. The muscles on the inside of the forearm (such as the flexor carpi radialis) are simpler.

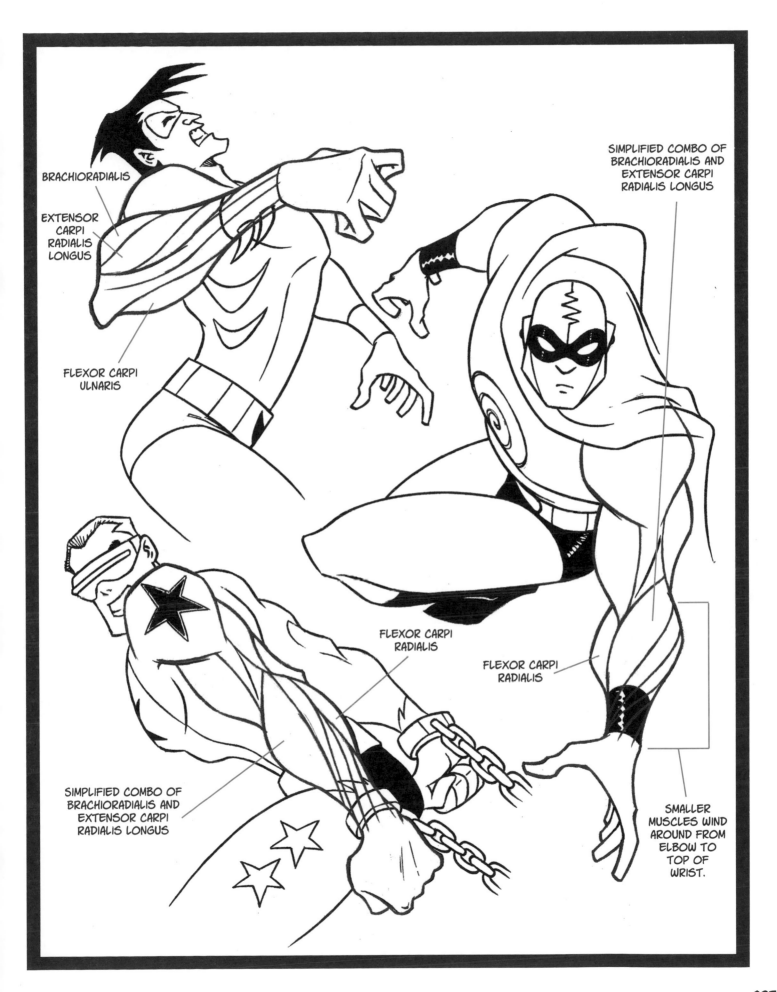

BRACHIORADIALIS

EXTENSOR
CARPI
RADIALIS
LONGUS

FLEXOR CARPI
ULNARIS

SIMPLIFIED COMBO OF
BRACHIORADIALIS AND
EXTENSOR CARPI
RADIALIS LONGUS

FLEXOR CARPI
RADIALIS

FLEXOR CARPI
RADIALIS

SIMPLIFIED COMBO OF
BRACHIORADIALIS AND
EXTENSOR CARPI
RADIALIS LONGUS

SMALLER
MUSCLES WIND
AROUND FROM
ELBOW TO
TOP OF
WRIST.

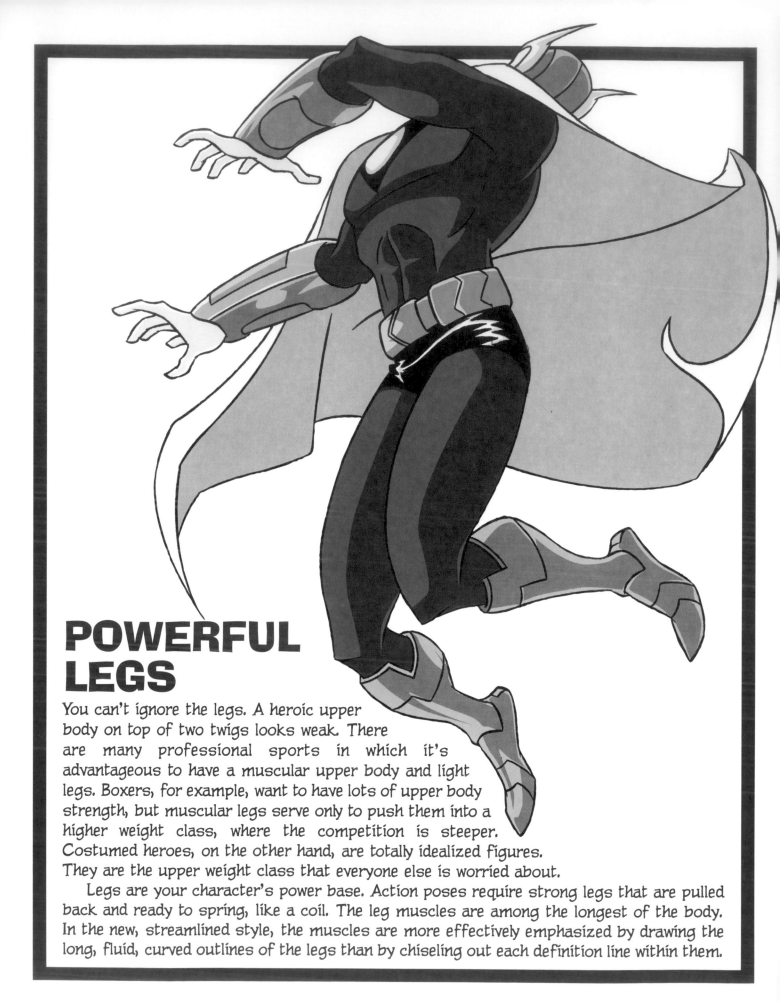

POWERFUL LEGS

You can't ignore the legs. A heroic upper body on top of two twigs looks weak. There are many professional sports in which it's advantageous to have a muscular upper body and light legs. Boxers, for example, want to have lots of upper body strength, but muscular legs serve only to push them into a higher weight class, where the competition is steeper. Costumed heroes, on the other hand, are totally idealized figures. They are the upper weight class that everyone else is worried about.

Legs are your character's power base. Action poses require strong legs that are pulled back and ready to spring, like a coil. The leg muscles are among the longest of the body. In the new, streamlined style, the muscles are more effectively emphasized by drawing the long, fluid, curved outlines of the legs than by chiseling out each definition line within them.

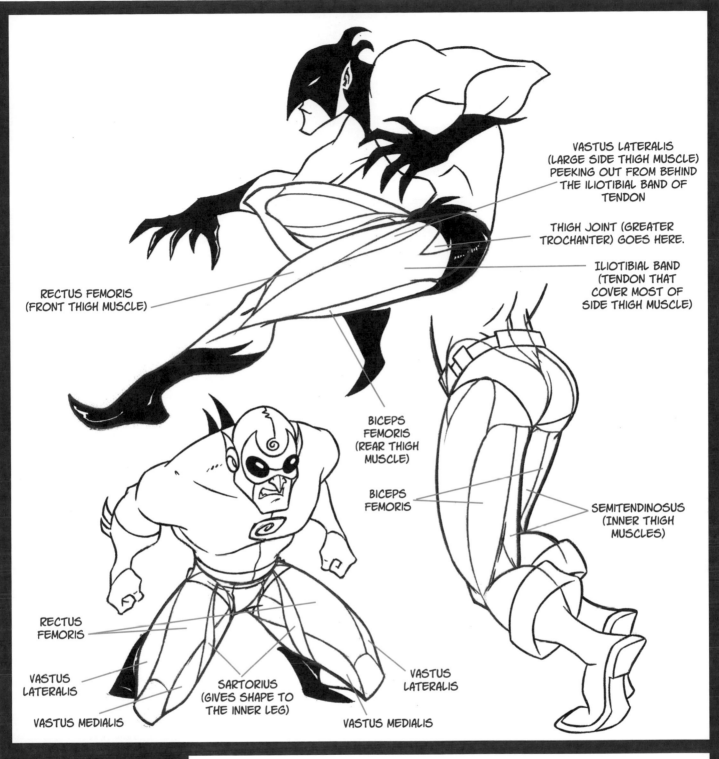

VASTUS LATERALIS
(LARGE SIDE THIGH MUSCLE)
PEEKING OUT FROM BEHIND
THE ILIOTIBIAL BAND OF
TENDON

THIGH JOINT (GREATER
TROCHANTER) GOES HERE.

ILIOTIBIAL BAND
(TENDON THAT
COVER MOST OF
SIDE THIGH MUSCLE)

RECTUS FEMORIS
(FRONT THIGH MUSCLE)

BICEPS
FEMORIS
(REAR THIGH
MUSCLE)

BICEPS
FEMORIS

SEMITENDINOSUS
(INNER THIGH
MUSCLES)

RECTUS
FEMORIS

VASTUS
LATERALIS

VASTUS MEDIALIS

SARTORIUS
(GIVES SHAPE TO
THE INNER LEG)

VASTUS
LATERALIS

VASTUS MEDIALIS

The Iliotibial Band

Let me now direct your attention to the top figure, specifically to the tendon named the iliotibial band. (Why couldn't they just have named it, oh, say, "Tendon #8?" No, that would've been too complicated.) This is a thick tendon that covers a thick muscle called the vastus lateralis, another tongue twister. Sometimes a tendon causes the definition lines in the thigh. Other times a muscle does. And there's a third option that's equally valid, especially for the simplified approach: Leave out the definition lines of the thigh altogether and just concentrate on a streamlined outline of the leg!

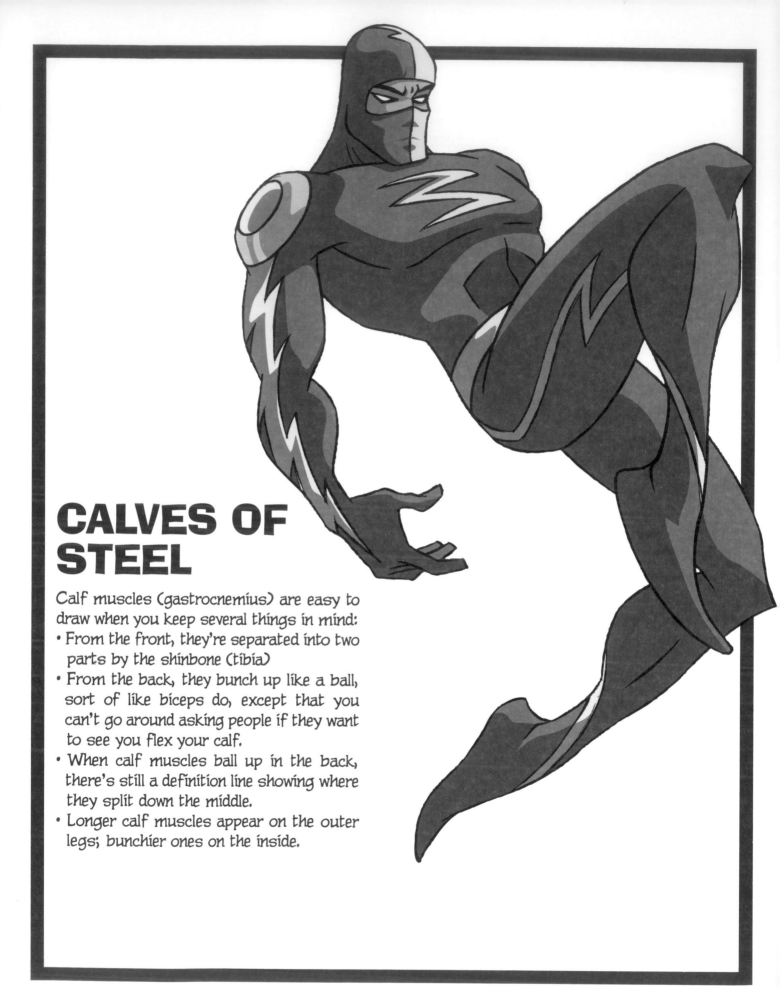

CALVES OF STEEL

Calf muscles (gastrocnemius) are easy to draw when you keep several things in mind:

• From the front, they're separated into two parts by the shinbone (tibia)

• From the back, they bunch up like a ball, sort of like biceps do, except that you can't go around asking people if they want to see you flex your calf.

• When calf muscles ball up in the back, there's still a definition line showing where they split down the middle.

• Longer calf muscles appear on the outer legs; bunchier ones on the inside.

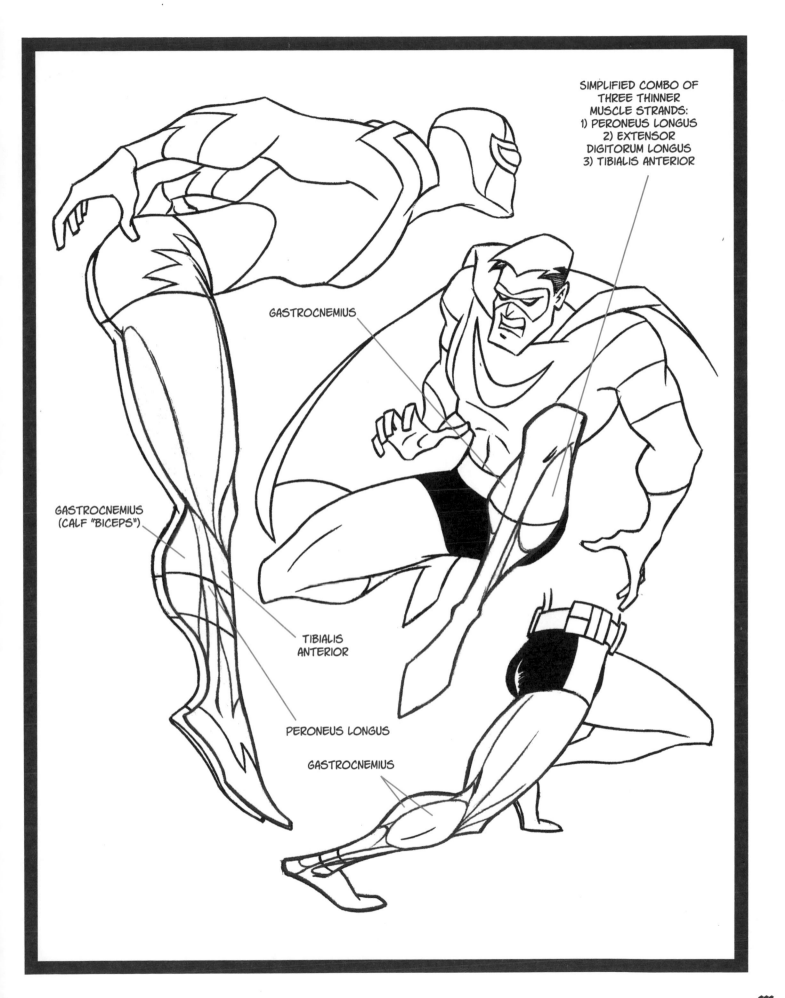

SIMPLIFIED COMBO OF
THREE THINNER
MUSCLE STRANDS:
1) PERONEUS LONGUS
2) EXTENSOR
DIGITORUM LONGUS
3) TIBIALIS ANTERIOR

GASTROCNEMIUS

GASTROCNEMIUS
(CALF "BICEPS")

TIBIALIS
ANTERIOR

PERONEUS LONGUS

GASTROCNEMIUS

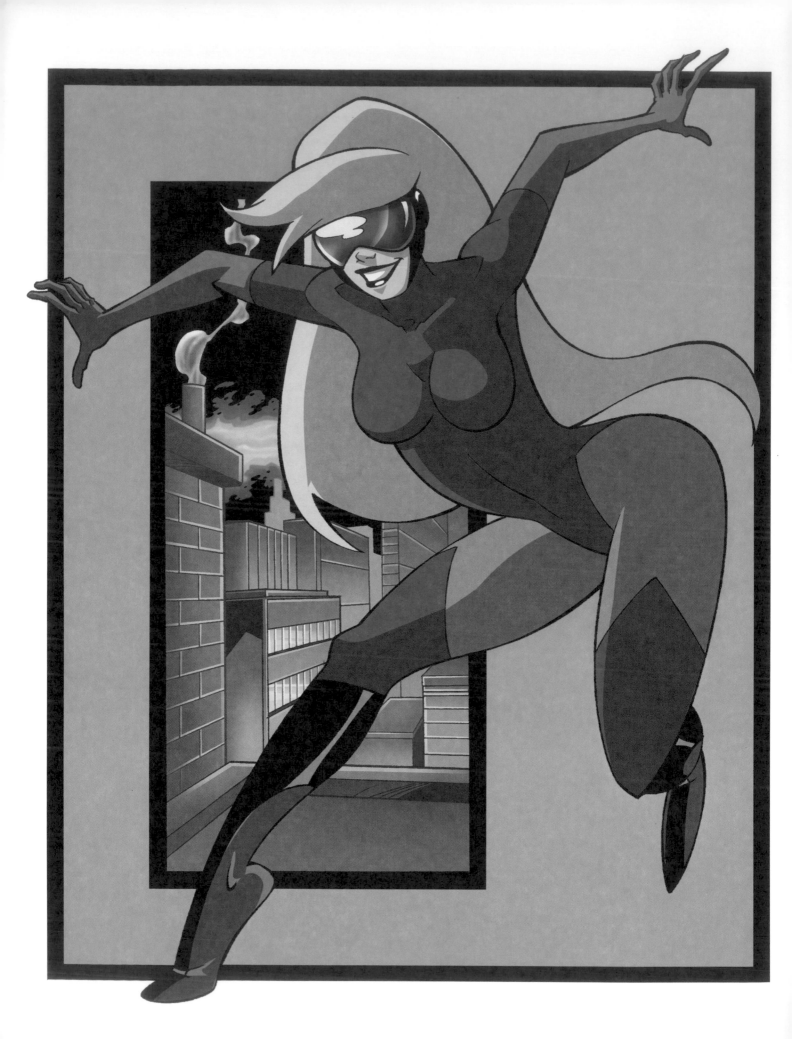

FABULOUS FEMALES: ONE MUSCLE GROUP AT A TIME

Naturally, we're not going to give the women the same treatment that we gave the men. No super-eye-popping muscles on our combat-ready beauties. And yet, these graceful powerhouses are still athletic, sinewy, and shapely. They flex, move, twist, and stretch. And since these are women of action, you've got to know how the muscles will look when they're in motion.

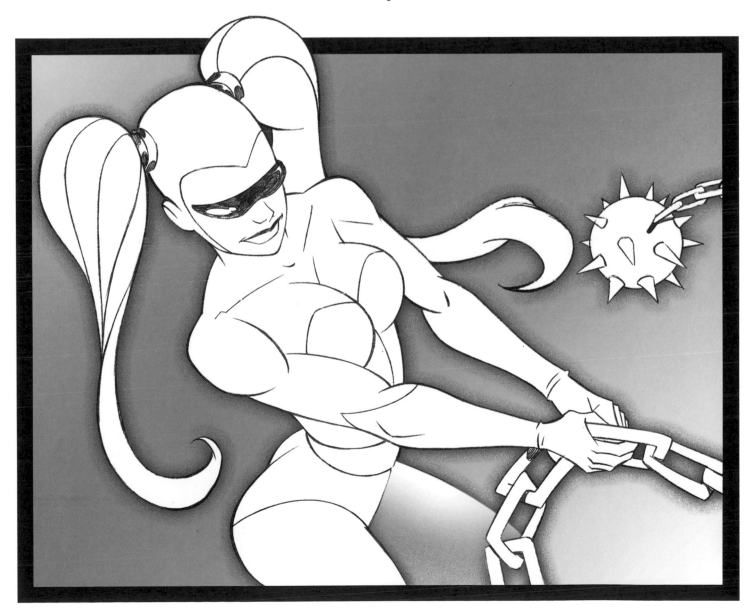

THE CHEST MUSCLES

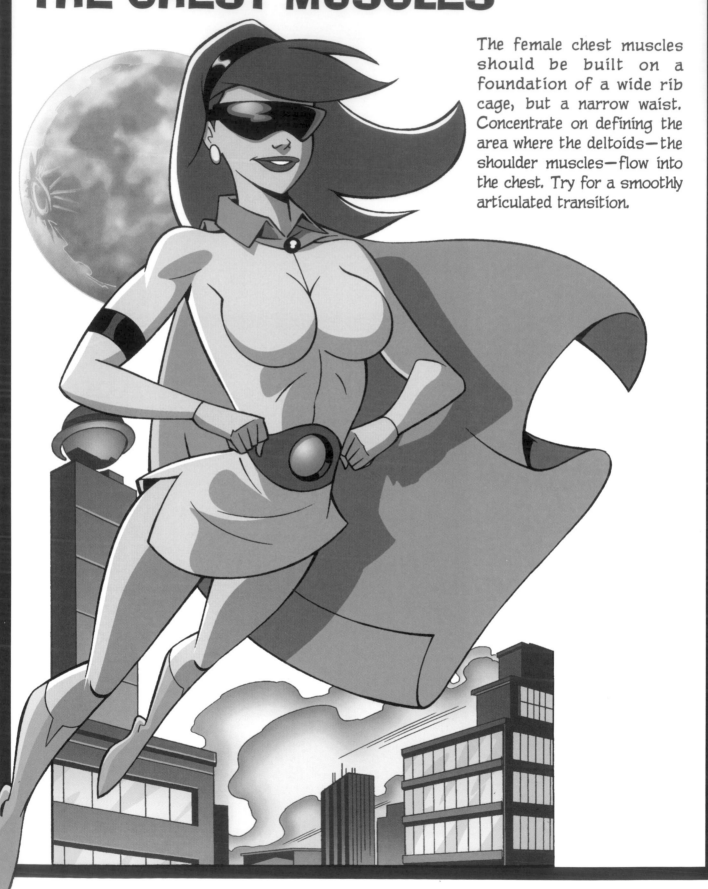

The female chest muscles should be built on a foundation of a wide rib cage, but a narrow waist. Concentrate on defining the area where the deltoids—the shoulder muscles—flow into the chest. Try for a smoothly articulated transition.

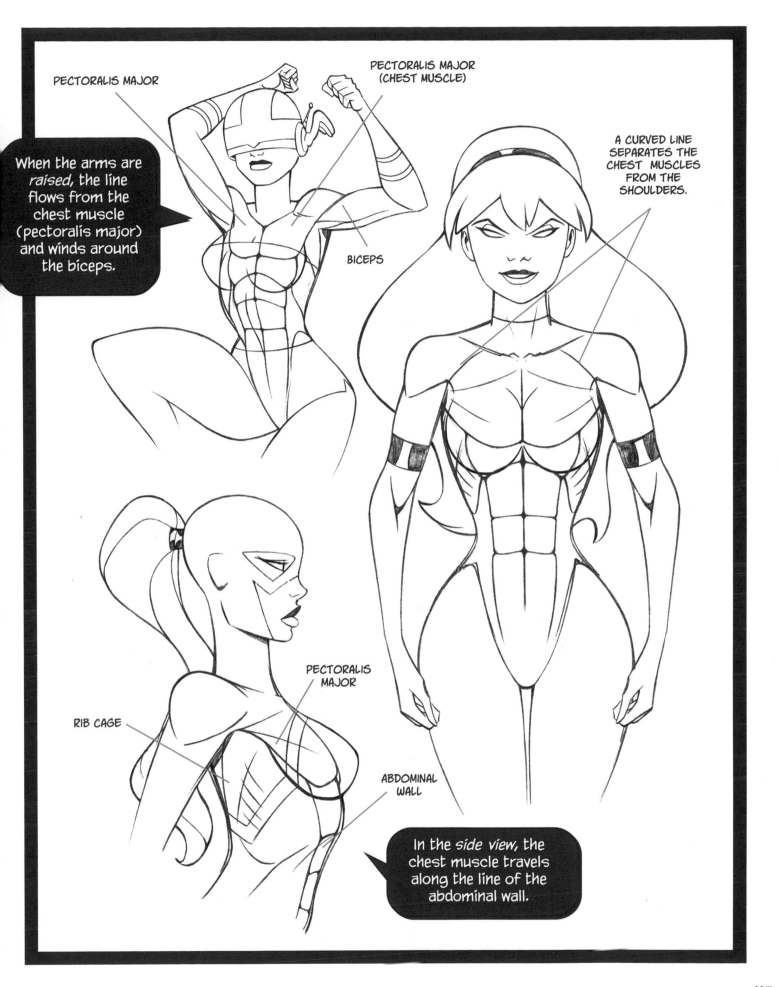

PECTORALIS MAJOR

PECTORALIS MAJOR
(CHEST MUSCLE)

A CURVED LINE
SEPARATES THE
CHEST MUSCLES
FROM THE
SHOULDERS.

When the arms are *raised*, the line flows from the chest muscle (pectoralis major) and winds around the biceps.

BICEPS

PECTORALIS MAJOR

RIB CAGE

ABDOMINAL WALL

In the *side view*, the chest muscle travels along the line of the abdominal wall.

115

ABS & RIB CAGE MUSCLES (DON'T OVERDO THEM ON FEMALE CHARACTERS!)

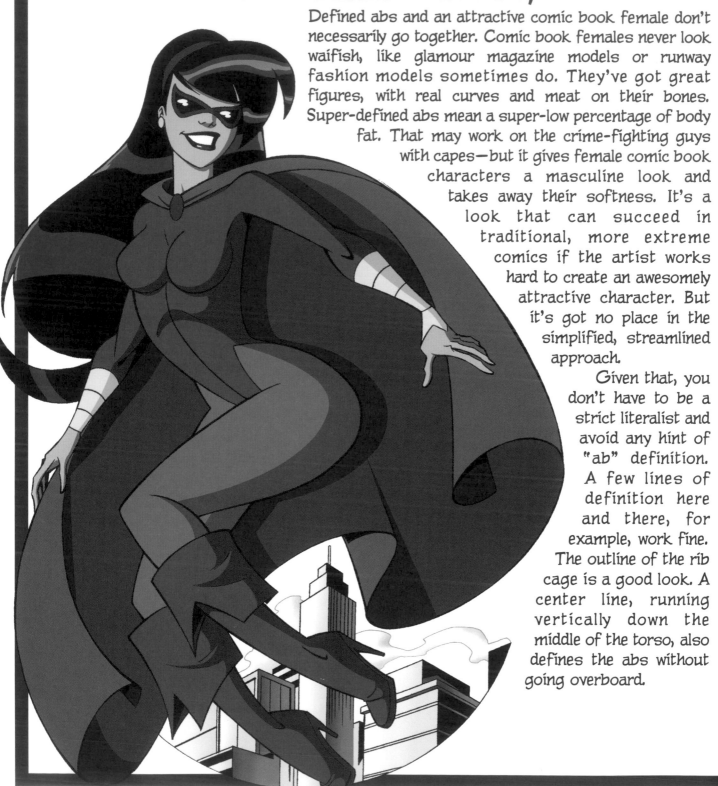

Defined abs and an attractive comic book female don't necessarily go together. Comic book females never look waifish, like glamour magazine models or runway fashion models sometimes do. They've got great figures, with real curves and meat on their bones. Super-defined abs mean a super-low percentage of body fat. That may work on the crime-fighting guys with capes—but it gives female comic book characters a masculine look and takes away their softness. It's a look that can succeed in traditional, more extreme comics if the artist works hard to create an awesomely attractive character. But it's got no place in the simplified, streamlined approach.

Given that, you don't have to be a strict literalist and avoid any hint of "ab" definition. A few lines of definition here and there, for example, work fine. The outline of the rib cage is a good look. A center line, running vertically down the middle of the torso, also defines the abs without going overboard.

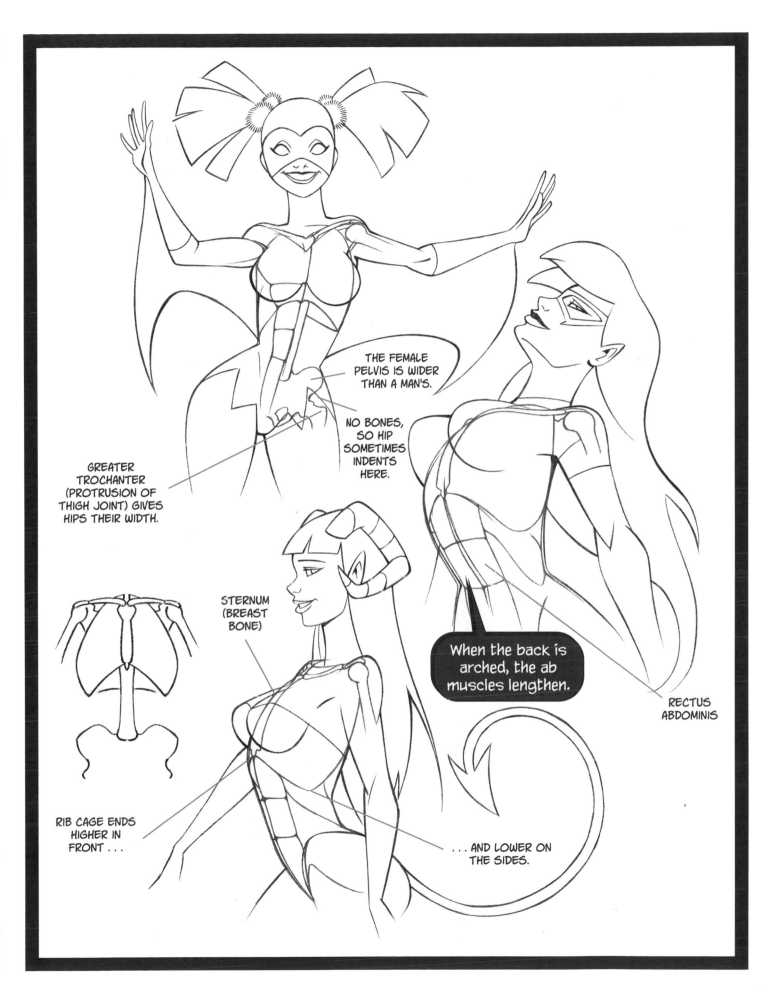

THE FEMALE PELVIS IS WIDER THAN A MAN'S.

NO BONES, SO HIP SOMETIMES INDENTS HERE.

GREATER TROCHANTER (PROTRUSION OF THIGH JOINT) GIVES HIPS THEIR WIDTH.

STERNUM (BREAST BONE)

When the back is arched, the ab muscles lengthen.

RECTUS ABDOMINIS

RIB CAGE ENDS HIGHER IN FRONT . . .

. . . AND LOWER ON THE SIDES.

THE SEXY NECK

Female characters' necks are long and slender, with just a hint of a trapezius muscle (the muscle that connects the neck to the shoulders) showing—never a set of built-up "traps" like on male heroes.

Unlike male characters, whose muscular necks widen out as they approach the collarbone, female characters have necks that travel straight down, keeping the look sleek.

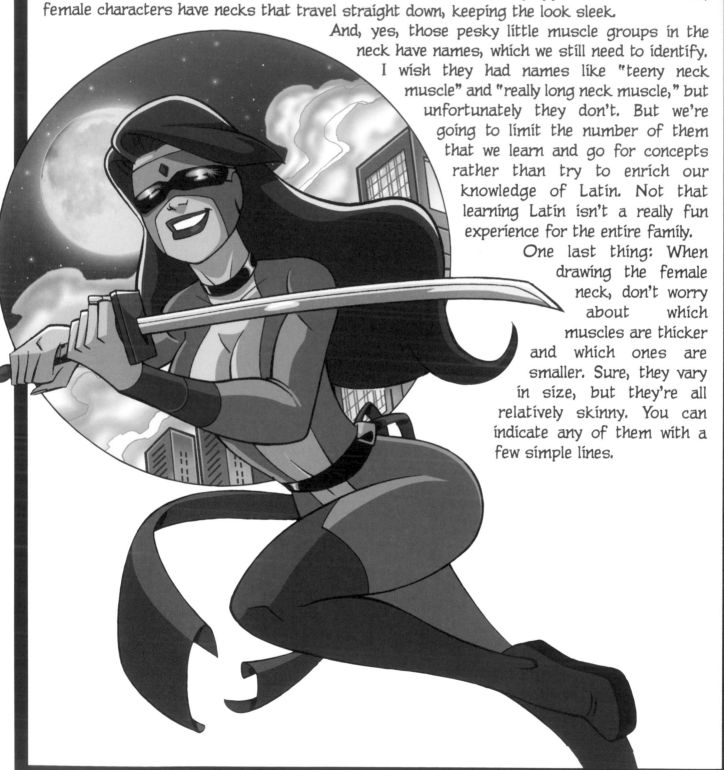

And, yes, those pesky little muscle groups in the neck have names, which we still need to identify. I wish they had names like "teeny neck muscle" and "really long neck muscle," but unfortunately they don't. But we're going to limit the number of them that we learn and go for concepts rather than try to enrich our knowledge of Latin. Not that learning Latin isn't a really fun experience for the entire family.

One last thing: When drawing the female neck, don't worry about which muscles are thicker and which ones are smaller. Sure, they vary in size, but they're all relatively skinny. You can indicate any of them with a few simple lines.

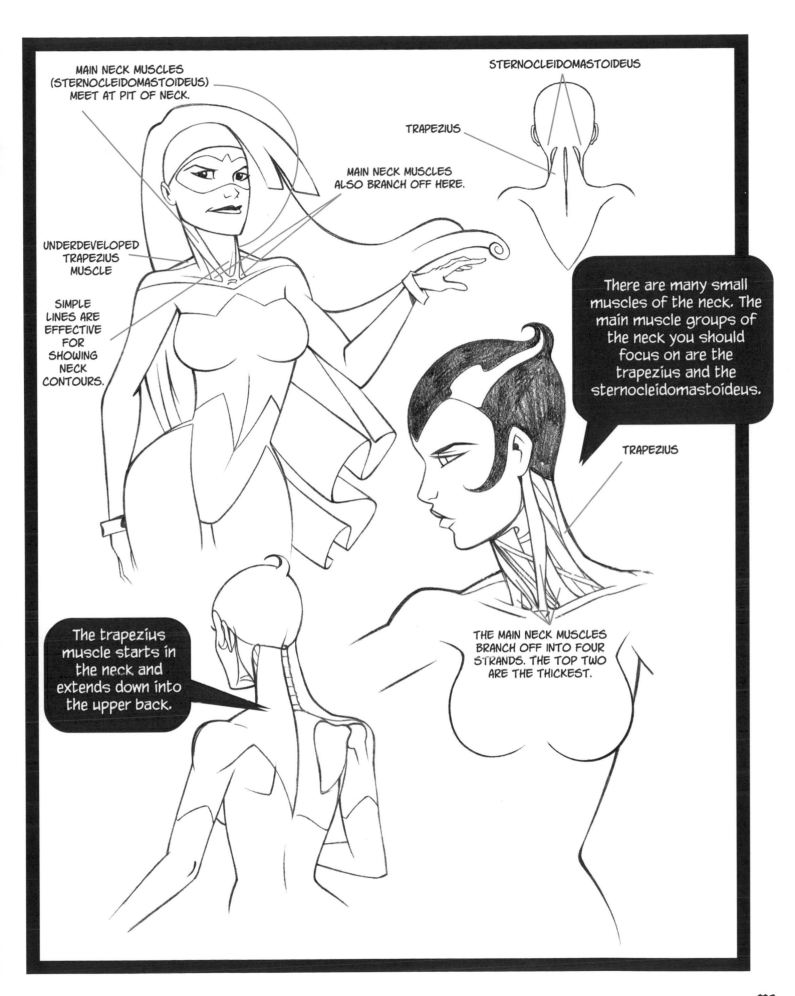

MAIN NECK MUSCLES (STERNOCLEIDOMASTOIDEUS) MEET AT PIT OF NECK.

STERNOCLEIDOMASTOIDEUS

TRAPEZIUS

MAIN NECK MUSCLES ALSO BRANCH OFF HERE.

UNDERDEVELOPED TRAPEZIUS MUSCLE

SIMPLE LINES ARE EFFECTIVE FOR SHOWING NECK CONTOURS.

There are many small muscles of the neck. The main muscle groups of the neck you should focus on are the trapezius and the sternocleidomastoideus.

TRAPEZIUS

The trapezius muscle starts in the neck and extends down into the upper back.

THE MAIN NECK MUSCLES BRANCH OFF INTO FOUR STRANDS. THE TOP TWO ARE THE THICKEST.

119

WELL-DEVELOPED SHOULDER MUSCLES

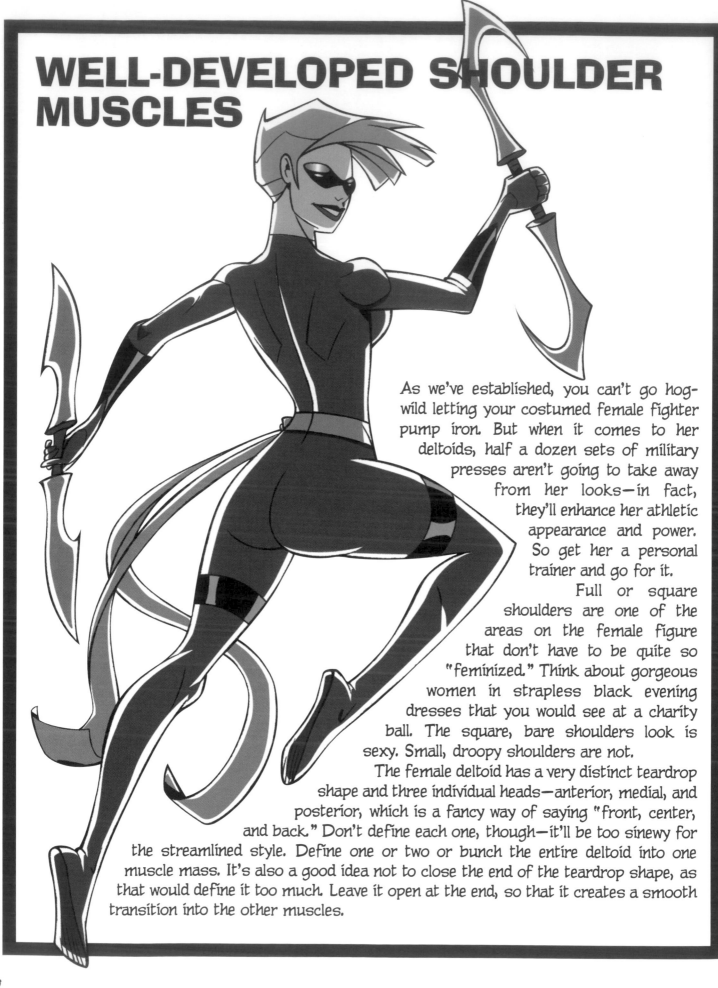

As we've established, you can't go hog-wild letting your costumed female fighter pump iron. But when it comes to her deltoids, half a dozen sets of military presses aren't going to take away from her looks—in fact, they'll enhance her athletic appearance and power. So get her a personal trainer and go for it.

Full or square shoulders are one of the areas on the female figure that don't have to be quite so "feminized." Think about gorgeous women in strapless black evening dresses that you would see at a charity ball. The square, bare shoulders look is sexy. Small, droopy shoulders are not.

The female deltoid has a very distinct teardrop shape and three individual heads—anterior, medial, and posterior, which is a fancy way of saying "front, center, and back." Don't define each one, though—it'll be too sinewy for the streamlined style. Define one or two or bunch the entire deltoid into one muscle mass. It's also a good idea not to close the end of the teardrop shape, as that would define it too much. Leave it open at the end, so that it creates a smooth transition into the other muscles.

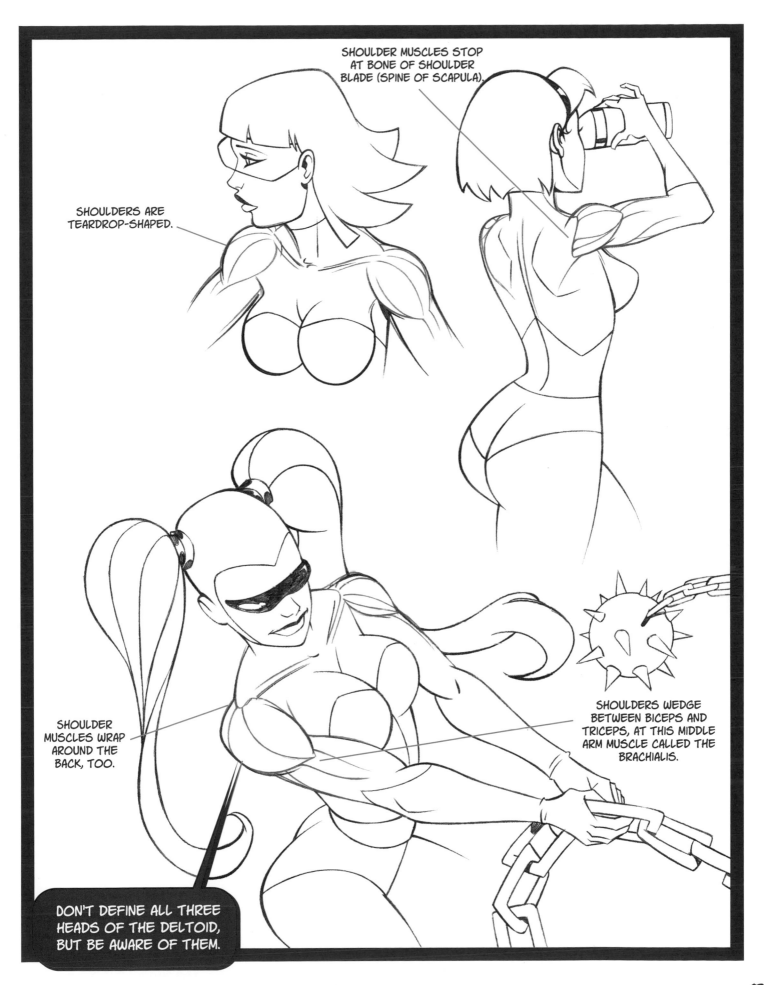

SHOULDER MUSCLES STOP AT BONE OF SHOULDER BLADE (SPINE OF SCAPULA).

SHOULDERS ARE TEARDROP-SHAPED.

SHOULDER MUSCLES WRAP AROUND THE BACK, TOO.

SHOULDERS WEDGE BETWEEN BICEPS AND TRICEPS, AT THIS MIDDLE ARM MUSCLE CALLED THE BRACHIALIS.

DON'T DEFINE ALL THREE HEADS OF THE DELTOID, BUT BE AWARE OF THEM.

THE BACK & THE "HOURGLASS" FIGURE

Let's look at the basic construction of the streamlined back. We'll use the waistline as the starting point. The waist is narrow. From there, the back widens to the outer edges of the shoulders. But it never—I repeat *never*—becomes broad on a female character. It stays relatively narrow. Below the waist, the hips quickly become wide, and the buttocks (gluteus medius and gluteus maximus muscles) are round and full. Combined with a small waist and narrow back, this is an attractive look.

When drawing this part of a female character, try to find a balance: You don't want a stringbean figure, but you don't want a huge amount of mass around the hips either. But full thighs and powerful glutes are a popular look in comics.

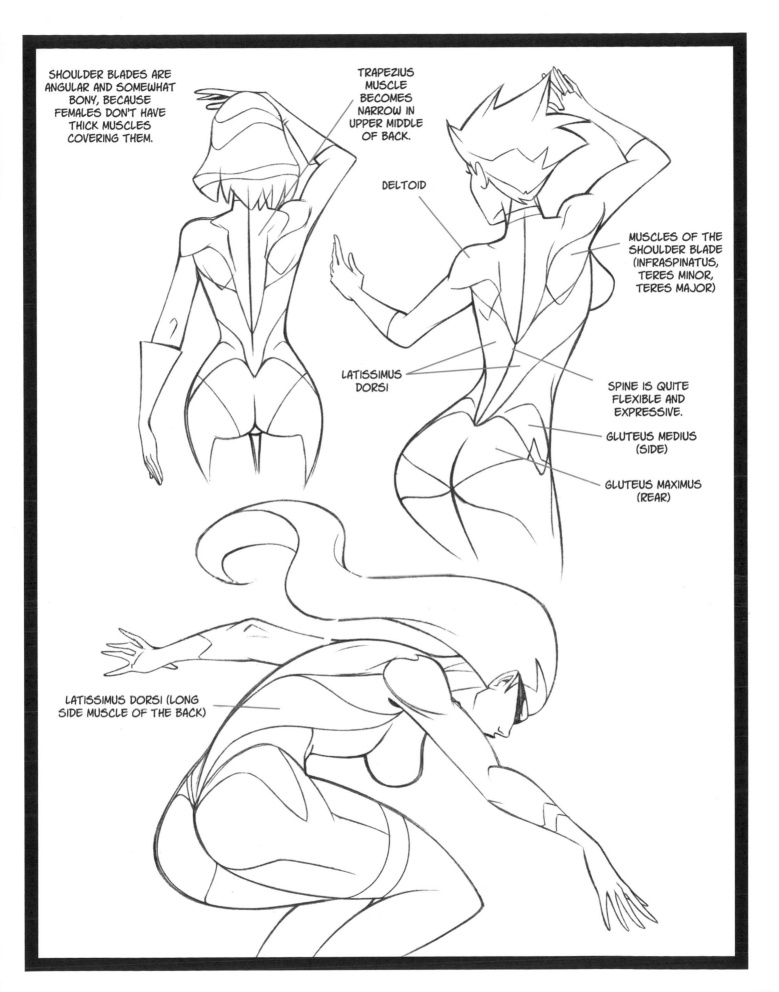

SHOULDER BLADES ARE ANGULAR AND SOMEWHAT BONY, BECAUSE FEMALES DON'T HAVE THICK MUSCLES COVERING THEM.

TRAPEZIUS MUSCLE BECOMES NARROW IN UPPER MIDDLE OF BACK.

DELTOID

MUSCLES OF THE SHOULDER BLADE (INFRASPINATUS, TERES MINOR, TERES MAJOR)

LATISSIMUS DORSI

SPINE IS QUITE FLEXIBLE AND EXPRESSIVE.

GLUTEUS MEDIUS (SIDE)

GLUTEUS MAXIMUS (REAR)

LATISSIMUS DORSI (LONG SIDE MUSCLE OF THE BACK)

123

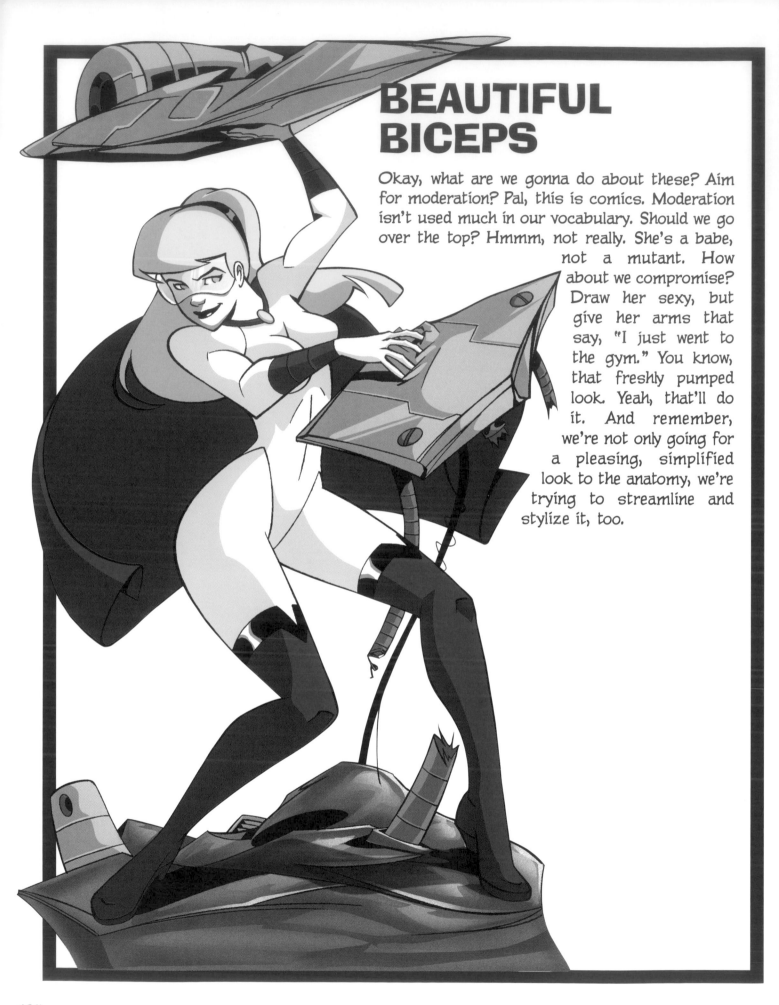

BEAUTIFUL BICEPS

Okay, what are we gonna do about these? Aim for moderation? Pal, this is comics. Moderation isn't used much in our vocabulary. Should we go over the top? Hmmm, not really. She's a babe, not a mutant. How about we compromise? Draw her sexy, but give her arms that say, "I just went to the gym." You know, that freshly pumped look. Yeah, that'll do it. And remember, we're not only going for a pleasing, simplified look to the anatomy, we're trying to streamline and stylize it, too.

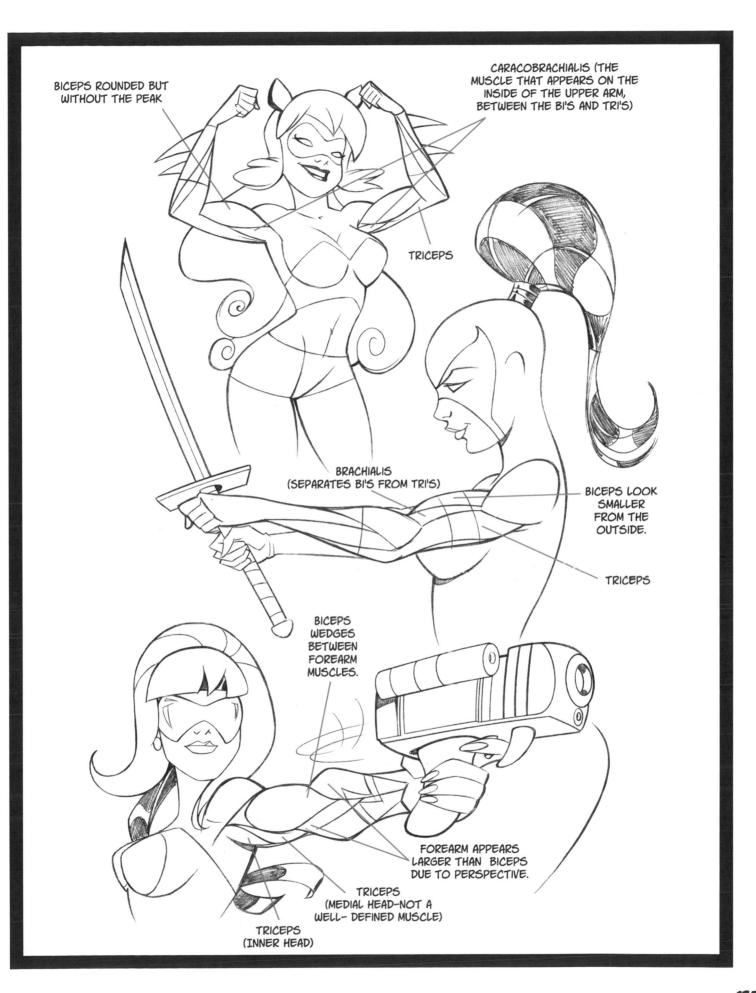

BICEPS ROUNDED BUT
WITHOUT THE PEAK

CARACOBRACHIALIS (THE
MUSCLE THAT APPEARS ON THE
INSIDE OF THE UPPER ARM,
BETWEEN THE BI'S AND TRI'S)

TRICEPS

BRACHIALIS
(SEPARATES BI'S FROM TRI'S)

BICEPS LOOK
SMALLER
FROM THE
OUTSIDE.

TRICEPS

BICEPS
WEDGES
BETWEEN
FOREARM
MUSCLES.

FOREARM APPEARS
LARGER THAN BICEPS
DUE TO PERSPECTIVE.

TRICEPS
(MEDIAL HEAD-NOT A
WELL- DEFINED MUSCLE)

TRICEPS
(INNER HEAD)

125

TANTALIZING TRICEPS

This particular arm muscle can be defined on the female but should not show any appreciable bulk. In drawing the semi-retro, cartoon-influenced action heroine, some guidelines apply. Whereas a male character's triceps can be effectively highlighted anytime the arm is flexed, the only time the female triceps require definition is when the arm is straightened, or locked. (Compare the triceps on the locked and unlocked arms of the figure below.) Also, the triceps never appears as pumped as the biceps.

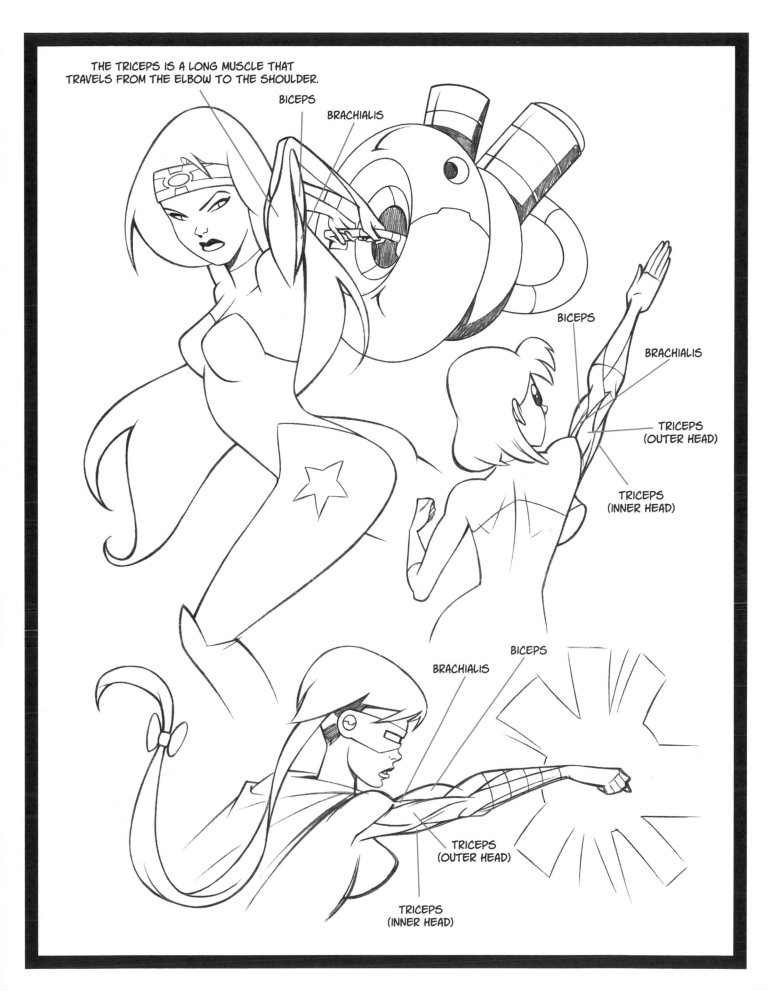

THE TRICEPS IS A LONG MUSCLE THAT TRAVELS FROM THE ELBOW TO THE SHOULDER.

BICEPS

BRACHIALIS

BICEPS

BRACHIALIS

TRICEPS (OUTER HEAD)

TRICEPS (INNER HEAD)

BRACHIALIS

BICEPS

TRICEPS (OUTER HEAD)

TRICEPS (INNER HEAD)

FIGHTING FOREARMS!

What did you assume? She was going to have scrawny forearms? That she sits in front of the computer all day, logging complaints that come into Human Resources? No, my friends, she is going to beat the tar out of bad guys. Pummel them. Stomp on them. Make them suffer. All in the name of justice!

When drawing the forearm, take special note of how the upper arm wedges into it. Also, the forearm's width near the elbow is greatly exaggerated.

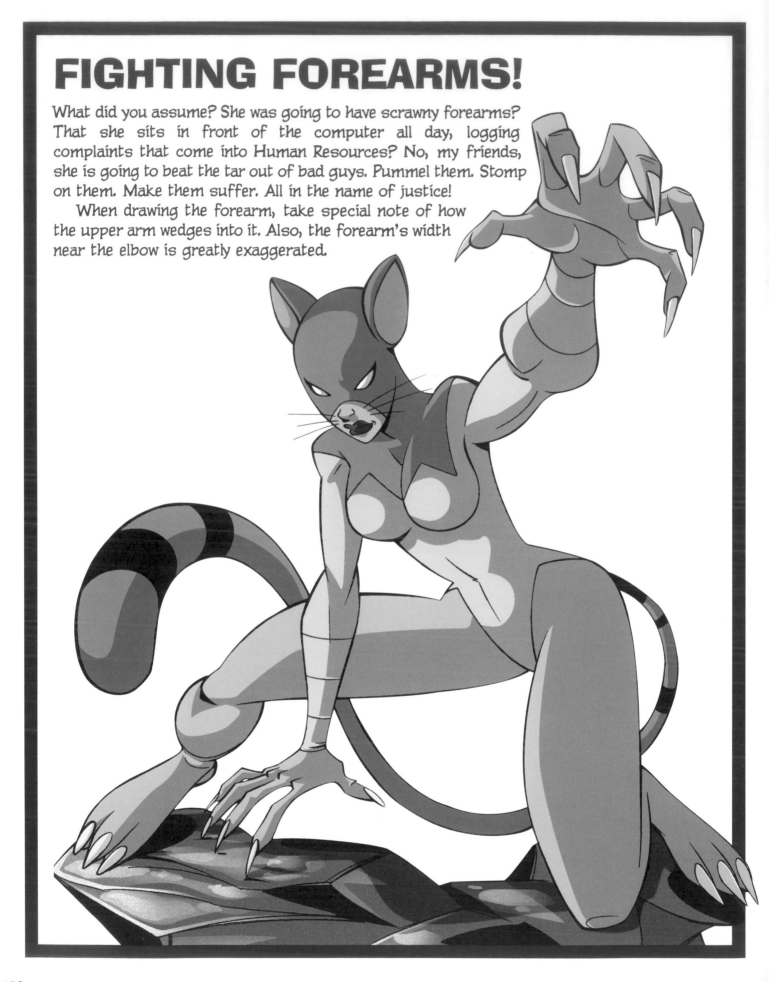

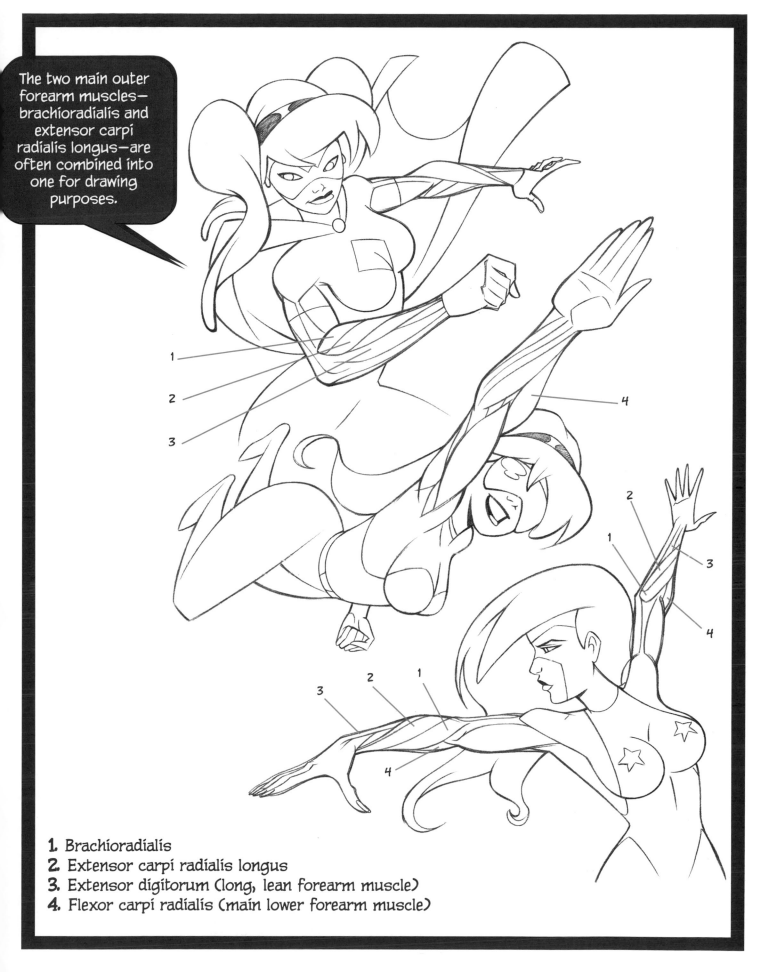

The two main outer forearm muscles—brachioradialis and extensor carpi radialis longus—are often combined into one for drawing purposes.

1. Brachioradialis
2. Extensor carpi radialis longus
3. Extensor digitorum (long, lean forearm muscle)
4. Flexor carpi radialis (main lower forearm muscle)

THE HIPS & PELVIS

Yeah, I know this chapter is about muscles, but in this case, it's the bones that you need to know about. This part's a little tricky. You wonder, "Can't I learn to draw without knowing about the pelvis?"

"No," I answer.

"Aw, come on," you say.

"No," I repeat.

"Will it be hard?"

"You're the one making it hard."

"You're making me feel like I'm in school!"

"Quiet, or you'll have to stand in the hallway."

The hips are important, because they serve several major functions:

- They support the weight of the spine

- They contain the largest ball-and socket joint in the body, the greater trochanter, which is the thick joint just above the thighbone (femur).

- They give the torso its depth, making it three-dimensional.

- They give width to the hips.

- They "frame" the abdominal wall.

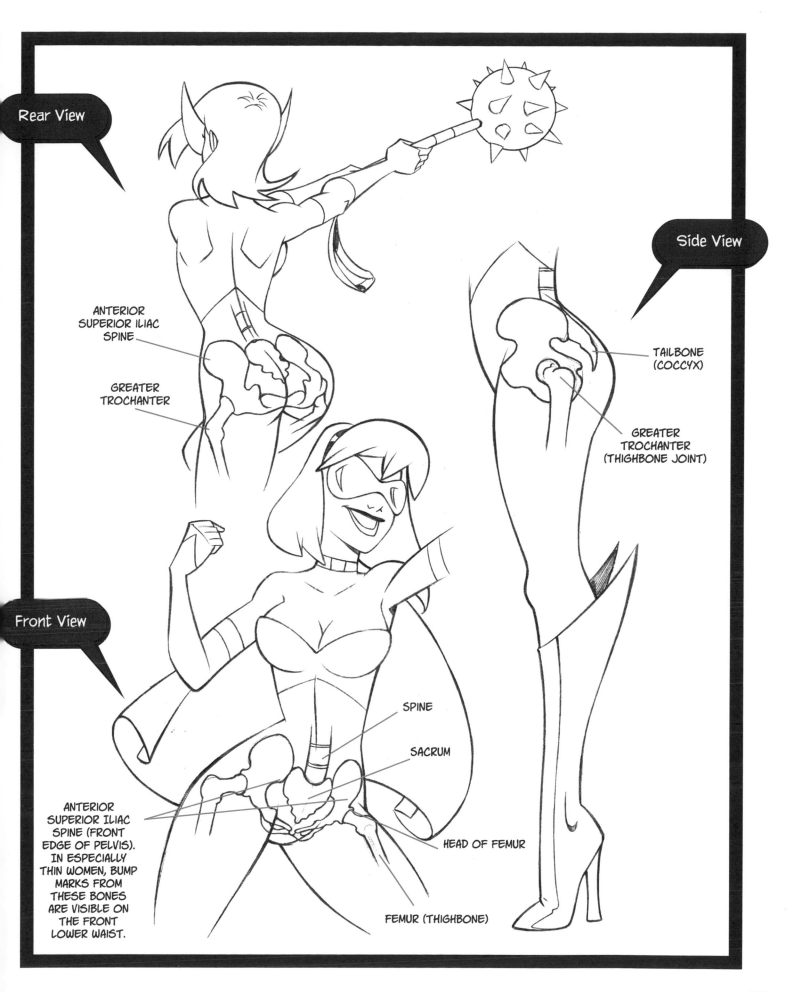

Rear View

Side View

Front View

ANTERIOR SUPERIOR ILIAC SPINE

GREATER TROCHANTER

TAILBONE (COCCYX)

GREATER TROCHANTER (THIGHBONE JOINT)

SPINE

SACRUM

ANTERIOR SUPERIOR ILIAC SPINE (FRONT EDGE OF PELVIS). IN ESPECIALLY THIN WOMEN, BUMP MARKS FROM THESE BONES ARE VISIBLE ON THE FRONT LOWER WAIST.

HEAD OF FEMUR

FEMUR (THIGHBONE)

HIGH-KICKIN' LEGS

This new streamlined action style of comics, with its semi-retro cartoon influence, puts an emphasis on adding a curved look to what would otherwise be a straight line. The legs are too long to go unaffected. Yes, comic fans, they're gonna have to bend under the weight of this style. And you know what, as strange as it may seem, warping the figure is not only a good look, but it's also going to look right. When you stay within the style you're drawing, breaking the rules sets up its own type of logic.

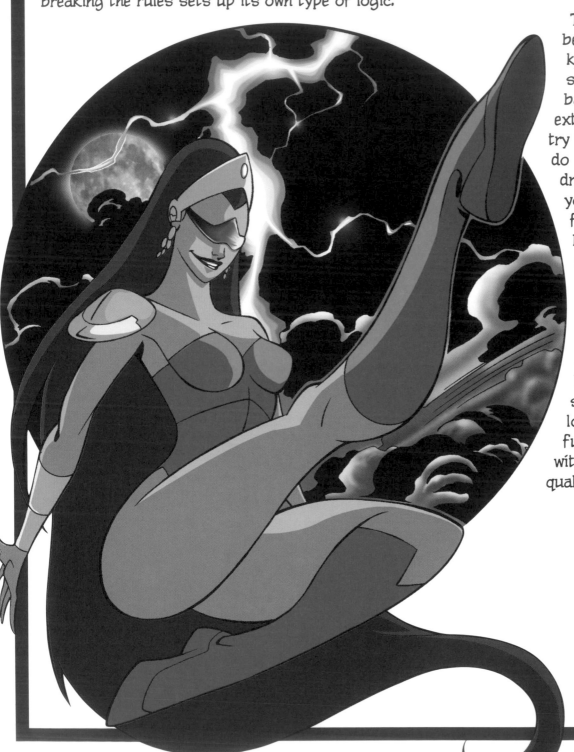

Take a look at this beautiful fighter's kicking leg. Ever see a calf bend backward to that extent? Please, don't try this at home. But do try it on your drawing pad, with your #2 pencil. The fluid line that begins at the waist and does a "reverse curve" up to the toe is very pleasing to the eye. Push the curviness of the legs, but don't go so far that they look rubbery. A full, shapely look with an elastic line quality is the ideal.

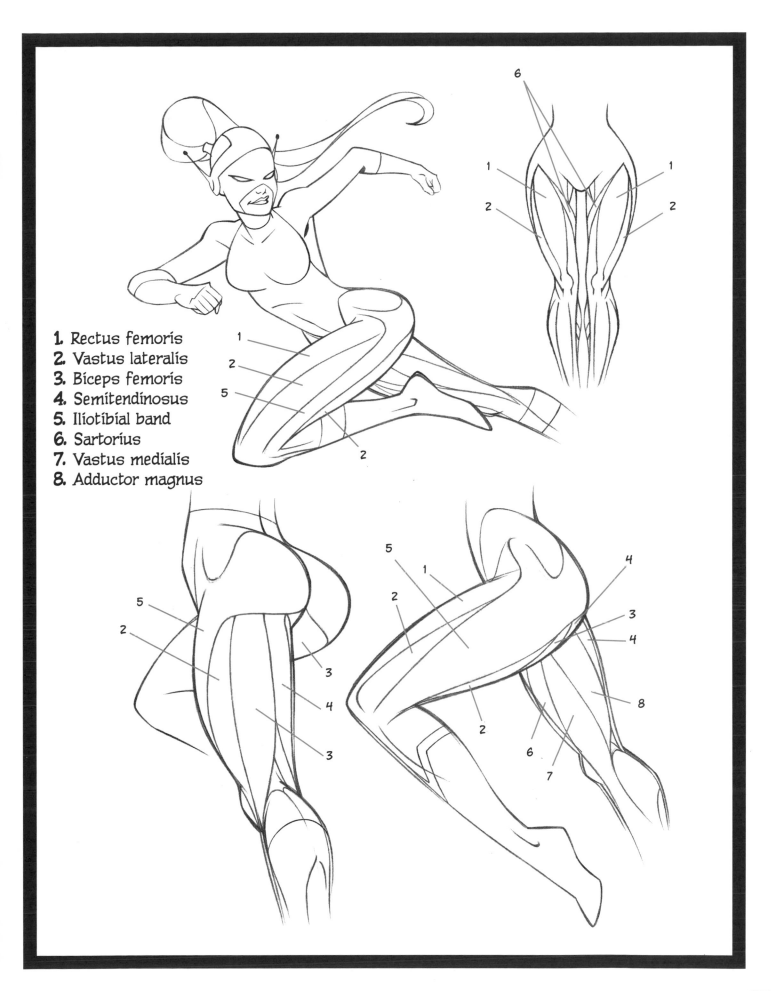

1. Rectus femoris
2. Vastus lateralis
3. Biceps femoris
4. Semitendinosus
5. Iliotibial band
6. Sartorius
7. Vastus medialis
8. Adductor magnus

SHAPELY CALF MUSCLES

Designer boots for the action-hero set are made to show off shapely calves to perfection. And because these boots are skintight and flexible, you can see every contour. Therefore, you still need to mold the muscle.

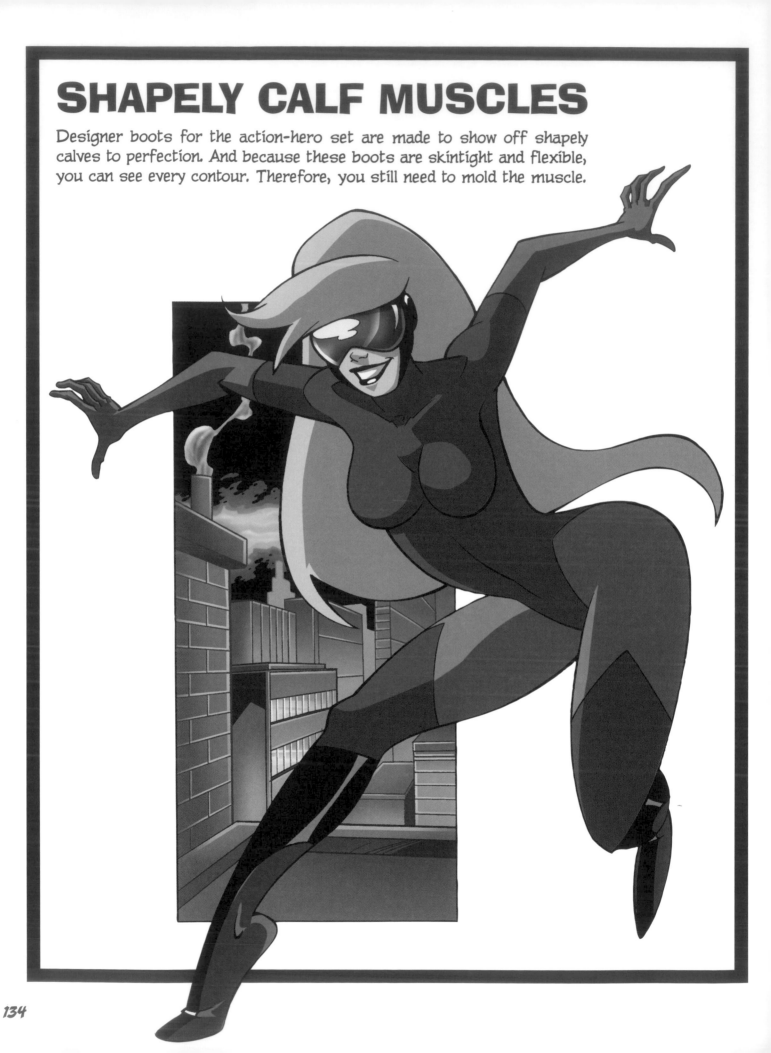

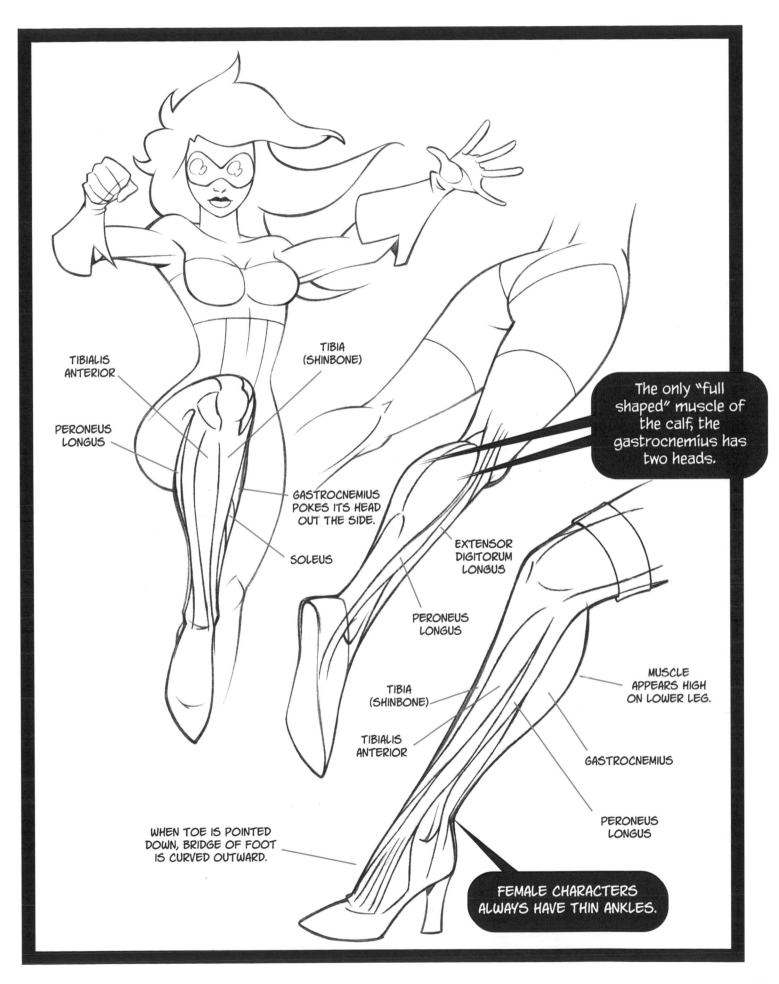

TIBIALIS ANTERIOR

PERONEUS LONGUS

TIBIA (SHINBONE)

GASTROCNEMIUS POKES ITS HEAD OUT THE SIDE.

SOLEUS

The only "full shaped" muscle of the calf, the gastrocnemius has two heads.

EXTENSOR DIGITORUM LONGUS

PERONEUS LONGUS

TIBIA (SHINBONE)

TIBIALIS ANTERIOR

WHEN TOE IS POINTED DOWN, BRIDGE OF FOOT IS CURVED OUTWARD.

MUSCLE APPEARS HIGH ON LOWER LEG.

GASTROCNEMIUS

PERONEUS LONGUS

FEMALE CHARACTERS ALWAYS HAVE THIN ANKLES.

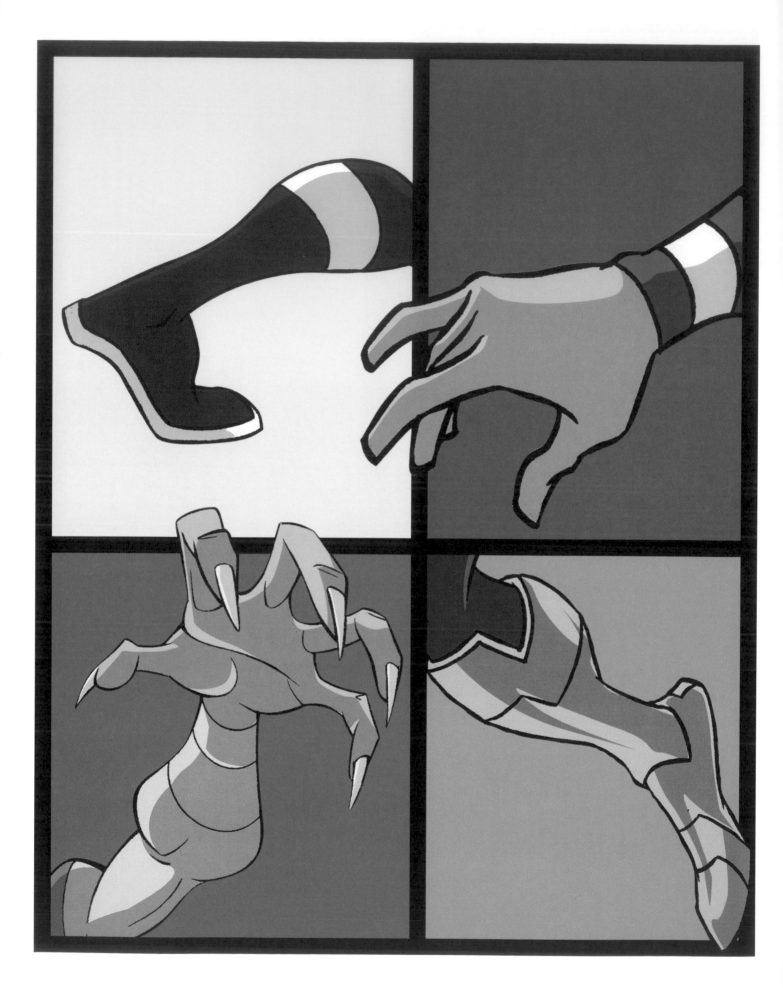

SIMPLIFYING HANDS & FEET

If you study every bone of the hand and foot, you'll drive yourself crazy—although you'll be the life of the party at a gathering of orthopedic surgeons. We can easily simplify the process of drawing hands and feet. All we need are a few basic proportions to compare to our drawings. Then we can adjust our image if it goes off course. It's an incredibly useful process. For those of you who are yearning for something a lot more complicated, feel free to sit this one out.

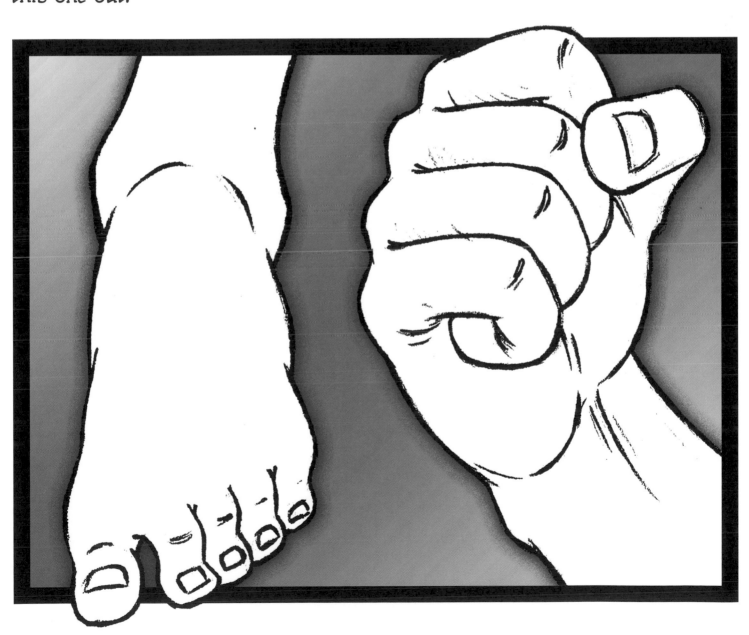

DRAWING HANDS: THE BASICS

Ouch! Drawing hands has given most artists a headache at least once in their careers. There's just a lot going on in a very small space. Joints, bones, bends, creases, nails. Heck, why do you think so many action heroes wear gloves?

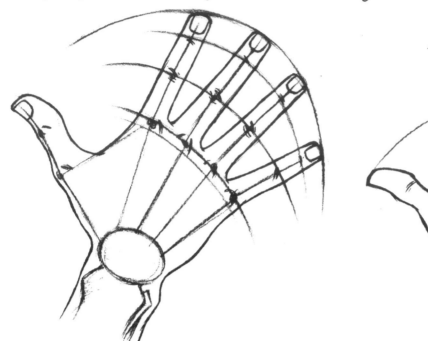

Back View
When spread apart, the fingertips can be sketched along an arched guideline. How simple is that? The knuckles (all three sets of them) are also drawn along arched guidelines.

Palm Side
The index finger and ring finger can be drawn at the same level. Now, some people's ring fingers are a touch taller, but that doesn't matter. This is a clean look.

THE KNUCKLES AT THE BASE OF THE FINGERS CAUSE A SHIFT IN PLANES.

LAST JOINT OF THUMB

Side View (Thumb Near)
The first joints of the fingers are at approximately the same location as the last joint of the thumb.

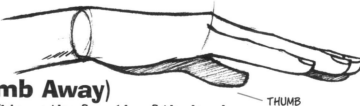

Side View (Thumb Away)
The thumb should be visible on the far side of the hand. Draw the fingers overlapping so the hand won't look flat.

THUMB

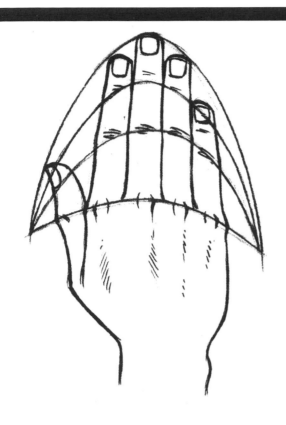

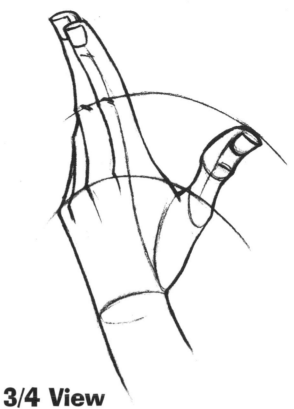

Fingers Closed

With the fingers closed together, the sketch lines take on a much higher arch.

3/4 View

Even in more complex hand gestures, you can use sketch lines to align the arches of the knuckles.

Male Hands

Female Hands

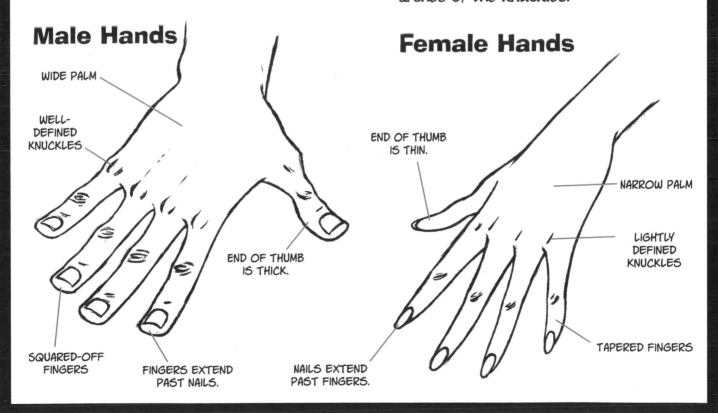

WIDE PALM

WELL-DEFINED KNUCKLES

END OF THUMB IS THICK.

SQUARED-OFF FINGERS

FINGERS EXTEND PAST NAILS.

END OF THUMB IS THIN.

NARROW PALM

LIGHTLY DEFINED KNUCKLES

NAILS EXTEND PAST FINGERS.

TAPERED FINGERS

COMIC BOOK HAND POSES

In comics, hands are as expressive as mouths, and require a lot less flossing. In reality, fingers aren't as wildly stretchable and flexible as they appear here. But nothing is ordinary in comics. In comics, "Oh my" is "Oh my gosh!!"—and that translates into the hand gestures. Here's a menu of comic book hand poses for you to try.

Male Hand Poses

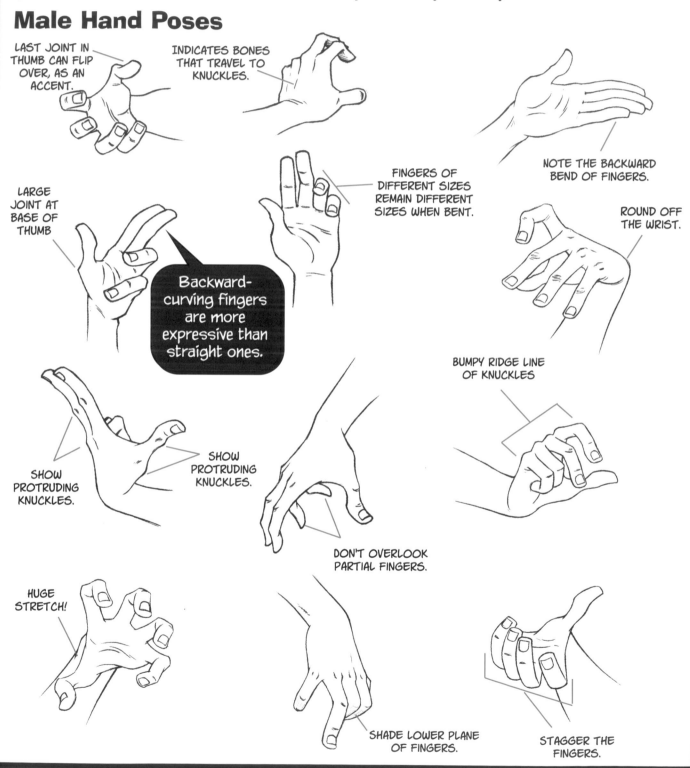

LAST JOINT IN THUMB CAN FLIP OVER, AS AN ACCENT.

INDICATES BONES THAT TRAVEL TO KNUCKLES.

NOTE THE BACKWARD BEND OF FINGERS.

LARGE JOINT AT BASE OF THUMB

FINGERS OF DIFFERENT SIZES REMAIN DIFFERENT SIZES WHEN BENT.

ROUND OFF THE WRIST.

Backward-curving fingers are more expressive than straight ones.

BUMPY RIDGE LINE OF KNUCKLES

SHOW PROTRUDING KNUCKLES.

SHOW PROTRUDING KNUCKLES.

DON'T OVERLOOK PARTIAL FINGERS.

HUGE STRETCH!

SHADE LOWER PLANE OF FINGERS.

STAGGER THE FINGERS.

Fist Poses

Don't duck this part! You need to know it. But let's break it down to make it simple. The only part that's challenging is how the thumb and index finger curl up. Everything else about drawing the fist is a cakewalk, so focus on the trouble spots and you won't get overwhelmed.

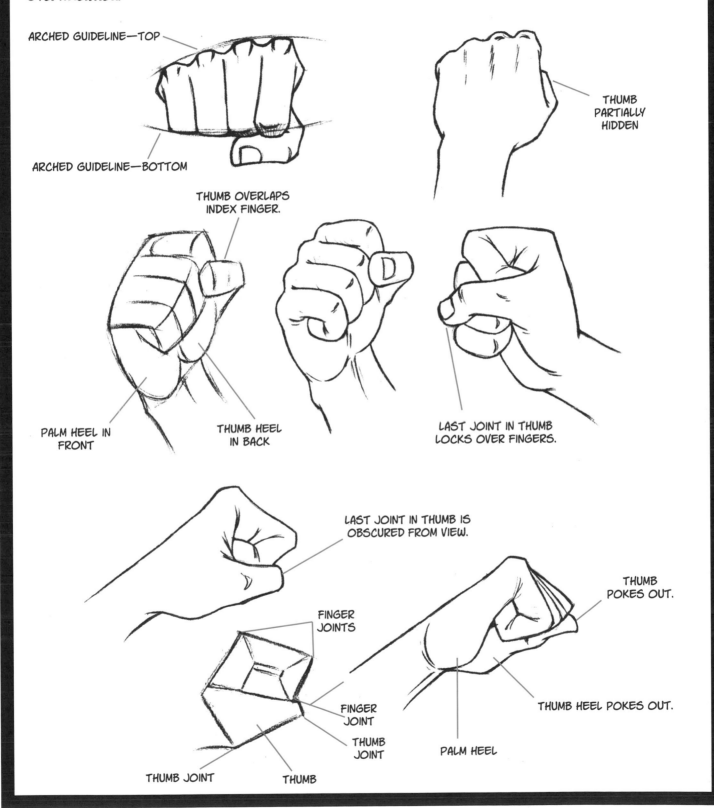

ARCHED GUIDELINE—TOP

ARCHED GUIDELINE—BOTTOM

THUMB PARTIALLY HIDDEN

THUMB OVERLAPS INDEX FINGER.

PALM HEEL IN FRONT

THUMB HEEL IN BACK

LAST JOINT IN THUMB LOCKS OVER FINGERS.

LAST JOINT IN THUMB IS OBSCURED FROM VIEW.

THUMB POKES OUT.

FINGER JOINTS

FINGER JOINT

THUMB JOINT

THUMB JOINT

THUMB

THUMB HEEL POKES OUT.

PALM HEEL

Female Hand Poses

Even if your female hero can pulverize bad guys with ax kicks, she still needs gracefully expressive hand gestures.

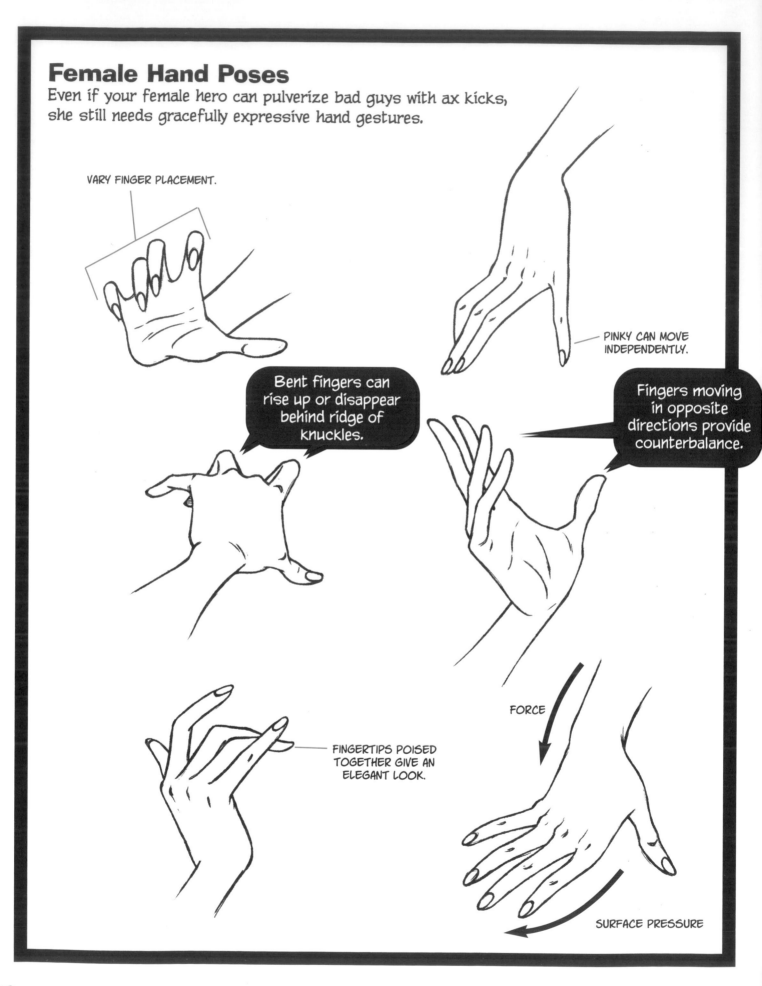

VARY FINGER PLACEMENT.

PINKY CAN MOVE INDEPENDENTLY.

Bent fingers can rise up or disappear behind ridge of knuckles.

Fingers moving in opposite directions provide counterbalance.

FINGERTIPS POISED TOGETHER GIVE AN ELEGANT LOOK.

FORCE

SURFACE PRESSURE

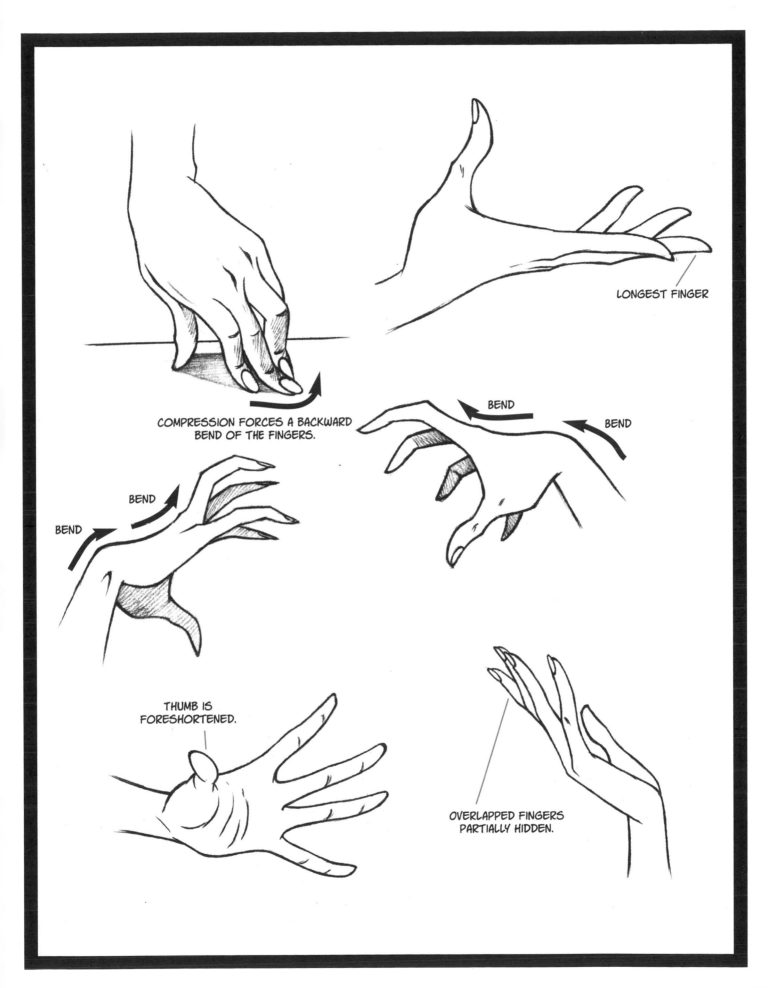

COMPRESSION FORCES A BACKWARD
BEND OF THE FINGERS.

LONGEST FINGER

BEND

BEND

BEND

BEND

THUMB IS
FORESHORTENED.

OVERLAPPED FINGERS
PARTIALLY HIDDEN.

143

ANATOMY OF THE FOOT

One might assume that the foot is difficult to draw, but compared to the hand, it's a snap. With the hand, you've got finger and thumb placement to worry about, but the toes aren't going anywhere. You draw them in a row, single file. And we can reduce the ankle to a simple problem of deciding which side is higher up on the leg, the inner ankle or outer ankle.

It's drawing the ball of the foot, the arch, and the heel that poses the challenge. This page is filled with hints designed to make that challenge much, much easier.

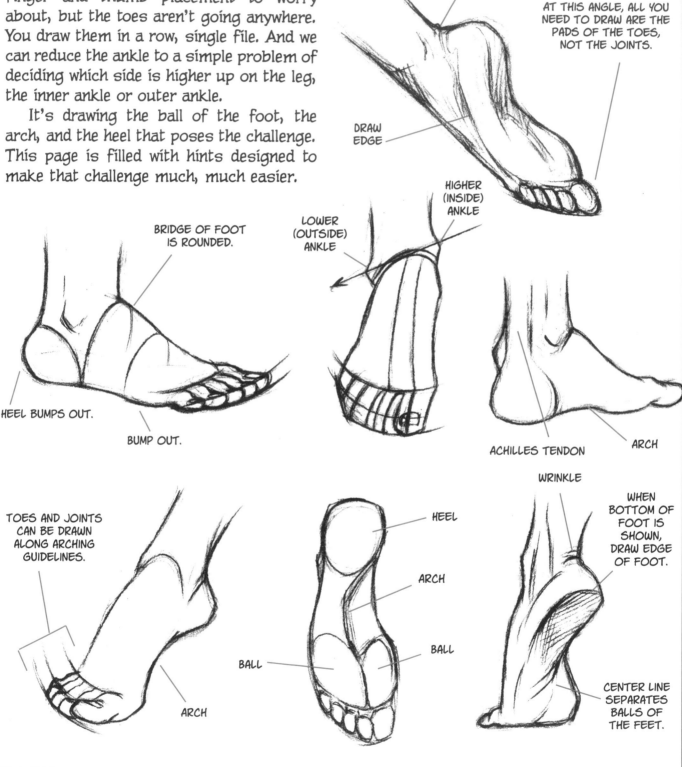

SMALL WRINKLE ABOVE HEEL

AT THIS ANGLE, ALL YOU NEED TO DRAW ARE THE PADS OF THE TOES, NOT THE JOINTS.

DRAW EDGE

BRIDGE OF FOOT IS ROUNDED.

HEEL BUMPS OUT.

BUMP OUT.

LOWER (OUTSIDE) ANKLE

HIGHER (INSIDE) ANKLE

ACHILLES TENDON

ARCH

TOES AND JOINTS CAN BE DRAWN ALONG ARCHING GUIDELINES.

ARCH

HEEL

ARCH

BALL

BALL

BALL

WRINKLE

WHEN BOTTOM OF FOOT IS SHOWN, DRAW EDGE OF FOOT.

CENTER LINE SEPARATES BALLS OF THE FEET.

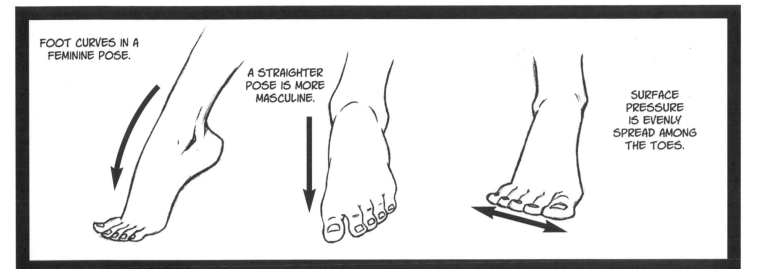

FOOT CURVES IN A FEMININE POSE.

A STRAIGHTER POSE IS MORE MASCULINE.

SURFACE PRESSURE IS EVENLY SPREAD AMONG THE TOES.

The Super Bootery

You now know how to draw the foot, but superheroes don't always run around barefoot, so let's take a look at some comic book footwear.

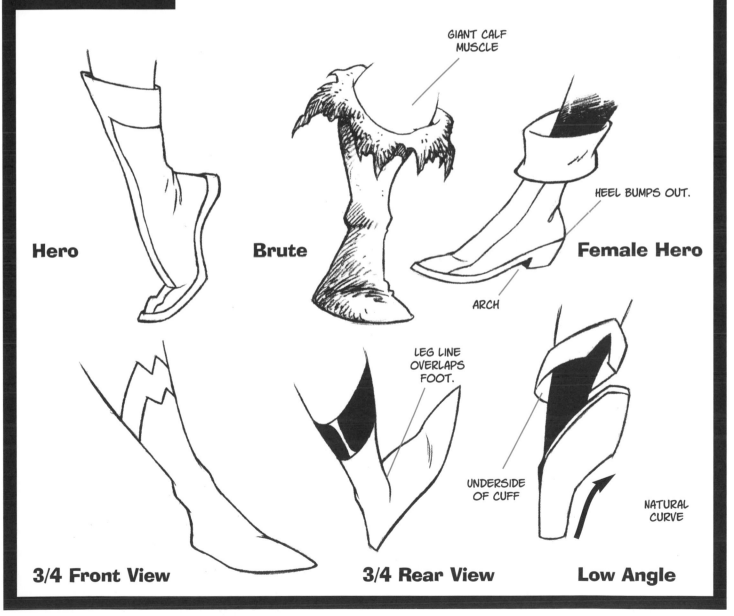

Hero

Brute

GIANT CALF MUSCLE

HEEL BUMPS OUT.

Female Hero

ARCH

3/4 Front View

LEG LINE OVERLAPS FOOT.

3/4 Rear View

UNDERSIDE OF CUFF

NATURAL CURVE

Low Angle

FORCED PERSPECTIVE ON THE BODY

Traditional drawing classes employ the principles of perspective, which have a subtle impact on the way we see the human figure. In comic books, perspective is right in your face. When your character is severely foreshortened, less of his or her body is visible. Therefore, it's important that what you *do* see helps the reader quickly grasp the gist of the pose. We're going to use what we've learned about anatomy to construct poses that will give the reader a jolt of perspective.

CLASSIC FLYING POSE: CHEST IN FOREGROUND

When drawing a character flying in the direction of your reader, try giving him a bit of an angle. Tilt the axis of the chest a bit and let him go off to one side just a little. It's more interesting than having him fly in a straight line.

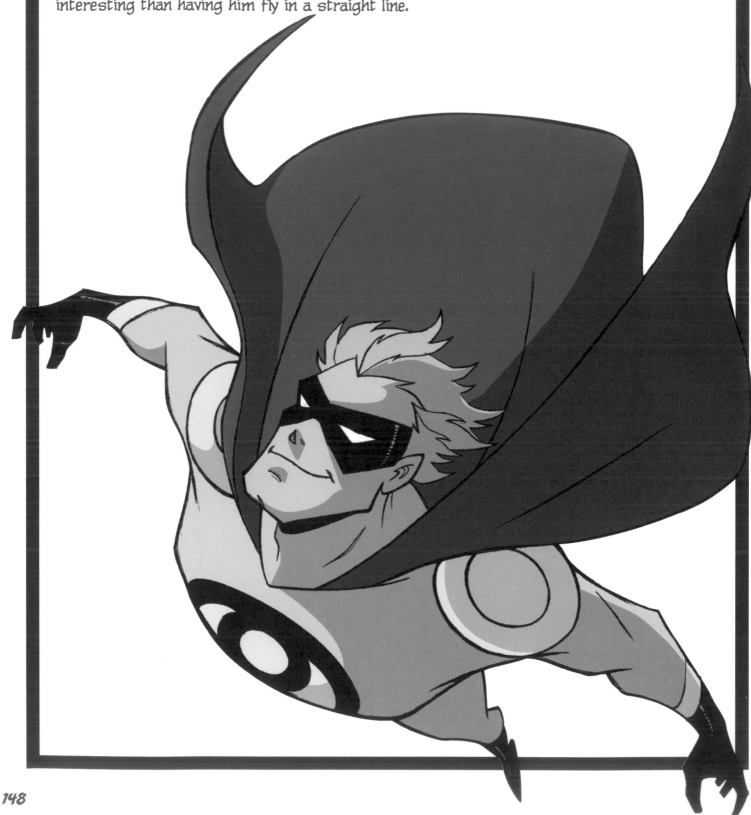

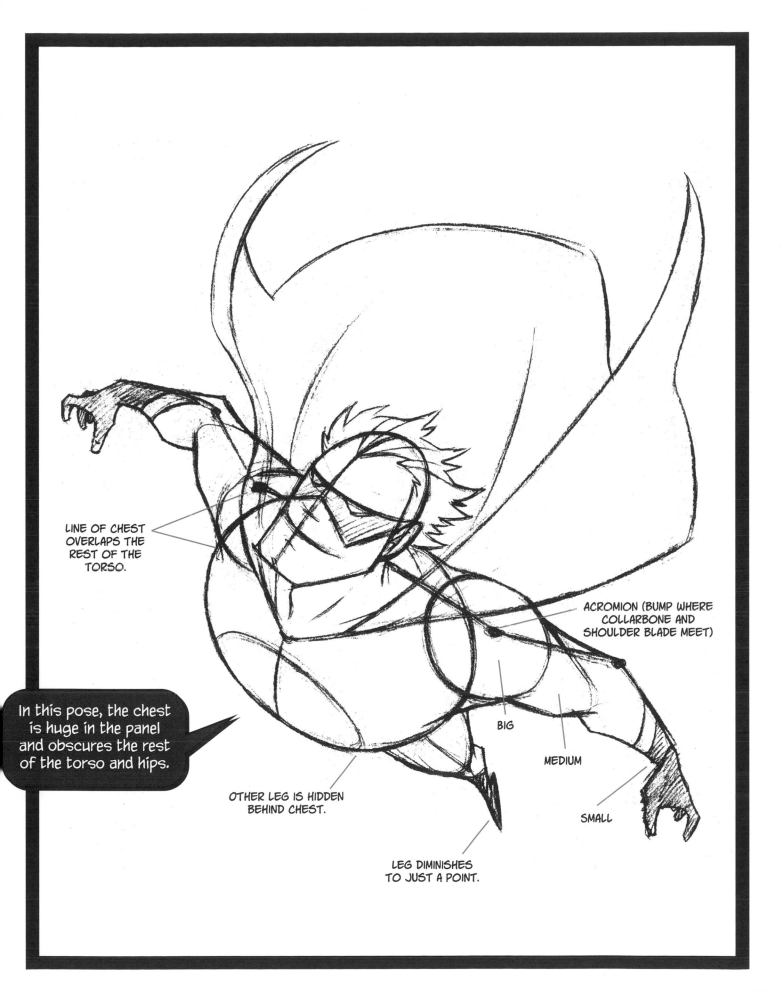

LINE OF CHEST OVERLAPS THE REST OF THE TORSO.

ACROMION (BUMP WHERE COLLARBONE AND SHOULDER BLADE MEET)

In this pose, the chest is huge in the panel and obscures the rest of the torso and hips.

BIG

MEDIUM

OTHER LEG IS HIDDEN BEHIND CHEST.

SMALL

LEG DIMINISHES TO JUST A POINT.

CAPED GUY OUT FOR JUSTICE: HAND IN FOREGROUND

You've seen this popular pose before, and I guarantee you'll see it again. It's the splash page, the cover shot. He's coming after you, and he won't stop until you give him his bicycle back!

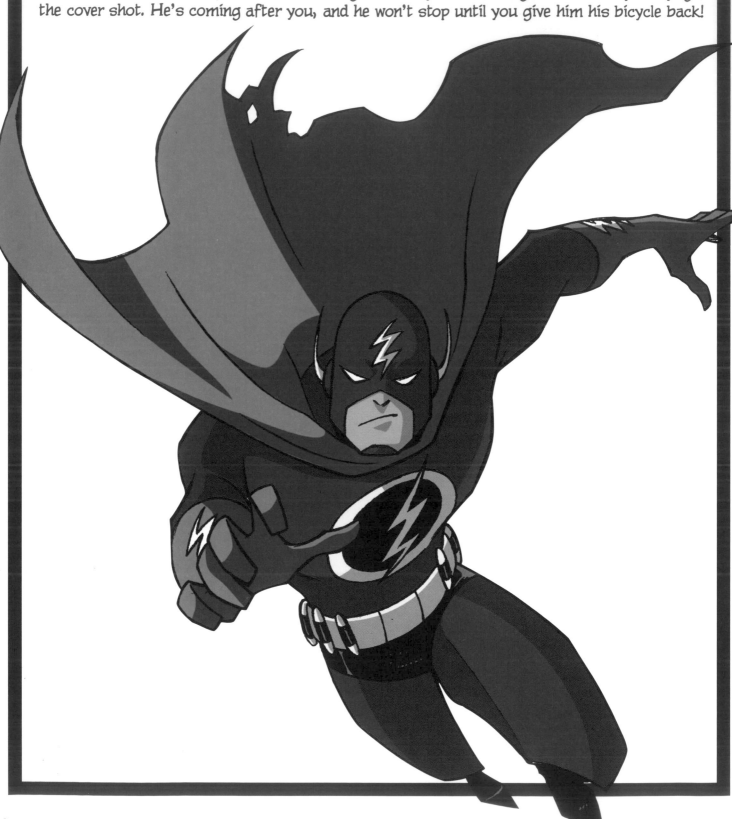

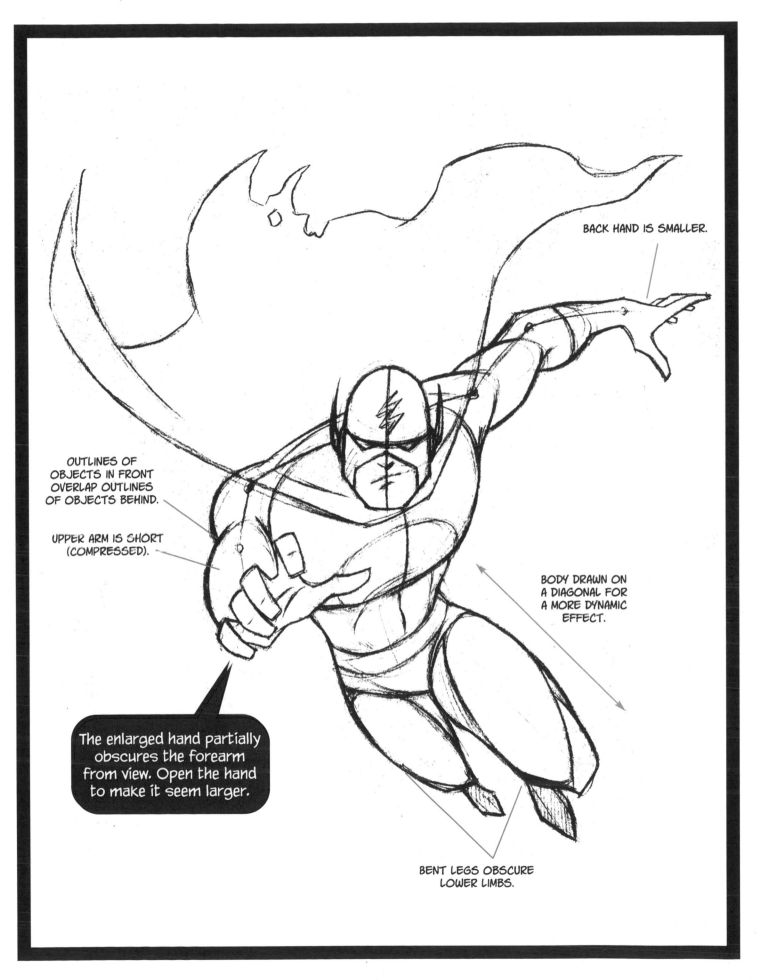

BACK HAND IS SMALLER.

OUTLINES OF OBJECTS IN FRONT OVERLAP OUTLINES OF OBJECTS BEHIND.

UPPER ARM IS SHORT (COMPRESSED).

BODY DRAWN ON A DIAGONAL FOR A MORE DYNAMIC EFFECT.

The enlarged hand partially obscures the forearm from view. Open the hand to make it seem larger.

BENT LEGS OBSCURE LOWER LIMBS.

TWIST & TURN: FOREARM IN FOREGROUND

Comic poses don't always have to have a clear purpose in order to be dynamic. What is this fighter doing? Heck if I know. But it sure looks cool! And I'd get out of her way while she's doing it, if I were you. The twisting body pose is a commonly used action position. But you've got to be careful. You want your character to be energetic, intense, and nimble, but if you overdo it, you'll wind up with an action hero who looks klutzy, uncoordinated, and accident-prone.

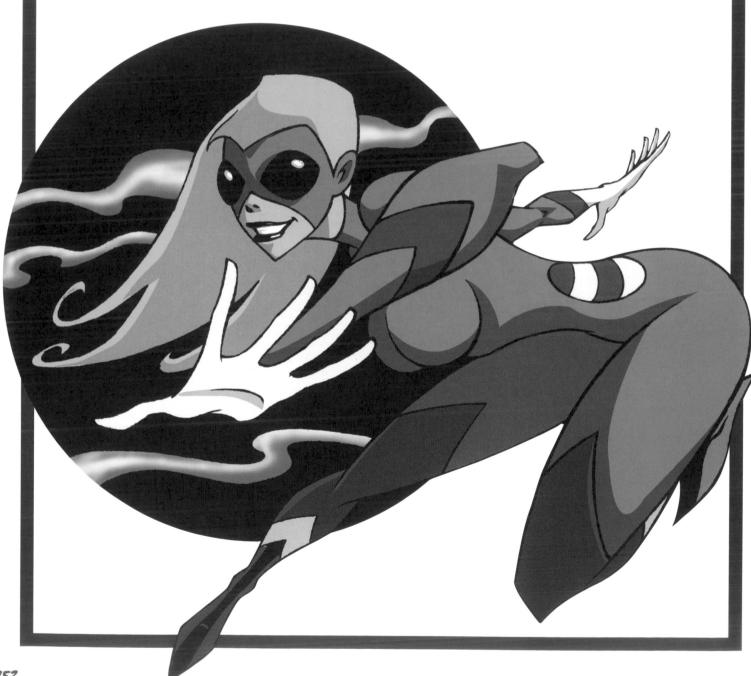

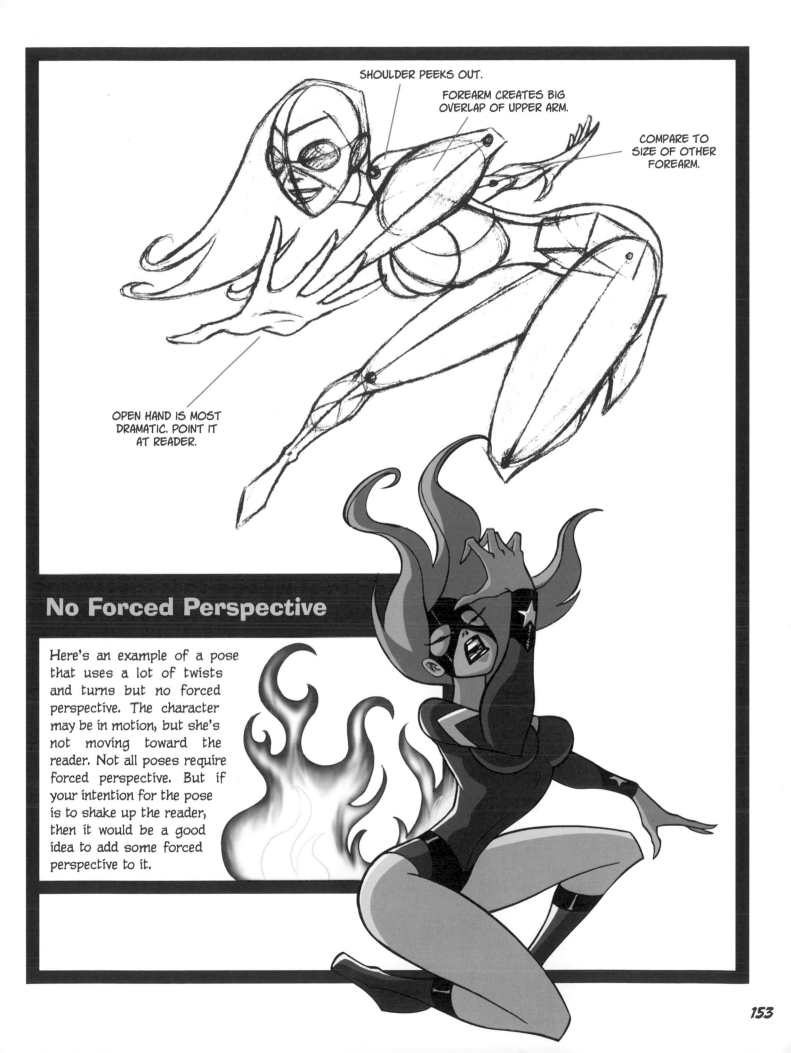

SHOULDER PEEKS OUT.

FOREARM CREATES BIG OVERLAP OF UPPER ARM.

COMPARE TO SIZE OF OTHER FOREARM.

OPEN HAND IS MOST DRAMATIC. POINT IT AT READER.

No Forced Perspective

Here's an example of a pose that uses a lot of twists and turns but no forced perspective. The character may be in motion, but she's not moving toward the reader. Not all poses require forced perspective. But if your intention for the pose is to shake up the reader, then it would be a good idea to add some forced perspective to it.

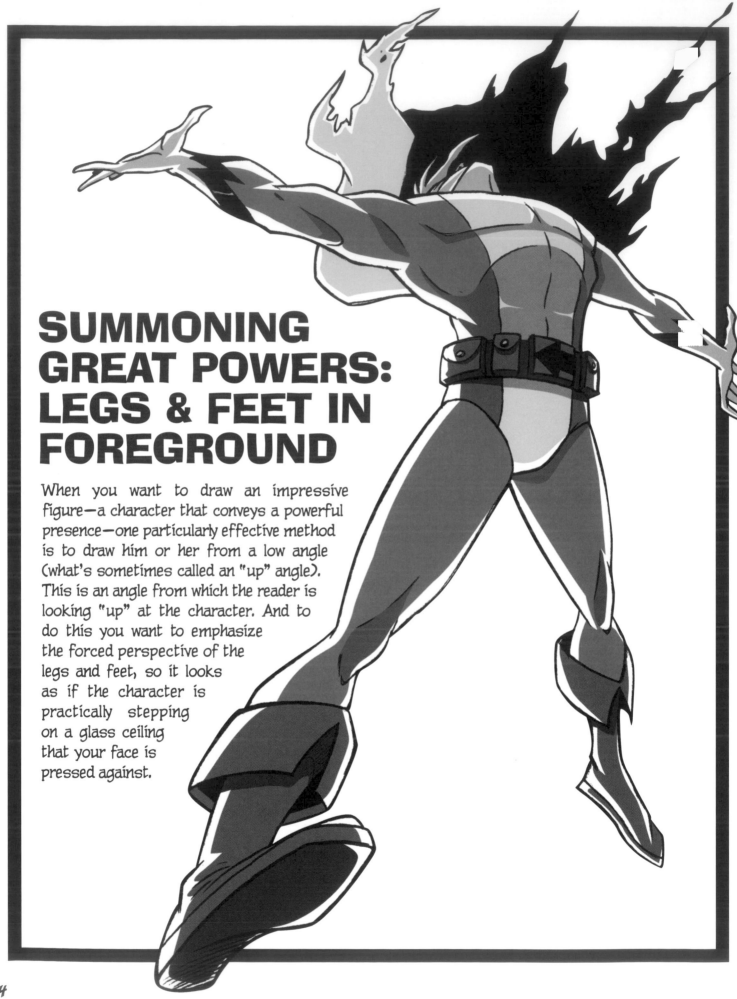

SUMMONING GREAT POWERS: LEGS & FEET IN FOREGROUND

When you want to draw an impressive figure—a character that conveys a powerful presence—one particularly effective method is to draw him or her from a low angle (what's sometimes called an "up" angle). This is an angle from which the reader is looking "up" at the character. And to do this you want to emphasize the forced perspective of the legs and feet, so it looks as if the character is practically stepping on a glass ceiling that your face is pressed against.

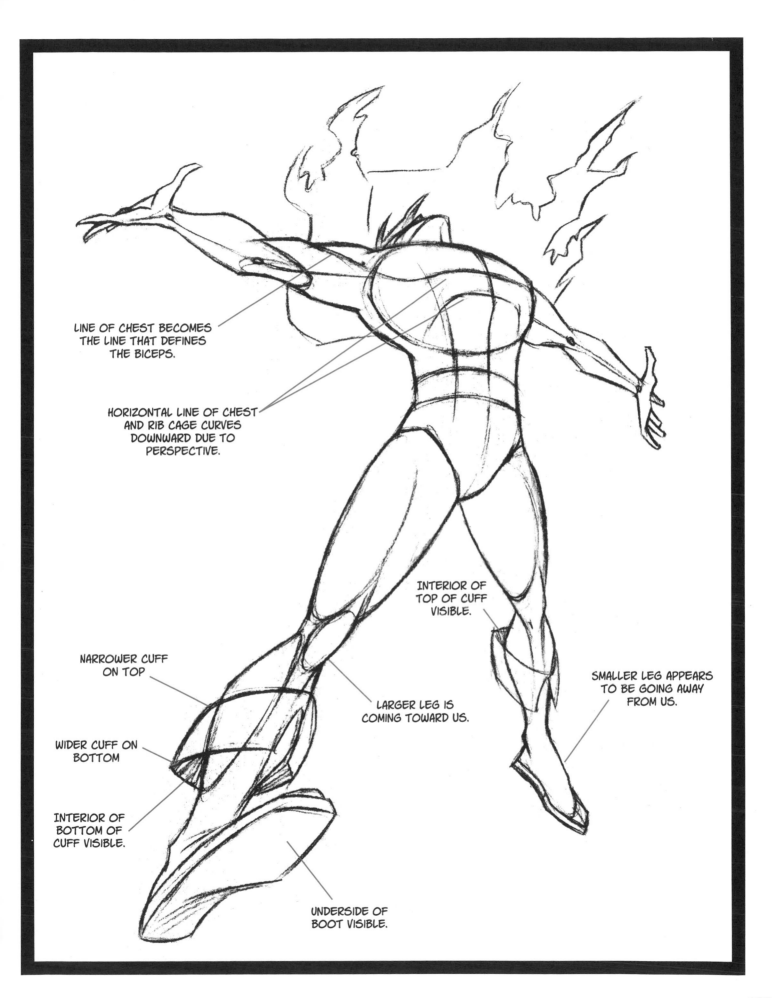

LINE OF CHEST BECOMES THE LINE THAT DEFINES THE BICEPS.

HORIZONTAL LINE OF CHEST AND RIB CAGE CURVES DOWNWARD DUE TO PERSPECTIVE.

INTERIOR OF TOP OF CUFF VISIBLE.

NARROWER CUFF ON TOP

SMALLER LEG APPEARS TO BE GOING AWAY FROM US.

LARGER LEG IS COMING TOWARD US.

WIDER CUFF ON BOTTOM

INTERIOR OF BOTTOM OF CUFF VISIBLE.

UNDERSIDE OF BOOT VISIBLE.

THE FAMOUS "BANANA PEEL" SHOT: HEAD IN FOREGROUND

Whoops! If you're going to wear a costume and fight bad guys, sooner or later you're going to get tossed off of a high-rise building. Come on, I mean, you'd probably feel left out if it didn't happen to you. So let's prepare for the inevitable, shall we?

When a character drops more than a couple of stories, he or she always falls headfirst. Is it a law of physics? No, but it's a law of comics. It just looks cool. Plus, it allows you to force the perspective on the character's head, which means we get to see the terror on her face, which is a lot more exciting than seeing the terror on her shoelaces.

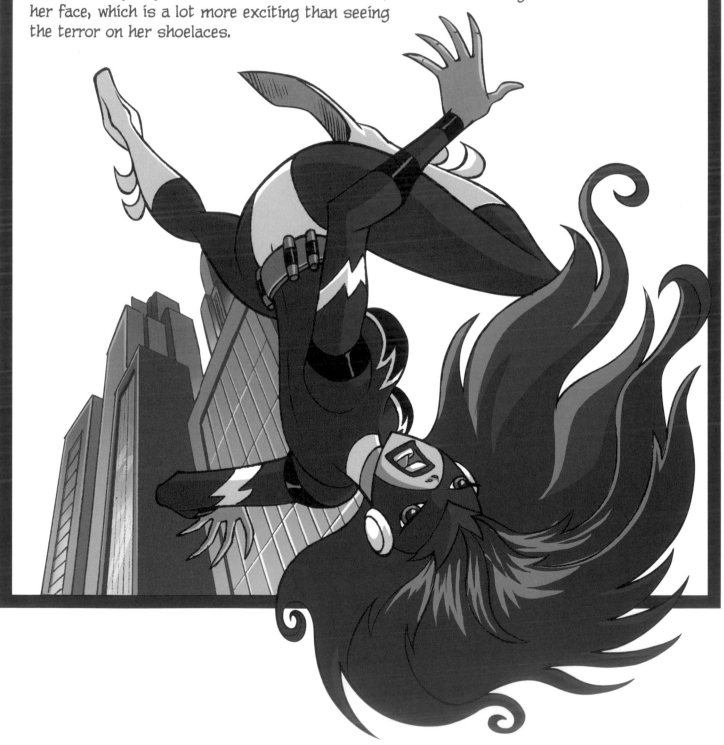

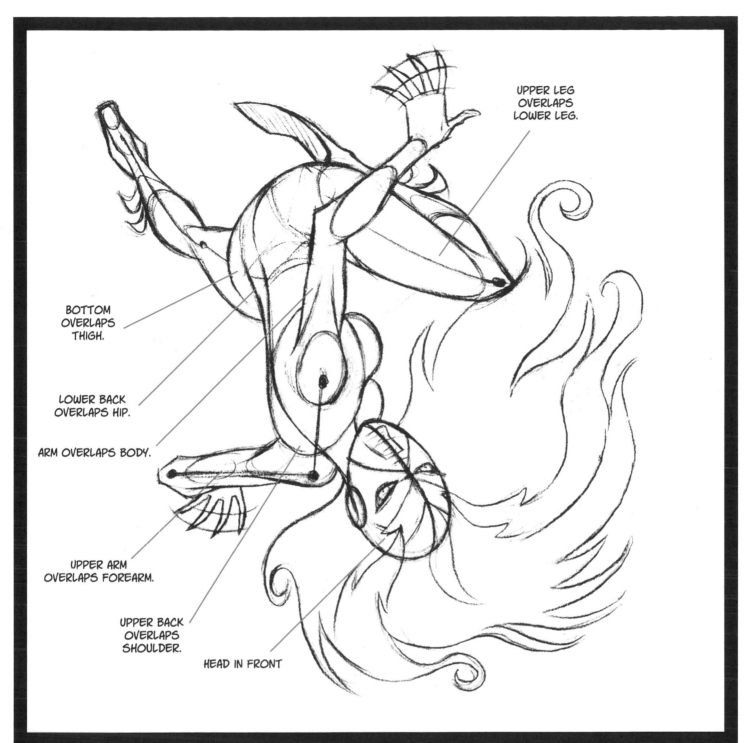

UPPER LEG
OVERLAPS
LOWER LEG.

BOTTOM
OVERLAPS
THIGH.

LOWER BACK
OVERLAPS HIP.

ARM OVERLAPS BODY.

UPPER ARM
OVERLAPS FOREARM.

UPPER BACK
OVERLAPS
SHOULDER.

HEAD IN FRONT

Another Approach

Here's the conundrum: If you make the head overlap the body too much, it'll look as if the head were hurtling sideways toward you instead of falling downward. So we "cheat" a little bit by sticking the head out in front, with big, wild hair flapping in the wind. Then we overlap the rest of the body. The result is that the character appears to be falling down, and at the same time, the head is out in front, still right in our face.

You *could* make the head huge and overlap the body, but as I just mentioned, that would make it look as though the character were hurtling sideways, toward the viewer. To do that, you would have to adjust the background so that it looks as if the interior of the panel were tilted. The buildings and horizon line would have to be drawn at a severe diagonal. Tilted panels give a scene an extreme, almost surreal look.

ATTACK STANCE: KNEE IN FOREGROUND

The foreshortened, bent knee is one of those areas that less experienced artists shy away from. But that's not you. And besides, in this streamlined style, drawing the foreshortened leg is 100-percent painless. In fact, it's going to be easier than you ever imagined. Often, less experienced artists try to draw the knee with great care, because they worry that people will be able to tell that they're "faking it" if they leave out any details. Well, I'm here to tell you that you're *supposed* to leave out the details when drawing the knee in forced perspective. This streamlined style demands it. Now isn't that less painful than a measles vaccine?

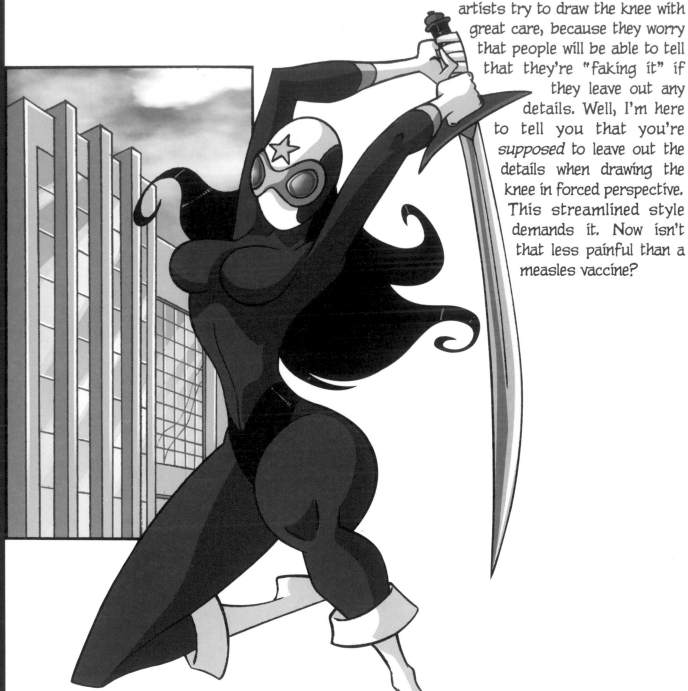

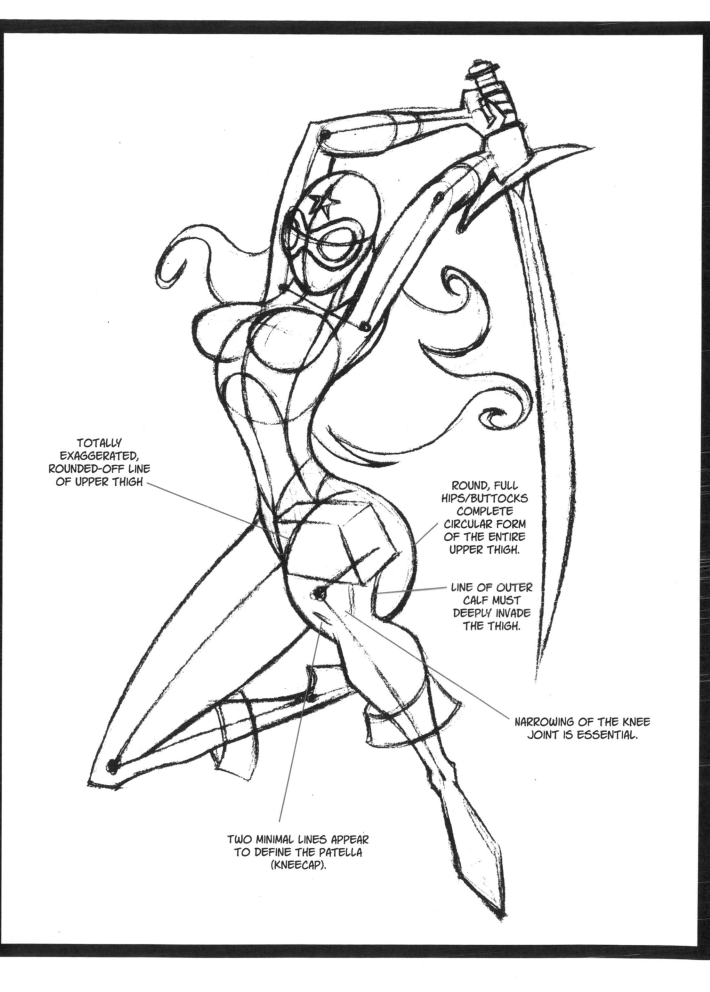

TOTALLY
EXAGGERATED,
ROUNDED-OFF LINE
OF UPPER THIGH

ROUND, FULL
HIPS/BUTTOCKS
COMPLETE
CIRCULAR FORM
OF THE ENTIRE
UPPER THIGH.

LINE OF OUTER
CALF MUST
DEEPLY INVADE
THE THIGH.

NARROWING OF THE KNEE
JOINT IS ESSENTIAL.

TWO MINIMAL LINES APPEAR
TO DEFINE THE PATELLA
(KNEECAP).

INDEX